LIFT EVERY VOICE

LIFT
EVERY
VOICE

A Celebration of Black Lives

FOREWORD BY
OPRAH WINFREY

INTRODUCTION BY
NIKOLE HANNAH-JONES

HEARST
HOME

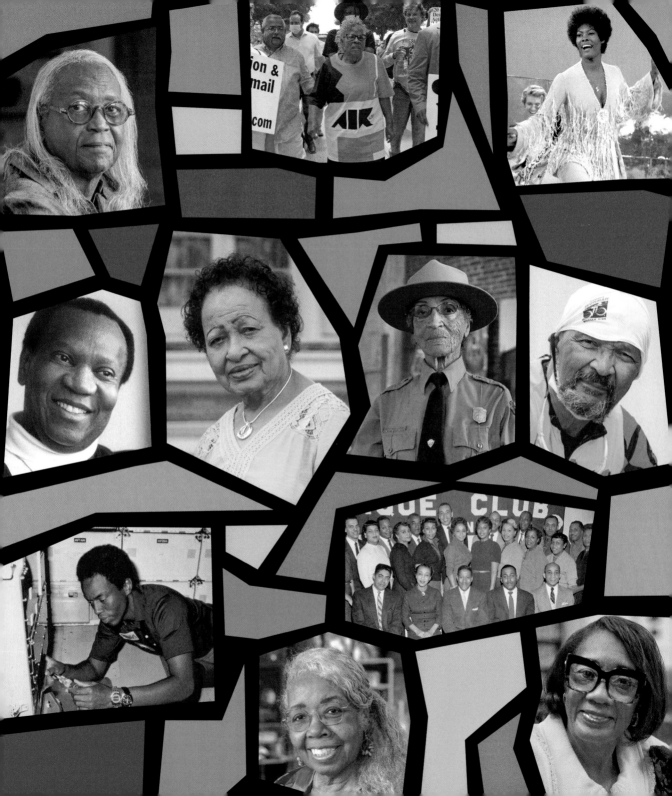

CONTENTS

Foreword
OPRAH WINFREY

When I was in my 20s, I was blessed to meet the woman I would end up calling my mentor and my mother-sister-friend, Dr. Maya Angelou. I have to tell you all, I loved literally sitting at her feet in my pajamas listening to her share stories of the past. We often talked about the need to know where we've come from in order to continue to build on where we need to go. "You know nothing about your life if you don't know your history," she would say to me.

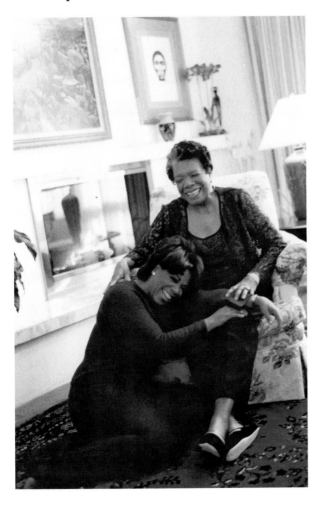

When we first started talking about *Lift Every Voice*, I could not help but think of my friend Maya and our many conversations. Named for the Black national anthem, "Lift Every Voice and Sing," this project brings together nearly three dozen young reporters, many from historically Black colleges and universities, and two dozen talented Black photographers. Together they tell the stories of members of our oldest generation of Black Americans, so that we may document, learn from, and celebrate our elders' life experiences.

Through more than 50 interviews, these young journalists have recorded the words and captured the images of civil rights pioneers, celebrities and non-celebrities, teachers and guidance counselors, artists and writers, doctors, coaches, homemakers, lawyers, and even a horticulturalist from across the country—remarkable women and men who, and God bless them, are now in their 70s or 80s or 90s, and even a couple centenarians. All are essential life stories that might have otherwise slipped into the white noise of history. This I know for sure: When we can lift every voice, we forge a deep and enduring connection to the past and carve a tunnel of hope to a brighter future for us all. Enjoy *Lift Every Voice*. ∎

Introduction
NIKOLE HANNAH-JONES

As a student of history and a journalist who writes about racial injustice, I have long been fascinated by the bridge generation—those Black Americans who were born into a nation of strict legal and social apartheid and then forced that horrific architecture to fall. These are people whose lives have spanned two starkly different Americas, whose struggles and fierce assertions of humanity brought about a country that none of them could have imagined when they were born.

It is a quintessential American inclination when it comes to the history of segregation and racism to pretend our society today resides far from this past. In our mind, we mark this period with grainy black-and-white imagery that gives us, individually and as a society, a false and comforting sense of distance. But this bridge generation makes up the last generation who knew people personally who had been enslaved in this country, and this generation is the generation immediately behind me.

That is why these days, as I reach the middle stage of my own life, where the end is quite likely closer than the beginning, I find myself thinking about, perhaps obsessing over, the passing of this generation. What will it mean when the last of those Americans who brought about our third founding, who fought to secure for everyone the inalienable rights set down by the white men who did not intend for those rights to include all men (and women), have left us? What fundamental understanding of our nation—both its magnificence and its horrors—will pass away along with them? What, I agonize over, will be collectively lost?

That is why this book in this moment feels essential. It serves, much like my own work, as both testament and testimony. The stories of our fellow Americans contained in these pages echo the work of the Federal Writers Project, which dispatched interviewers across the South to collect the narratives of the formerly enslaved, preserving invaluable stories and insights that might otherwise be lost to history and without which we could not fully understand our society today.

And in our community tradition of elders passing on knowledge and wisdom to the next generations through the word, *Lift Every Voice* tasked the collective descendants of these elders with gathering the narratives of the last U.S. generation born into apartheid, to set them in amber so that their experiences and the lessons they hold will remain with us even when this generation is gone.

What is so remarkable here, and what makes these stories extraordinary, is that they showcase the struggle and determination of Black Americans to simply be able to do ordinary things and be treated in ordinary ways. These pages hold the recollections of the foot soldiers, the barrier breakers, the firsts, the lasts, those who were born into a country that still believed it had the right to discriminate against the descendants of American slavery in every aspect of life, and yet were to determined to fight and live in their full humanity.

"

What makes these stories extraordinary is that they showcase the struggle and determination of Black Americans to simply be able to do ordinary things and be treated in ordinary ways.

There's the story of 95-year-old Anna Bailey, the first Black showgirl in Las Vegas. And Fred Gray, who, fresh out of law school, became the lawyer for the Alabama civil rights movement, representing the Montgomery Bus Boycott and filing the lawsuit that ultimately desegregated every public school in the state. There's the story of Dorothy Butler Gilliam, 85, who in 1961 became the first Black woman reporter to ever work at the *Washington Post*. And of 94-year-old Nina Bellamy, who raised 13 children, and whose progeny now includes 28 grandchildren, 57 great-grandchildren, and 30 great-great-grandchildren; she did all this while working a job and caring for sick children in her neighborhood whose own parents couldn't afford to take them to the doctor.

These stories, more than 50 of them—a snapshot of millions—reflect the beautiful and triumphant breadth of Black life, and the people who, as W.E.B. Du Bois wrote, "have woven ourselves with the very warp and woof of this nation." Their stories are powerful. Their images are profoundly moving in their capturing of their subjects' dignity and resolve. This book serves as tribute to this nation's true "Greatest Generation," and the legacy they leave, as documented here, is one of which every single American should be proud. This book, above all else, is a reminder of where we have been, and the debt we owe those who came before. These Americans have not passed the torch but are clasping it with us, urging us to continue the work alongside them. This book leaves each of us with a charge to work to become, ourselves, ancestors befitting of their legacies. ■

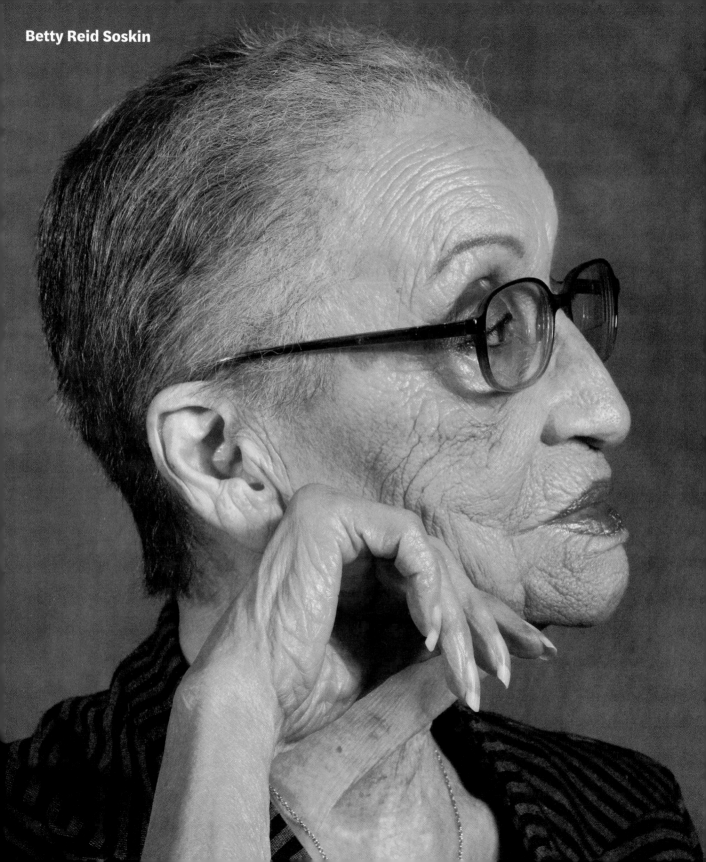

Betty Reid Soskin

CHAPTER 1
Perseverance

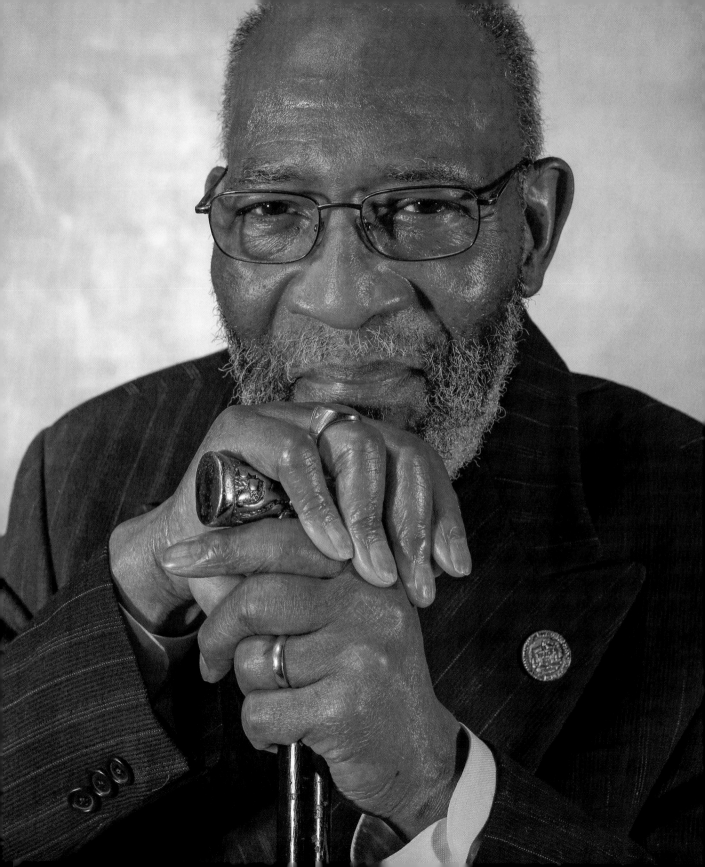

REV. AMOS BROWN

President of the NAACP San Francisco Branch, 81,
San Francisco

Interview by Ryce Stoughtenborough
Portrait by Yalonda M. James

The **Rev. Amos Brown** is the embodiment of history. A champion of the American civil rights movement, Brown has experienced firsthand what most have only read in books. Born in 1941 in Jackson, Mississippi, Brown was a few months older than 14-year-old Emmett Till, who in 1955 was brutally killed in Money, Mississippi—an hour away from Brown's home. The anger surrounding Till's murder sparked a movement for justice among the Black community, and magazine images of the boy's mutilated face led a terrified Brown to the Mississippi field office of the National Association for the Advancement of Colored People and its new field secretary, Medgar Evers. "I told him how upset I was, and just how evil those men were," Brown says. "And he said to me, 'Amos, don't just be sad, mad, and upset. Let's be smart.'"

Brown has dedicated his life to following Evers's advice and to the enrichment and liberation of not only Black Americans, but Black people around the world. At age 15, he started the first NAACP Youth Council in Jackson, and in 1960 he was arrested alongside the Rev. Martin Luther King Jr. at an Atlanta lunch counter sit-in. Two years later, as a student at Morehouse College in Atlanta, he was one of eight students in the only college class taught by the civil rights leader.

Today, Brown is the president of the NAACP's San Francisco branch, and he has served as pastor of Third Baptist Church of San Francisco since 1976, advocating for the rights of all people regardless of race, religion, or sexual orientation. In 2008, when a measure to ban same-sex marriage was on the California ballot, he was one of the few Black ministers to oppose it. He is also a member of the city's African American Reparations Advisory Committee.

"They say in Mississippi, 'God gave us two eyes to see, two ears to hear, and one mouth to speak,'" he says. "And the more you look, listen, speak less, and do the right thing, the better we all will be."

Ryce Stoughtenborough *After all the violence against Black people and trauma you've witnessed both during your childhood in the South and more recently, how are you able to carry such violent memories without being paralyzed by them?*

Amos Brown How do I do it? Because I know America. America is a racist country. The Church of Jesus Christ of Latter-day Saints did a family search on me. They went back five generations and found my great-great-grandfather, Patrick Brown. He was born enslaved in 1821 in Roxie, Mississippi, and even in spite of that cruel, evil system of enslavement, that didn't make him bitter. It made him a man to respond to the oppression of Blacks by defining his own reality. What was that reality? To be a learned man and to own some land.

"Dr. King was a very regular, down-to-earth person. He was not haughty or arrogant at all. In fact, in physical stature, he was only 5-foot-7—a short man—but the thing that made him bigger than life was his intellect and his commitment to the welfare and advancement of others."

Documents I received verified that in 1882, Patrick Brown bought 150 acres of land in Franklin County, Mississippi. He didn't let having been a slave define him. He and two other African American gentlemen were able to acquire land and to build a church and a school. I have the documentation that Patrick Brown, who was chair of the trustee board of what became Bethlehem Baptist Church, received that land and established those two institutions.

Would you say you're inspired by his work?

It did verify that the things I've done in my years on this earth had to happen because it was in my DNA. So as Alfred, Lord Tennyson said in his writing of "Ulysses," "I am a part of all that I have met." And it's a blessing to me that even in my genealogical chart there was a meeting of self-determination, of enlightened piety, social justice, and high and noble respect for education.

What was it like to personally learn from the Rev. Martin Luther King Jr.?

That was fulfilling what my name meant, what my ancestry demanded of me. Dr. King was a very regular, down-to-earth person. He was not haughty or arrogant at all. In fact, in physical stature, he was only 5-foot-7—a short man—but the thing that made

him bigger than life was his intellect and his commitment to the welfare and advancement of others. And the other thing that I learned, sitting at his feet there at Morehouse, was the idea of personalism. What is personalism? Every person should be viewed as having dignity regardless of how different they may be. We should respect them.

Black people have long distrusted police, but other communities, including white people, are voicing distrust today. Can we improve the relationship police have with our communities?

First, the police need to understand that to wear that badge is not license for you to beat up on human beings. Number two, you are human, and as a human being, deserving of respect and safety, you should want the same thing for others. Thirdly, you always need the right kind of police. Because we live in a world in which everybody who is taking advantage of the least of those, or everybody who has lost his or her manners and is causing pain and destruction for others, must be checked. Policing should be done with common sense, compassion, courage, and high professionalism. And you do that by working with people, not working at them, around them, or over them. In communities where that kind of principle is lived out, you are developing what Dr. King called the "beloved community."

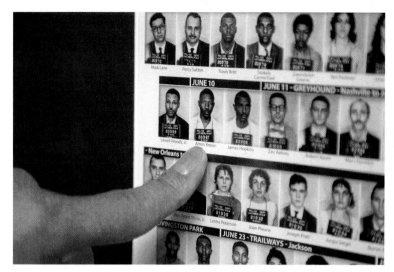

Brown points to the booking photo from his arrest during a June 1961 Freedom Ride.

As a San Franciscan, do you believe that the Bay Area is a safe haven for Black people and other people of color?

No. The Bay Area and specifically San Francisco has been living a lie. The city does not deserve the brand and image that it has of being liberal and progressive. The only thing San Francisco is liberal and progressive on is sex. That's it. And there should be no restrictions on people on how they express their sexuality. But there's a problem for Black people to get quality education in San Francisco. [Statewide assessments show a stark achievement gap between Black students and other students in the San Francisco Unified School District.] Since 1970, we have lost Black people who were pushed out of this city. The '70s Black population was between 15 and 16 percent. Well, now it's down to about 4 percent. [According to the U.S. Census, the 2019 Black population of San Francisco was 5.2 percent.] That didn't happen by accident, and it wasn't just economics. This happened because of public policy.

How can Black activists keep our history alive?

What I'm sharing with you needs to be a story that's told every month, every week, every day. We need to have rituals of remembrance. There should always be intergenerational gatherings of the elders regularly sitting down with the younger genera-tion and telling the story of how, even in spite of persecution, their ancestors excelled. That's what's missing.

And it's important for people to read, and to know history. To have what's called a "Sankofa Experi-ence." There's a bird in Ghana, West Africa, the Sankofa bird. The bird that looks back with the egg in its mouth to go forward. The moral behind that symbolism is you cannot go forward to a bright future unless you know your history and you have wisdom—the wisdom to weigh that history and know what things represent wisdom, common sense, and the good of all humankind. ∎

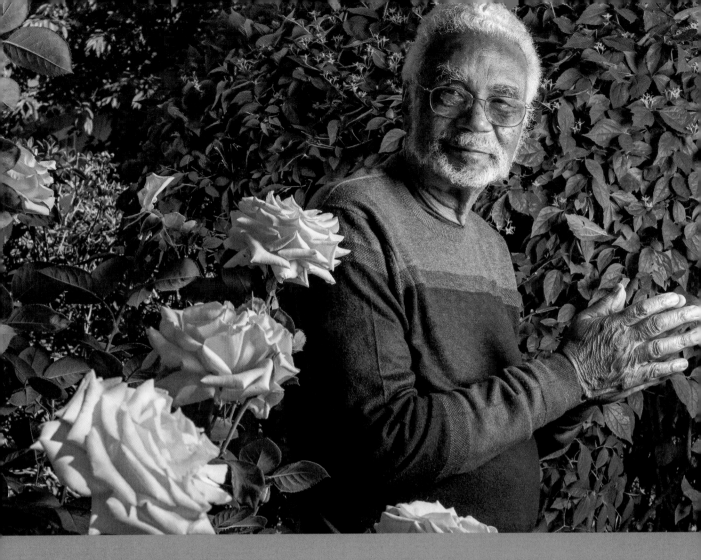

CLAYBORNE CARSON

*Director of the Martin Luther King Jr. Research
and Education Institute, 77, Palo Alto, California*

Interview by Ashlea Brown
Portrait by Yalonda M. James

There may be no one on earth who knows the words and writings of the Rev. Martin Luther King Jr. better than **Clayborne Carson**. In 1985, Coretta Scott King handpicked him to edit and publish her late husband's archive of sermons, speeches, and correspondence. Though reluctant at first, Carson took on the challenge and brought it to Stanford University, where he is the director of the Martin Luther King Jr. Research and Education Institute and has spent the past decades on the King Papers Project, turning the civil rights leader's archives into a series of books, with seven volumes published so far and plans for 14 in all. Carson, now retired, is dedicated to activism and promoting change regarding Black lives and the freedom struggle. Today he spends his time educating young activists by holding office hours at the Martin Luther King Jr. Freedom Center in Oakland.

Ashlea Brown *Do you remember your first thoughts back in 1985 when Mrs. King wanted you to take on and edit Dr. King's papers? Did you set any goals after accepting this challenge?*

Clayborne Carson My first thought was, "Do I really want to do this now?" Because King was not the center of my research. That was, rather, a broader topic of the freedom struggle, and I focused on young people, the Student Nonviolent Coordinating Committee. Young people in SNCC thought they were ahead of King; they were the vanguard that King was trying to catch up with, rather than the other way around. I kind of had that attitude.

I admire King a great deal, but I wasn't a follower. I felt that the work I started doing in Los Angeles when I was at UCLA, organizing in South Central Los Angeles, was at least as important as what King was doing in the South, taking on part of the problem, but there was still another part of the problem that was more national. Deeper-rooted problems. He was trying to overcome a particular system of segregation, but I felt even once that was done, it really wouldn't change things very much outside the South or even inside the South. People would still be poor, they would still need jobs, and they still wouldn't have political power.

I first said there might be some other people, and I remember suggesting David Garrow, who wrote a book about King. There was another aspect to this: Mrs. King wanted someone willing to move to Atlanta. At that point in my career, I wasn't about to leave a tenured job and, especially with my kids in school, go to Atlanta to work on a project that might go on for a while. Well, it has gone on for 35 years.

What have you learned about King through receiving those papers that you did not expect?

I think learning more about his relationship with Coretta has been exciting. The love letters he wrote to her when they were dating back in 1952, and discussing things like socialism. Coretta was much more of a political activist than he was at that time. She was two years older than him. She had been politically active since 1948 with the Progressive Party. That was the third party that was set up in the 1940s, and it was kind of socialistic; it was against the Cold War. She knew people like Paul Robeson, for example, who was a major figure in the Progressive Party, and Martin had none of that kind of experience. He was much more sheltered. He lived at home through his years at Morehouse College, and then he went out to a small seminary in Pennsylvania, Crozer Theological Seminary, in a very isolated small town. Then he went off to Boston University, and that's where he met Coretta.

"If you don't know your history, how are you going to move forward? If you don't know where you are, how can you know where you're going in the future?"

How important is it to have archives like the King Papers Project as a resource for movies, books, and movements today?

Well, if you don't know your history, how are you going to move forward? If you don't know where you are, how can you know where you're going in the future? If you don't know anything about the past, how do you even know where you are?

It's kind of like saying, "Where are you geographically?" without knowing the geography of the world. And then the only way you know that you're in the United States is that somebody tells you that there's a map and you're here. History is kind of like that too. You have to know something about what happened before, before you can figure out where you should be heading or at least what you should be escaping from.

Did you see the film One Night in Miami, *which depicts Cassius Clay, Jim Brown, Sam Cooke, and Malcolm X all in conversation one night during the civil rights movement? Who are four people you'd like to sit in a room with to have a conversation, and why?*

Yeah, I watched it. I think all of us who are into ideas and studying and reading books all kind of think, "Gosh, it'd be nice to sit down and have a conversation with XYZ and have them all together around a dinner table." Some of them I have already met, like I met Jim Brown, who came by the institute one day. I wrote a book about Malcolm X, so obviously it would be wonderful to have a conversation, but I feel privileged because I have had conversations with some of the people that would be on my wish list. I had the Dalai Lama come by. I'll be talking in about an hour with Bernard Lafayette, one of the Freedom Riders and one of the people who worked very closely with Martin Luther King.

A lot of those kinds of people—Andrew Young and Dorothy Cotton, Bob Moses—each of us has our list of people we've learned from, fascinating people to talk to, and I guess one of the things that I think has

Carson with Coretta Scott King at Stanford University in November 1986.

been very fortunate in my life is that I can tick off at least 20 or 30 of those types of people whom I have had extended conversations with. You always have those regrets, that I never got a chance to have a personal conversation with Martin Luther King. But on the other hand, I had 20 years of conversations with Coretta King, and lots of other people around Martin Luther King. So in a way, I kind of know him now.

You've taught at Stanford, Morehouse College, Emory University, and UC Berkeley, just to name a few. What drives you when teaching young students around the work of Martin Luther King?

When I see myself as a teacher, I see that as part of the process of learning. You can't teach and you can't write unless you first learned. When I walk into the classroom, I try to be one step ahead of my students. Now, a lot of times I'm like 12 steps ahead, but I want to be at least one step ahead. If I walk into a classroom and some students in there know more than I do, we should exchange places. It has to be a constant process of trying to keep learning. The lecture I would give today is hopefully better than the lecture that I would have given a year ago.

I have heard about teachers who write out their lectures, and they come in and it's the same as they gave the year before. And I just despise that. What's the point of that? It seems like it'd be the worst kind of boring. I want to come in and try to say something new every time I go into the classroom.

What brings you joy today, and what do you look forward to in the future?

Keeping busy, doing things I like to do now. I'm at a stage in my life where I don't have to go to an office ever again. I'm at a stage where I don't have a job; I have titles. None of my titles require me to go to an office. That's ideal, just being able to spend each day doing something that you think is interesting. Either reading or writing or talking with someone and teaching online, which is nice since I don't even have to go someplace to teach. I can just sit here in the same place where I'm sitting right now, and in exactly an hour, I will be teaching. ∎

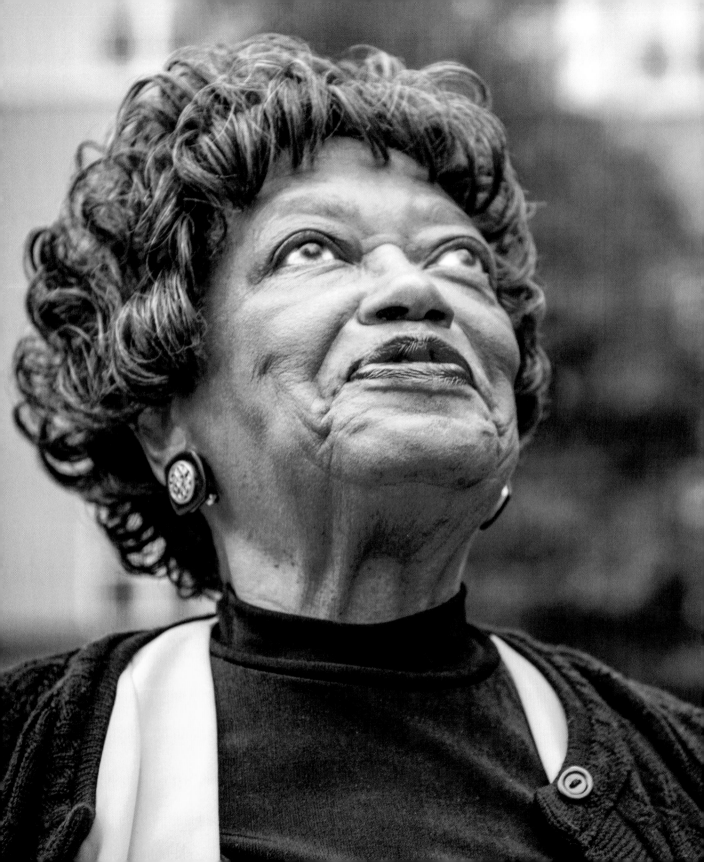

CLAUDETTE COLVIN

Civil Rights Pioneer, 82, Birmingham, Alabama

Interview by Rachel Williams
Portrait by Andi Rice

Claudette Colvin was a true pioneer in the civil rights movement. In 1955, when she was 15, she refused to give up her seat on a Montgomery, Alabama, bus to a white woman–nine months before Rosa Parks's refusal in the same city sparked sparked a bus boycott. As an adult, she worked as a nurse's assistant in New York City until her retirement in 2004. In October 2021, she filed a petition to have her arrest record expunged, declaring that justice was overdue; in December, a judge in Birmingham granted her request.

The coverage of the verdict in Colvin's case in the *Montgomery Advertiser*.

ON GROWING UP IN THE SOUTH

I lived with relatives on a farm in the little town of Pine Level, North Carolina. We had horses, cows, pigs, chickens, a dog, and a cat. All the big holidays were like a family reunion–my relatives would show up in big, shiny automobiles from the North. At that time we didn't have electricity, so the little boys would take turns turning the crank on the ice cream maker. We made stew from scratch and had a barbecue pit. It was so much fun!

ON HER FIRST ENCOUNTER WITH RACISM

When I was 6 years old, I was looking around with my mother in a store to get a lollipop. Suddenly all the kids were laughing, so I turned around and said, "What's so funny?" A little white boy said, "Let me see your hand." So I raised my hand, and he put his hand up against my hand. Out of nowhere, my mother, Mary, popped me on the forehead. And the boy's mother yelled, "That's right, Mary!" When I got home, my mother explained that I was never to touch or talk to a white child.

> **I was sitting on the bus and they dragged me off the bus, manhandled me off the bus, and put me into the patrol car, and then they handcuffed me through the window. And instead of taking me to a juvenile delinquent center, they took me to an adult jail.**

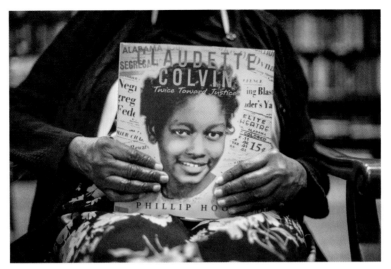

Colvin holds her copy of *Claudette Colvin: Twice Toward Justice* by Phillip Hoose, which won a National Book Award in 2009.

ON NOT GIVING UP HER SEAT ON THE BUS

I was a teenager at the time, and we had been learning about Harriet Tubman and Sojourner Truth in school. When a white woman got on the bus and the driver told me to get up from my seat so she could sit down, I felt that those women each had a hand on my shoulders pushing me down. History had me glued to the seat. The police dragged me off the bus, handcuffed me and took me to jail. Later that day, my mother and a local pastor bailed me out, and that night after I got back home, my father sat up with a loaded shotgun by his chair. He said, "The KKK is not going to take you out tonight."

ON ROSA PARKS

After I got out of jail, I lost most of my friends because their parents told them I was a trouble-maker. Then I got pregnant out of wedlock and had my son Raymond. At that time, Rosa Parks was the secretary of the Montgomery chapter of the NAACP, and as a seamstress, she had a lot of white, affluent customers. So she became the face of the movement, and I was ostracized by a lot of activist organizations. But I wasn't seeking notoriety. In fact, Ms. Parks became a close friend and mentor to me after I joined the NAACP Youth Council. We have to remember that Black women may not always have all the support they need growing up. Struggles you've gone through have nothing to do with your capabilities as a leader. It's a shame to miss out on so many precious minds and contributions.

ON THE LESSONS SHE WANTS TO PASS ON

Don't be afraid to stand up and fight for what's right. Get out there in the struggle. The more of us are out there, the more powerful we will be. You might not benefit from it right away, but the younger genera-tion behind you will benefit from it.

ON WHAT SHE'S MOST GRATEFUL FOR

I'm most grateful for raising my two boys to adult-hood. I provided for them and gave them courage. I can say I have reaped some of the fruits of my labor through my grandchildren. These are the last days of my life, but God has blessed me. I don't have money, but I have hope and faith. ∎

BETTY DANIELS ROSEMOND

Freedom Rider, 82, Cincinnati

Interview by Ashley Kirklen

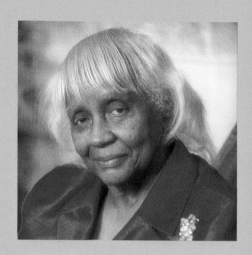

Betty Daniels Rosemond grew up in New Orleans with Jim Crow laws and segregation as the norm. She saw firsthand how racism held her family back when her mother tried to vote or buy a home and was ultimately denied. She decided she wanted to be part of a movement that was changing the country, so she joined CORE, or the Congress of Racial Equality, to become a Freedom Rider. "We knew every time we took a ride that if we died, we died," Rosemond said.

Rosemond said there was a general fear growing up that she could be stopped by police or harassed at any moment for simply being out. "You would be stopped, but you had to, if they told you to move—for instance, if you got on a metro bus, and a white person wanted your seat, they could insist that you move and go to the back of the bus because that part was for Black people," she said. "And if you didn't do what they said, you would be arrested. So there was always, you had to do it, or you pay consequences."

At 21, she decided to leave school at Louisiana State University to join the Freedom Riders. "I went through some of the training, and one of the girls slapped me and almost knocked me down," Rosemond said. "But that was part of your training to see if you would retaliate—you couldn't retaliate."

She and four others went on a Freedom Ride from New Orleans to Mobile, Alabama, just days after another group's bus was bombed. "On the way back, we got to a little town in Mississippi," Rosemond said. "Now, Freedom Riders were testers. Their job was to test the facilities to see if they were following the law." Her job was to make a phone call back to their headquarters in New Orleans. "When I got to the phone booth, men in a pickup truck, white men, pulled up at the little bus station. They literally dragged three girls out, put them in the back of a truck, and drove off. Now, I knew if they found me, it would have been another lynching that night."

I asked Rosemond how she feels now that the nation has seen its first Black president and its first female, Black, and Southeast Asian vice president. "Oh, I feel good. I really do," she said. "It's good to know that people were still willing to try to see that change will come and there are still people who risk their life to see that this happens."

Rosemond said she believes we're closer to Dr. King's dream, but still far from the goal. "You know, we have work to do," she said. "It's not over until God says it's over. The Bible tells us this, that we must love each other, love our neighbor as ourselves; we are compelled to love one another. And that's what's missing in the world today." ∎

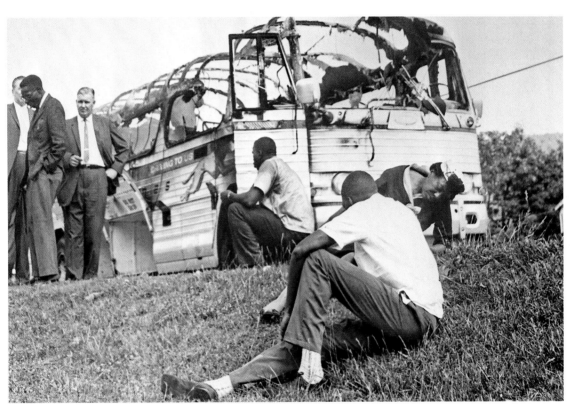

Freedom Riders sit beside a burned-out Greyhound bus they had ridden
after being attacked on the highway near Anniston, Alabama, in May 1961.

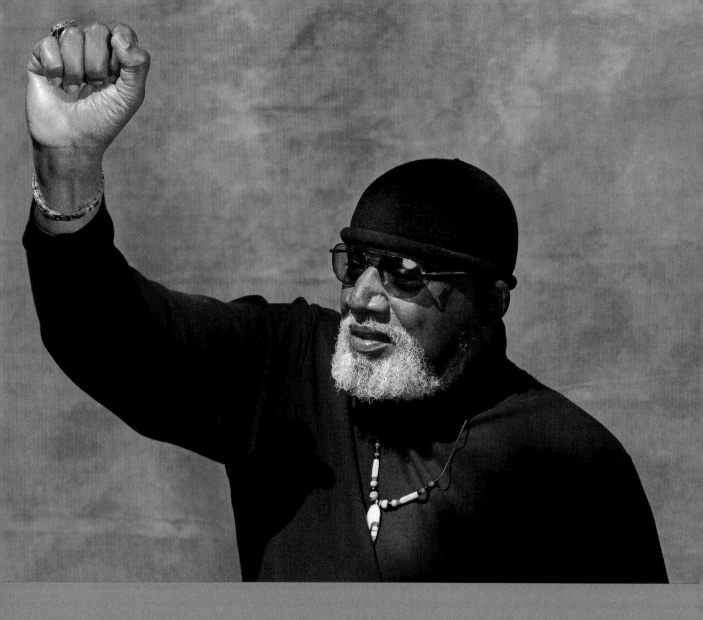

HARRY EDWARDS

Sociologist, Advocate for Human Rights in Sports, 79,
Fremont, California

Interview by Jerusha Kamoji
Portrait by Yalonda M. James

S tanding on the San Francisco 49ers field at 6-foot-8, **Harry Edwards** could be mistaken for a former football player. Edwards has never been a professional athlete, but the sociologist and retired UC Berkeley professor is an advocate for human rights in American professional sports, who has consulted for the 49ers and Golden State Warriors and counseled quarterback Colin Kaepernick on taking a knee to protest police brutality in Black and brown communities.

Perhaps Edwards's most famous contribution to activism in sports was founding the Olympic Project for Human Rights, an organization that challenged segregation and racism in athletics and called for the exclusion of apartheid South Africa and Rhodesia from the 1968 Olympic Games in Mexico. The image of sprinters Tommie Smith and John Carlos raising the Black power salute on the podium in Mexico City (see the image on page 31) has been an enduring symbol of the movement for civil rights in sports.

Today, Edwards works as a consultant for player personnel and staff development with teams in the National Football League and the National Basketball Association, and he's still speaking out and teaching about the state of race relations on and off the field in America.

Jerusha Kamoji *What current issues do Black pro athletes have, and how do we address them?*

Harry Edwards There are all kinds of issues. The challenge becomes, how do you prioritize them? The NFL has a major problem in terms of its distribution of funds to athletes who have begun to show signs of chronic traumatic encephalopathy, dementia, or some other cognitive decline suspected of being football-related. As it turns out, qualification for those funds is "race normed," with white former players having a much lower threshold than Blacks in terms of qualifying for that money, because the working medical presumption is that Black players start off with a lesser intellectual ability and there- fore have to present increased signs of cognitive deficiency before qualifying for the funds that the NFL has set aside. [In June 2021, the NFL vowed to stop the practice in response to a petition, outcry from medical experts, and a civil rights lawsuit by retired Black players.]

If you look at circumstances beyond the locker room, there are all kinds of things that come over the wall of the stadium. The athletes are very much concerned about the ongoing challenge of police brutality and murder under the cover of the badge. I mean, LeBron James knows the only reason that it was George Floyd and not him who was murdered by police was that he was not there. The women of the WNBA know the only reason that it was Breonna Taylor who was murdered in her own home by police is that they were not there.

The voter suppression thing is something they've been concerned about for some time, because all of the demands being made in terms of change, reimag- ining policing, dealing with the issues of inequality and injustice in society, depend upon putting people in positions of power in the government who can make the changes that are being asked for.

Can athletes have an impact on big societal issues outside the arena of sports?

Athletes can have a tremendous impact in terms of continuing to organize and mobilize around getting out the vote. They can have a tremendous impact in terms of convincing people they should get their vaccinations. They can have tremendous impact in terms of helping to convince people that they should wear masks, that they should use sanitizer, and deal with some of the more obvious issues that divide us.

> **"When we begin to talk about representation based upon the populations, what we're really talking about is quotas and not opportunities."**

You have been addressing systemic racism in the sports industry for decades. Have you seen any positive changes?

Well, there have been positive changes, but whether those changes have been progress, that's another issue. We're still battling to get representative access in front-office and coaching positions at the NFL. The locker rooms are about 74 percent Black, but we are now down to four minority coaches overall and only three Black coaches in the league. The problem is that all of these changes are taking place, but they haven't been based upon morality or constitutional guarantees of equality, freedom, and justice; they've been transactional.

When Jackie Robinson broke into Major League Baseball, it was proclaimed as a major step in progress. Nobody said, "Yeah, but what about predatory inclusion? What about the collapse of the Negro Leagues? What about the fact that most Negro League teams were not compensated for the players who were taken out by the Major League teams?" How does one determine that that constitutes progress when they didn't bring over the managers, they didn't bring over the team owners, they didn't bring over the front offices?

Has there been recognition of predatory inclusion in the sports industry?

If you go on any college campus today, in the wake of *Brown v. Board of Education*, there has never been a representative proportion of people of color on the faculty, in the student body, or in the administration. But when you look at revenue-producing sports, such as football and basketball, you tend to find that Blacks are overrepresented. That situation continues to this day, and much the same way as the Negro Leagues were destroyed with the predatory inclusion of Black baseball players—not one athlete was picked out of a historically Black college or university this year in the NFL draft. What that means is the schools developing the top Black athlete candidates are the predominantly white schools. They're bringing in most of the blue-chip Black athletes, which is destroying athletic programs at HBCUs, just as surely as predatory inclusion by Major League Baseball destroyed the Negro Leagues.

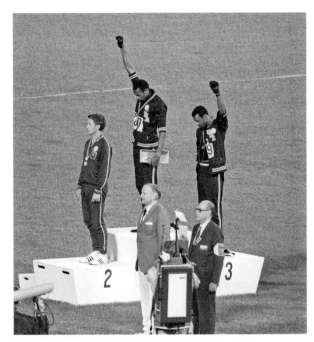

Tommie Smith and John Carlos making the Black power salute on the medal podium after winning gold and bronze in the 200-meter sprint at the 1968 Olympics.

Do you feel as though your decision to be an advocate for humanitarianism in the sports industry was a choice?

It became very clear to me early on that something needed to be done about the headlock that American sports and the American sports media had on Black people, if for no other reason than we were wasting some of our most talented, competitive, determined, and committed young people in this mad pursuit of athletic stardom in circumstances where they had a greater chance—statistically—of being hit by a falling star than becoming a star in the NFL or the NBA.

Only 2 percent of all athletes who participate in collegiate sports ever sign a professional contract, not to speak of the 98 percent who, after they played their last home game, for all practical purposes were back on the street [because many didn't graduate]. They ended up finishing up their athletic eligibility with no degree, and no means of going to school to complete the degree. They wound up back home in their old bedroom at their mom and dad's house if they were lucky. If not, they ended up on the street, trying to figure out how they were going to make a living and survive.

Tell me about your experience with mental health among Black athletes. How much of a concern is it in the industry, and are there enough resources to provide support?

One of the things that we're trying to put together at the University of California at Berkeley is a program in the department of social work [under its dean, Linda Burton]. Former athletes will be recruited into a program where they are trained as clinicians, community workers, and so forth. They will be certified with a master's in social work degree to work in that extended capacity, not just with athletes but defunding police departments and shifting those funds to other categories of city workers who are more qualified to go out and de-escalate the situation where there may be a mental health issue, a drug problem, a domestic violence problem involved.

When implementing representation at the highest levels in sports, wouldn't it be logical to look at the statistics of minorities in the U.S. and have those numbers reflected in management?

If we use that measure for the front office, why not for the locker room? In the NFL, rather than 74 percent Black players it would be 13 percent, and in the NBA, rather than 78 percent Black players there would be 13 percent. So when we begin to talk about representation based upon the populations, what we're really talking about is quotas and not opportunities. Once you open it up to opportunities that are transactionally based, then whoever competes and becomes the best at winning begin to be the ones that show up. That is the measure that you want applied.

Are you hopeful for the future of race relations in the United States?

I'm not hopeful; I'm confident, because I know the history of the struggle in this country that has gone on since the first Africans arrived on slave ships, since the first Native American was murdered for their land. I understand that America has been through worse and come out better. We went through a bloody civil war that took more people than the other American wars combined, but we came out with an end to slavery, with Recon-struction and other efforts to broaden the basis of democratic participation. We went through a civil rights movement that killed—between the turn of the 20th century and the assassination of Dr. King—three times as many people as were killed on 9/11, but we came out of it with a Voting Rights Act, the Civil Rights Act, and the Open Housing Act. We came out with more Black officials in public office than at any time since Reconstruction.

America is built from movements. We came up with the abolitionist movement, the labor movement, the civil rights movement, the women's suffrage movement, the gay rights movement, the Me Too movement, and the Black Lives Matter movement. That is part of the American political legacy and always will be. That is where these young people are today. I'm not only still hopeful, I feel confi-dent that this struggle will continue to progress. It will not be linear, but Americans are better at this kind of struggle than any of the people on the face of this earth, and that is something that is not going to simply come to an end because of our divisions. ∎

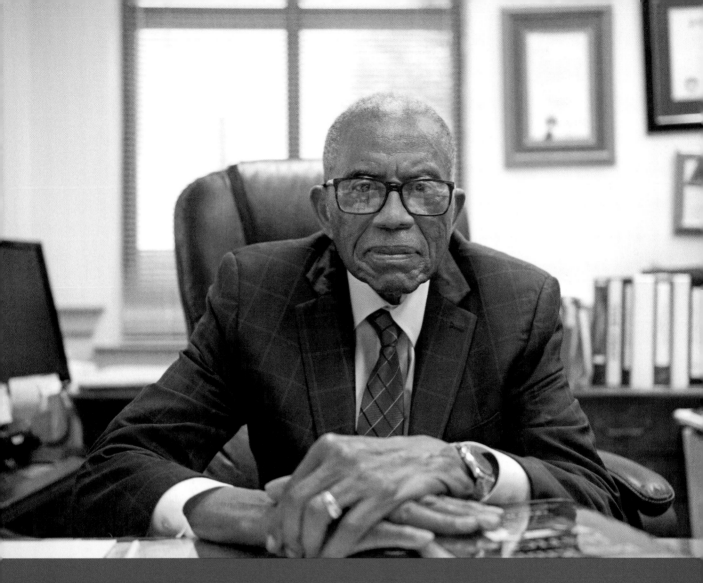

FRED DAVID GRAY

Civil Rights Lawyer, 91, Tuskegee, Alabama

As told to Hali Cameron
Portrait by Andi Rice

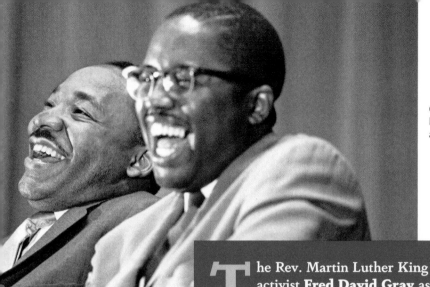

Gray and the Rev. Martin Luther King Jr. break into laughter at a joke told by a speaker at a political rally in Tuskegee, in April 1966.

The Rev. Martin Luther King Jr. once described lawyer and activist **Fred David Gray** as "the brilliant young Negro who later became the chief counsel for the protest movement." Gray defended both Claudette Covin (read her story on page 23) and Rosa Parks against disorderly conduct charges for their refusal to give up their bus seats to white passengers, and was instrumental in guiding the Montgomery Bus Boycott of 1955-'56. He filed the landmark case *Browder v. Gayle* and argued it before the U.S. Supreme Court, leading to a ruling declaring Alabama laws mandating bus segregation to be unconstitutional. His autobiography, *Bus Ride to Justice*, was published in 1995.

I'm the youngest of five children. My father died when I was 2. My mother had no formal education, except to about the fifth or sixth grade. But she told the five of us that we could be anything we wanted to be if we did three things. One, bring Christ first in your life. Two, stay in school and get a good education. And three, stay out of trouble. I have tried to do all three of those things. And they have helped me to do all the other things I have done.

When I finished my high school work, at that time, as a young Black man in Montgomery, basically the only two real professions you could look forward to, one was preaching and one was to be a teacher. And if you did either one, you did it on a segregated basis, because everything was segregated. So I decided I would be both. And I enrolled at what was then Alabama State College for Negroes, now Alabama State University. It is on the east side of Montgomery, and I lived on the west side of Montgomery. So I had to use the public transportation system every day.

As I used that system, I realized that people in Montgomery, African Americans in Montgomery, had a problem. They had a problem with mistreatment on the buses, and one man had even been killed as a result of an altercation on the bus. I didn't know nothing about lawyers, but they were telling me that lawyers helped people solve problems. And I thought that Black people in Montgomery

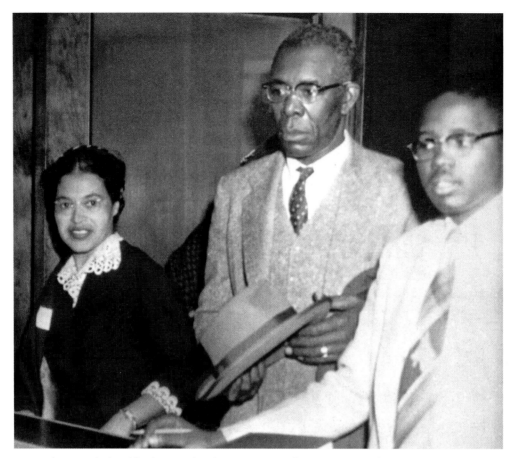

Gray, right, signs the bond for the appeal to the Circuit Court after Rosa Parks, left, was convicted of violating Montgomery's segregation ordinance for city buses. E.D. Nixon, former state president of the NAACP, stands between the two.

had some problems. And not only that, everything was completely segregated. So I made a commitment, a personal commitment, a private commitment. And that was that I was going to go to law school, finish law school, take the bar exam, pass the bar exam, become a lawyer in Alabama, and destroy everything segregated at the time. Now, for a young teenager to think that way, you may say I was thinking a little bit out of the box.

On the seventh of September, 1954, I became licensed to practice law in the state of Alabama. I then was ready to begin my law practice and begin destroying everything segregated I could find.

Dr. King came to Montgomery just about the same time I started practicing law. He was installed as pastor of Dexter Avenue Baptist Church in October of 1954. But nobody knew Martin Luther King. He didn't come to Montgomery for the purpose of starting a civil rights movement. I doubt whether he knew anything about civil rights. The church that he became pastor of, Dexter Avenue, was a small African American Baptist church that consisted of basically educated persons who were employed by some governmental agency or another, and all of those governmental agencies enforced segregation. So that church would have been the last church whose members would have ever filed a lawsuit to desegregate anything in Montgomery. And the

pastor that they had before him, Vernon Johns, they got rid of him because he was too liberal. So nobody knew anything about Dr. King when he came to Montgomery. And, but for what Mrs. Rosa Parks did, and what Claudette Colvin did—if they had not done that, probably nobody would ever have known who Martin Luther King was.

I had met Mrs. Parks when I was in college at Alabama State. She was then and for quite a while secretary of the Montgomery branch of the NAACP. She was also the director of the youth program, and of course the young people she was dealing with when I was in college were just a little bit younger than my age. So I used to visit some of her meetings. After I came back to start practicing law, I renewed my relationship with Mrs. Parks. In our meetings we talked about the way a person should conduct themselves if the opportunity presented itself and they were asked to get up and give their seat on a bus. And Mrs. Parks was the right type of person. We didn't want somebody who would be a hothead, or who they could accuse of being disorderly, but someone who would let them know they were not going to move. If they were told that they were under arrest, they would go ahead and be arrested. And we would try to be sure that somebody was there to take care of them.

We also knew that it was going to take a lawsuit in federal court in order to have the Jim Crow laws declared unconstitutional. And we knew that would take time. So we felt we couldn't tell the people to stay off of the buses until they could go back on a nonsegregated basis. But the plan was, let's tell them to stay off of the bus one day, on Monday, the day of Mrs. Parks's trial. And then we'll decide where we go from there.

Somebody had to be the spokesman for the group, to tell the people and the press what we were doing and why we were doing it. It needed to be a person who could speak, and someone said to me, "Well, I'll tell you, Fred, the person who can do that the best of anybody I know is my pastor, and that's Martin Luther King." He hadn't been in town long, and hadn't been involved in any civil rights activity. But he could move people. I said, "If he can do that, that's the kind of person we need."

It didn't take long to try Mrs. Parks's case because I knew they were going to find her guilty, and I was gonna have to appeal it. So I simply raised the constitutional issues. We had a trial that took less than an hour. She was convicted; we posted the appeal. And they had a mass meeting that night at the Holt Street Baptist Church. And when Dr. King spoke, everybody knew. And that is the beginning of how the bus boycott started. And the people stayed off the buses for 382 days.

> A little bit before he died I said to my good friend John Lewis, 'Congressman, you've done a good work, and as long as I'm living, I want to continue to do it. What do you want me to do?' He looked at me and said, 'Brother, keep pushing, keep going, and keep the record straight.' And I say to you young people, Keep pushing, keep going, and set the record straight.

As a result of people seeing what had happened in Montgomery, the thought then was, If you can solve a problem with staying off the buses, then Black people can solve their problems elsewhere. So you had the students up at A&T that started the sit-ins at the lunch counter. You had all of these people getting involved in what developed into the civil rights movement as a result of seeing what 50,000 African Americans had done in Montgomery.

I have now been practicing law for some 66 years, and it all started because when I was a student at Alabama State, I made a decision that I was going to destroy everything segregated I could find. Doing away with segregation on buses was just the beginning of my career. I've filed lawsuits that have ended segregation at the University of Alabama. I represented Alabama State in a case that ended up desegregating all of the other institutions of higher learning. Our responsibility, and the responsibility that the NAACP and other groups were working on since slavery, was filing lawsuits one at a time, one area at a time, and getting the court to declare it unconstitutional. We have for the most part knocked out those laws. However, the most discouraging thing for me and my practice in Alabama was

that I was naive enough to believe that when the white power structure in this state saw that African Americans could perform as well as they, or better in some instances, that they would be willing to accept it. But while we have knocked the laws out, the attitudes of some have not changed. But we have made a tremendous amount of progress.

The best advice I can give to young people—and old ones too, for that matter—is, look in your communities. See the problems that exist? Do as we did in Montgomery: Let's talk about those problems. Don't just run out on your own and try to solve it all, but work with others. And you may find that there are other people in the community who believe that what you think is a problem is also a problem to them. And you may be able to get together. And by talking and working and formulating, you just might start a movement.

Use your own good common sense and help to finish the job of destroying racism and destroying inequality. Things certainly have changed, but what has not changed is racism and inequality. And that was my object, to get rid of those two things. But it's gonna be up to you to do it. ∎

ALICE GREEN

Social Justice and Prison Reform Advocate, Albany, New York

Interview by Jamel Mosely

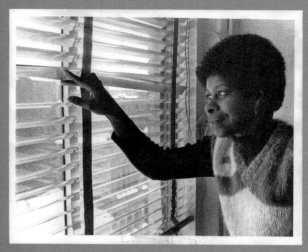

Alice Green in January 1983

Born in South Carolina in the mid-1940s and raised in the Adirondacks, **Alice Green** is a social justice and prison reform advocate. In the early 1980s, she served as legislative director of the New York Civil Liberties Union, and was appointed in 1986 by Gov. Mario Cuomo as deputy commissioner of the state Division of Probation and Correctional Alternatives. In 1985, she founded the Albany-based Center for Law and Justice, a nonprofit civil rights organization in which she serves as executive director.

Jamel Mosely *How did you get into activism? Or how did you become who you are today?*

Alice Green I always have to go back quite a ways when I'm asked that question. I think I'm one of the few people alive today who was actually held by someone who was enslaved: My great-grandmother was born enslaved around 1859; she lived to be a ripe old age. Even though I was very young, I still have this vague memory of her. But when I realized that my great-grandmother was owned by someone, that really hit me—because she was owned the way people own cattle, pigs, cows, and things like that. And something seemed to be wrong with that.

I also had a maternal grandmother who was a sharecropper in the South, and she taught me about being active. She was a leader in her community, even though she had been raised as a sharecropper. And then I had the experience of my parents, who lived in the Jim Crow South, and particularly my

dad, who was very fearful of the criminal justice system because, during that time, there were efforts to re-enslave people: There was a contract lease system that basically grabbed young men off the street, incarcerated them, and then leased them out to businesses. So my dad decided to go north.

But I learned about what they had gone through. And I knew something was wrong, and they instilled in me this belief that we had to do something, to change the way we exist in this country. Racism followed us—it wasn't just in the South.

There can be misconceptions about what it means to be an activist. What does it mean to you?

People started calling me an activist when I started working in the South End of Albany. I had gotten quite a bit of education, and I was, first, an educator. I was interested not only in being in the classroom but in learning more about where my

students came from. And the first job I had actually was in Rochester, in what you would call the ghetto area. I went to their homes and in the community to find out more about what was going on in their lives.

I decided to get more education so I could learn more about society. So I became a social worker. And you couldn't escape the fact that so many of the people I worked with were being incarcerated. I decided to study criminal justice, and I ended up actually getting three master's degrees and a doctorate in criminal justice. And when they first started calling me an activist I was a little insulted, because I wasn't sure what that meant—I didn't know if people just didn't want to recognize my educational background.

I got my real education in the prison system. Prisoners reached out to me; they told me about what their lives had been like. Some of them had been at Attica. And they taught me about how important it was to educate the people who were incarcerated so they could go out when they were released in their communities and work for the change that they thought needed to happen. I'm someone who absolutely hates prisons. I want to get rid of prisons in much the same way that we worked to get rid of chattel slavery. We've got to get rid of incarcerating people, because incarceration looks a whole lot like enslavement.

And so that's when I decided that I am an activist. Because I don't work in academia; I don't work behind the desk; I don't work in a bureaucracy. My work is being active in the community, and working for change.

You've been doing this for a long time.

Yes. One of the things I decided to do was to form my own organization. I'm very sensitive about being controlled by others, particularly white people. So I started the Center for Law and Justice 36 years ago, focusing on the criminal justice system and how it oppresses Black people and other people of color.

Do the young people you work with give you hope?

Absolutely. The people in my office now are young people who see things a bit differently than I did; we come from different generations. But they are extremely determined to make sure that they make a mark on the society, that they change it. And they're not afraid to. I get new ideas from them, and new ways of looking at the world. And they come with hope. And my generation, no, we didn't have as much hope. But I think the young people have allowed us to share in that feeling of hope.

So what keeps you energized?

Probably every day, I still think about my great-grandmother. I'm convinced that she speaks to me in a way, to tell me that, you know, "You got to keep going." I hear my grandmother, who was a sharecropper, who played a leadership role in her community because she thought it was important. And my parents of course are not alive, but they guide me still, when I think about what I'm doing or not doing. I ask myself, "What would my mother say?" or "What would my mother do?" And it guides me. And I want a different world for my grandchildren. I could sit back and do nothing, but that's not an option for me. Because I think we all must continue to do whatever we can, as long as we can, to make the changes that we want to see happen. ∎

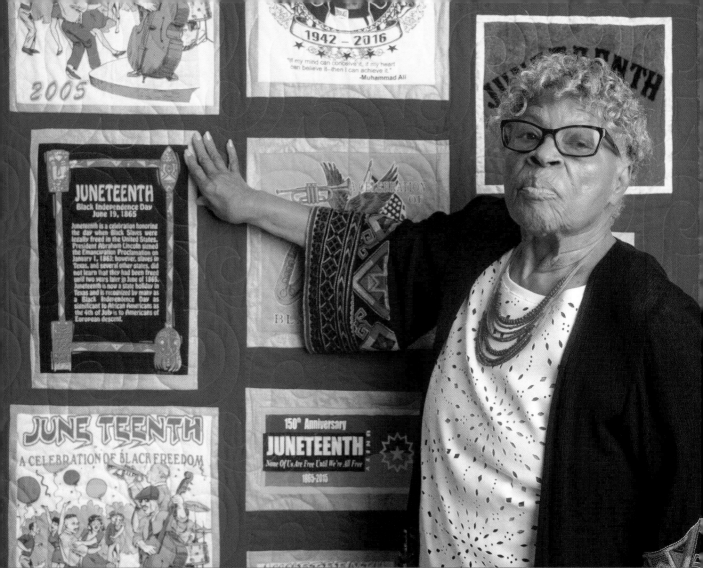

OPAL LEE

Juneteenth Advocate, 95, Fort Worth

Interview by Mariah Campbell
Portrait by Zerb Mellish

Opal Lee has been working to make June 19–Juneteenth–a national holiday since 2016, when she began the "Opal's Walk to D.C." campaign. Lee walked for 2.5 miles in different areas of the country, drumming up support along the way, to symbolize the 2.5 years it took for the Emancipation Proclamation to be enforced in Texas. She delivered to Congress a petition with 1.5 million signatures. Lee's dream was realized on June 17, 2021, when President Joseph R. Biden signed legislation designating Juneteenth a federal holiday to commemorate the end of slavery in the United States.

Mariah Campbell *What were your dreams for the future when you were a child?*

Opal Lee I guess like all kids, I wanted to be a teacher. And I ended up being a teacher, but it didn't happen right away. I finished high school at 16, and my mom was ready to send me to college. I disappointed her. I got married. She wouldn't even go to the wedding. I was unhappy, and it took me four years and four babies before I decided I wasn't going to raise a husband too. So I cut my losses, went home to my mother, and said, "I'm ready to go to college now." She said, "I'm not sending you to nobody's college." Then in the next breath, she says: "I'll keep the children."

I worked like a Trojan to get the money to go to college in the fall and spent it on a television so she wouldn't have to run all over the neighborhood looking for those kids. I went to Wiley College in Marshall, Texas, without a dime, and I would come home to Fort Worth on the weekends. I finished in three and a half years because I couldn't stay four.

So I taught third grade for about ten years, and then I became a visiting teacher. It wasn't teaching; it was social work. If a child was out of school, then it was my responsibility to find out why and alleviate that situation: shoes, clothes, food, a place to stay. I did the social work thing for about 25 years.

Did you carry the values you gained as a teacher into your day-to-day life?

Yes, because when I retired, people who needed food, who needed clothes, who needed a place to stay would still come to me. If you can help, it's sacrilege if you don't. I ended up being the chair of a food bank that burned to the ground. There was this big building behind my house where I wanted to put the perishables that we were still taking to people, so I asked about the building and was told they could rent it to us for $4,000 a month. I nearly had a hemorrhage: $4,000! Well, we paid that $4,000 for 11 months, and the month we didn't have it, the owners came to us and said, "You're doing a good job. We're going to give you this building." Now the food bank has services that help 500 families a day. We also have 13 acres of land called Opal's Farm, and we share the produce we grow with the WIC program.

Now, you've worked to get Juneteenth recognized as a national holiday. I didn't learn about Juneteenth until I began college at Texas Southern. When did you first learn about it?

I learned about Juneteenth in Marshall, Texas, where I grew up. We would go to the fairgrounds for the festival. Everybody would have such a good time. There were sack races, food, dominoes, all kinds of things. When we got to Fort Worth, not so much. People celebrated with their families. There was an incident that happened after we moved from Marshall to Fort Worth. My parents bought a house, and my mom had it fixed up so nice. But on the 19th of June, 500 people gathered who didn't want us in that neighborhood, and they tore that place apart and burned the furniture. My parents had sent us to friends several blocks away, and they left after dark. I don't know whether that had anything to do with it or not, but Juneteenth has been foremost in my mind for a long time, a long time.

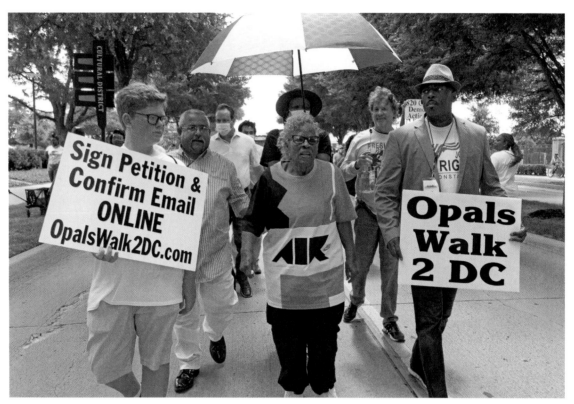

The "Opal's Walk" caravan in Fort Worth, Texas, on Juneteenth in 2020.

Lee, second from left, at the White House on June 17, 2021, watching President Biden sign the Juneteenth National Independence Day Act.

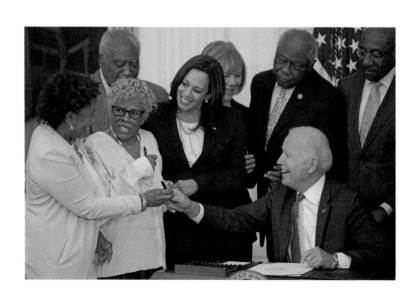

"We weren't truly free after 1863 or 1865 or even 2020."

What inspired your walk from Fort Worth to Washington, D.C., to raise awareness?

People just think of Juneteenth as a festival and as a Texas thing. Unity, freedom is what Juneteenth is all about. So I decided that I would walk from Fort Worth to Washington, D.C., doing two and a half miles in the morning and two and a half in the afternoon to symbolize that in Texas, the enslaved didn't know they were free for two and a half years after everybody else. We've carried 1,500,000 signatures to Congress to let them know it's not just one little lady in tennis shoes and her little group called the National Juneteenth Observance Foundation who feel that Juneteenth needs to be a national holiday. Let's celebrate freedom from the 19th of June to the Fourth of July, because we weren't all free in 1776.

After the protests surrounding the killings of George Floyd, Breonna Taylor, and Ahmaud Arbery, so many people finally recognized and learned about Juneteenth. How does it feel knowing that it took America so long to catch up?

I am delighted that so many people understand, but it's a pity that it was because people lost their lives. We're not going to have things back to normal as they were—it's going to be a new normal. There are going to be people who will want to join together to fix what's wrong with our society. It took Quakers and John Brown and Lloyd Garrison and Frederick Douglass and Sojourner Truth and all of those people who worked in concert to get those slaves free. Now we have the pandemic, job disparities, health system needs, climate change—these are the things we ought to be working on together.

What is one thing that you want people to learn from your life?

That each of us can make a difference. It doesn't have to be anything spectacular. Keep the neighbor's kid while she goes to the store or to the doctor, or befriend somebody in need. I don't mean you have to take them into your home, but you can find a place for them to stay or see that they get food. You can do an act of kindness every single solitary day, because it's needed. ∎

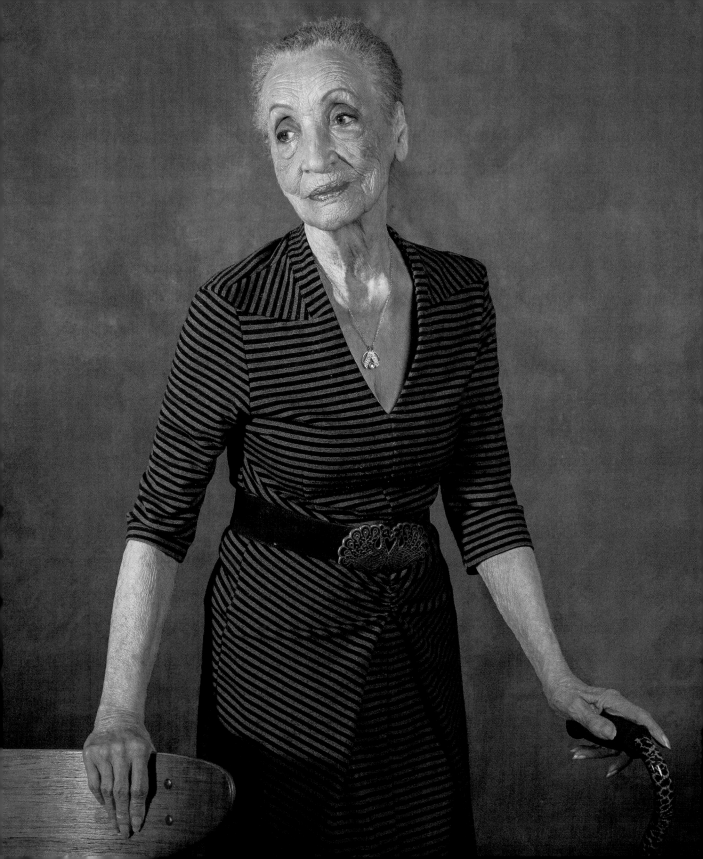

BETTY REID SOSKIN

National Park Ranger, 100, San Pablo, California

Interview by Brittany Bracy
Portrait by Yalonda M. James

At age 85, **Betty Reid Soskin** started a new career. She took a job as a park ranger at Rosie the Riveter WWII Home Front National Historical Park in Richmond, California, sharing her story and the story of Black women's and men's efforts during World War II with visitors who are often familiar with the white "We Can Do It!" propaganda figure—and little else. Soskin grew up in Oakland in the 1920s and '30s, and she found ways to contribute to her community well before she became the country's oldest park ranger. She has been a record store owner, a fundraiser for the Black Panthers, and a political aide during her "ordinary extraordinary" life.

Brittany Bracy *In 2007, at age 85, you became the oldest national park ranger in the country. Why did you feel it was important to share your story with others?*

Betty Reid Soskin I don't think I took that going in as being my way to tell my story. I think my story grew out of living those years; it grew out of the fact that the park was being planned to be an homage to the women who had worked in the war effort during WWII, and by so doing, it was leaving out so many of the stories that should have been told.

It was my going into those stories around the planning tables for the park when I discovered that they were not known. There was the story of 120,000 Japanese Americans who were interned and put into concentration camps. There was the explosion at Port Chicago [in Contra Costa County] that lost 320 mostly Black men that had been forgotten. By bringing these stories up, I was able to remind the present people who were planning the park that these people had existed and that there were reasons why they were not recognized. To this

day I'm sure that the park is so much more than it ever wanted to be, and that the National Park Service is grateful for it being there.

During World War II I worked in a union hall for Black members. They didn't have Black members in unions, except that they had to enter this union. The Black men went to work in the shipyard in '43; the Black women went in '44. They didn't start training Black women to be welders until 1944 and '45. So these pictures that you see with Black women in them date from very late in the war, but no one knew that. The building itself was destroyed when the war ended. By insisting that they had to include these stories, we were able to bring forth people who would not have been remembered.

How do park-goers react to hearing your story?

I was amazed, because they were actually grateful for learning. They wanted to know. It was not a case of fighting anyone; it was a case of including everybody and having everybody approving, and that's, I think, what surprised me more than anything. Except for

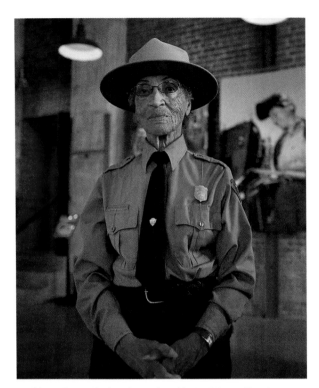

Soskin at the Rosie the Riveter/World War II Home Front National Historical Park in Richmond, California, on October 24, 2013.

the women who had been Rosies, had worked in the factories. There were about six or eight of them who went along with me, and they acted as if none of this were true. That was the thing I think that got to me most of all, is that there are many truths. We have to somehow make room for all of them, because they are all true.

Two-thirds of park rangers are men, and Black staff in the National Park Service is disproportionately low. Why do you think that is, and how can we fix that?

I don't know how we fix it. I do know that there are many rangers who would love to be employed outside of Washington, D.C., where there are many rangers because there are so many stories that are in and around Washington, D.C. When you go out into the country, they disappear. I think that is changing. I think there are more and more rangers now who

are looking to tell these stories to visitors, but I don't think that we, as Black people, have accepted our role. I think that will probably change and is changing, but it's hard for it to change.

In your book, Sign My Name to Freedom, *you write about a family member who passed as white in their workplace. Why was it important for you to embrace being Black and to not pass as white?*

I don't think it ever dawned on me. I don't remember even wondering, because my race was not a problem to me. It was a problem to people I moved among, I suppose, but not to me. I don't remember ever even being tempted to pass.

Why did you and your first husband, Mel Reid, pick Walnut Creek to build your dream home in 1952 after experiencing redlining in Berkeley?

I don't think our choosing Walnut Creek to live had anything to do with redlining. I think that it was a place we chose to put our family, and we didn't realize this would not be accepted. We expected it to be objected to, but we also knew that this would be something that would pass, that we would go through to another side and that our children would not face what we were facing. Mel's family had built a house with a garden and a couple of horses out in Danville, and we used to take our children to ride the horses and visit their grandparents. We would go by this little lot, and Mel decided that this was where he wanted to be. It was just halfway between where our house was in Berkeley and Danville. That was all we needed to know.

While you were in that area, you raised money for the Black Panthers. Did you view yourself as an activist at the time?

No. I don't think I ever viewed myself as an activist. I was acting, of course, but I was using everything I had according to the times I was living in, and that's what the times demanded of me.

"I don't think I ever viewed myself as an activist. I was acting, of course, but I was using everything I had according to the times I was living in, and that's what the times demanded of me."

You worked for a member of the Berkeley City Council and as a staffer for California Assembly-woman Dion Aroner in your 70s. What did you take away from your work in politics?

I took away a sense that I could demand to live the life I wanted to live. And by doing so, I began to set down the kinds of things that I would accept. I think that is probably what I learned from Dion. Dion was perfect to work with me because she was strong enough as a woman to believe in herself, and by believing in herself she gave me the chance to believe in myself. I worked for her for a number of years. I don't think she second-guessed me at all.

What has it felt like for you to see the growth of the Black Lives Matter movement and the response to police violence?

That has been the biggest surprise of my life. I don't think I ever expected to see it, but now when I see people marching for justice, they're all colors. They are Black and white and green and gold, everything. And they're waiting to be told what to do in many cases. I think that is the most incredible thing that could've ever happened. It has only happened in the last five years.

What advice would you give to young people who want to be a part of the change in their generation?

I get a feeling that change is going to come. No matter whether or not we want it to. I think they've got to be open to what's right and ready for what's to come. ∎

BARBARA SMITH

Scholar, Writer, Activist, 75, Albany, New York

Interview by Jamel Mosely

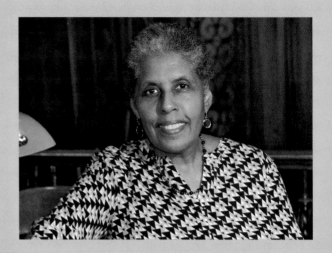

A ctivist, author, and academic **Barbara Smith** has worked since the 1960s for change through causes as diverse as racial justice, anti-imperialism, opposition to the death penalty, feminism, the LGTBQI+ movement, and workers' rights. She was a cofounder of Kitchen Table: Women of Color Press, has taught at numerous colleges and universities for a quarter century, and served two terms (2006-2013) as a member of the City of Albany's Common Council. Her books include *The Truth That Never Hurts: Writings on Race, Gender, and Freedom* and *Ain't Gonna Let Nobody Turn Me Around: Forty Years of Movement Building with Barbara Smith.* In 2005, she was nominated for the Nobel Peace Prize.

Jamel Mosely *How did you get to be* the *Barbara Smith?*

Barbara Smith [Laughs] I'll try to respond in an appropriate fashion: I grew up in Cleveland, Ohio, and I was born in 1946. And—I always then quickly add—that means I was born into Jim Crow. And even though I was growing up in the North, it absolutely affected us. We lived an almost absolutely segregated life.

My family came from Dublin, Georgia, which is a rural little town between Macon and Savannah. I'm a twin, and my sister and I were the first children in the family to be born in the North. I grew up as the civil rights movement was unfolding. And I guess I just got politicized because of what was happening. My family was very racially conscious—or, as we

say, they were "race women" and "race men" as well. The church that we attended in Cleveland had a very socially conscious minister and a kind of socially conscious way of doing things, even more so than other churches in Cleveland, because there were certain churches that would host civil rights rallies and civil rights organizations, and ours was one of them.

There was a major school boycott in April of 1964 that my sister and I participated in, and our family supported us. They didn't say, "You have to go to school." They understood: This is a day for Black kids to stay home, because this board of education was continuing to build and place new school buildings in ways that would maintain segregation.

What does it mean to be an activist?

A political activist is somebody who is willing to speak out, and also to do work around the causes and issues that they are committed to and that they believe in. They don't just sit on the sidelines and comment. Because I have an academic background, I know lots of people who have really insightful thoughts and perspectives about what's going on politically, but they don't ever lift a finger. That's not to cast aspersions on any particular group of people.

Being an activist may mean you only come out for protest, or rallies, or one-time things. But if you're an organizer, you're pretty much at it on a consistent basis. I hope that I've reached the organizer stage.

What keeps you energized, doing this over 40 years?

The success that I have experienced over the decades in the movements—plural—that I've been a part of. I haven't just been a part of anti-racist organizing, or Black liberation organizing. I've been involved in multiple movements, including the movement to end the war in Vietnam. I have been centrally involved in building the Black feminist movement in the United States and also have been a committed feminist since the 1970s, when it was very, very challenging to even say that because there was so much pushback, and so much hostility toward the politics of the women's movement, feminism, women's liberation.

I'm also a part of our LGBTQI+ community. And I'm also a person who questions the current economic status quo, and I define myself as a socialist. I've been involved in a lot of different movements, including anti-imperialist struggles, such as supporting the work to end apartheid in South Africa. And I was supportive of the Central America Solidarity Movement because of things that were happening in Latin America in the 1980s.

Jim Crow—at least legal Jim Crow—was ended by the Black civil rights struggle of the mid and late 20th century. But now we have all kinds of new Jim Crows—as Michelle Alexander defined it in relationship to the prison industrial complex and mass incarceration; we also have voter suppression all over the United States to make sure that people like me don't get to vote. So it's not like the practices of Jim Crow were eradicated. We still have much work to do.

With so much new energy around social movements, what do you say to new activists and organizers?

How do you keep your spirits up and keep engaged when you're doing really hard work? I talked about how the successes keep me going. But most days, you're not going to have successes. You're just going to keep on doing the work and try to figure out how to get more justice and more transformative change.

But one of the things I always advise people about is that you should not be miserable doing your activism and your organizing. If it's making you miserable, you need to move on. And that doesn't mean move out of being in movements. But if the issues that you're working on are not a good fit, or if the group of people with whom you're working just get on your last nerve on a regular basis, then you need to move on—you need to find a place or places where you feel wholly seen and fulfilled and can actually get really good work done.

If you're miserable, you really do need to change the environment and find your place—and you absolutely will, if you're committed to everyone having the quality of life and the opportunities, and the things that they need and the things that they desire. If you're committed to that, you'll find your place. ∎

GEORGE STARKE JR.

First Black Student at University of Florida Law School, 90, Orlando

Interview by Stewart Moore

George Starke Jr. was the first African American ever to attend the University of Florida Law School. Grainy footage shows a nervous Starke on campus receiving his registration packet. A row of seats separated him from his white classmates on their first day. "On September 15, 1958, when I went to University of Florida, I didn't know what to expect," he says.

"I got to meet some of my classmates. Some of whom really weren't my classmates, though I didn't know it at the time. Two of them were Florida Highway Patrol. They had been assigned to ensure my safety. They didn't know what to expect either. Except that my name did come up once in a while in Klan meetings. I didn't know about it until later because they were able to keep that information away from me."

It wasn't the first time the focus had been on Starke in what would otherwise have been a segregated situation. Years earlier, Airman Starke was selected to participate in a ribbon-cutting ceremony for a new building on the Kisarazu air base in Japan. At the time, the military had only recently been integrated by President Harry S Truman.

Starke grew up in the historically Black Parramore neighborhood of Orlando. He was slated to attend Jones High School, an all-Black institution; instead, his parents sent him to a boarding school in North Carolina. For his undergraduate studies, he attended Morehouse College in Atlanta, an experience that would shape his future.

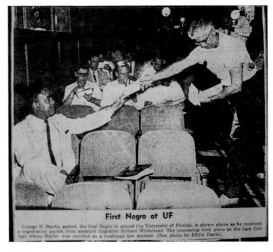

Starke at the University of Florida Law School on September 15, 1958—his first day as the first Black student there.

Starke was in Atlanta at a time when Martin Luther King Jr. was beginning to make his mark on the world. "He gave my graduation speech at Morehouse," Starke says. "And I knew his brother from high school. I knew a few of the people that he knew. And so naturally I was impressed with what he was doing."

"Although people can't blame themselves for what happened 400 years ago, there's still a legacy, and many of those problems still need attention."

Starke says the war for equality that was raging in the 1950s and '60s is the one marchers in the street are still fighting today after high-profile incidents of police brutality, including the killing of George Floyd. "Back then my focus was on what was going on at the University of Florida and what was going on at other schools in the South," he says. "I remember when James Meredith in Mississippi was shot, and they later built a monument to him on campus." Meredith, also an Air Force veteran, was shot by a sniper after he became the first African American to attend the University of Mississippi.

"There are people in our society and our culture who never thought of things like that before George Floyd, seeing what happened to him," Starke says. "And of course this has been going on since 1614 or 1416. That's a long time to break all those habits. Knowing the difference between what's right and wrong. Although people can't blame themselves for what happened 400 years ago, there's still a legacy, and many of those problems still need attention."

Starke didn't end up graduating from Florida law in the 1950s. (His departure from the university was documented in the campus newspaper.)

Instead, he went to New York City and entered the world of corporate finance, serving in top roles with numerous Wall Street companies. "I wouldn't say it was easy, by any means," he says. "Finding the quality of employment that I was looking for was in fact difficult. Took a lot of time to get on the right track. When I was growing up, you know, there were limits on where you could go, what you could do. Today, they're more subtle. There may be some limits, but then other avenues open to offset that. No restrictions, basically, on what a person growing up today can do if they prepare themselves to do it."

In 1998 and again in 2018, Starke was honored by Florida Law's Center for the Study of Race and Race Relations, and in 2009, he was given the University of Florida's distinguished alumnus award. He has a simple message for those coming up today: "Do the best you're capable of doing. Come out and be involved in the community. Work for causes you identify with and accomplish as much as you can. Learn as much as you can. Keep learning new things all your life." ∎

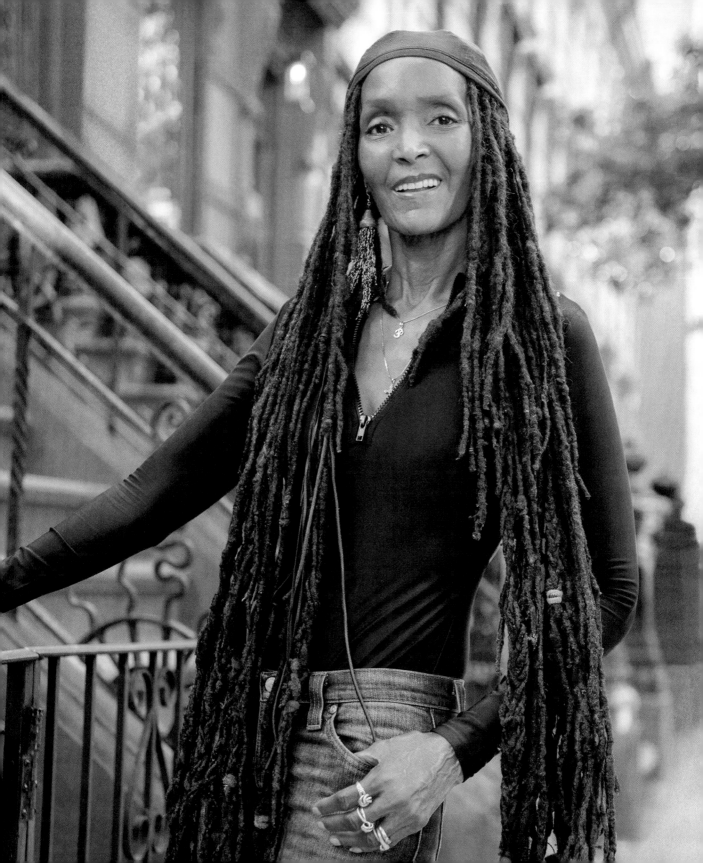

JOYCE WALKER-JOSEPH

Model, Actress, Activist, 74, New York City

Interview by Jada Jackson
Portrait by Makeda Sandford

Joyce **Walker-Joseph** appeared on the November 1972 cover of *Seventeen*—the first Black model to get the full cover of the magazine. (Though, as Walker-Joseph points out, it wasn't actually her first time on the cover; in her previous appearance, she was "postage-stamp size" above the logo.) She soon became an icon of the "Black is Beautiful" movement, and a major role model to young Black women. In 1997, she and her husband, playwright, poet, and former Black Panther Jamal Joseph, cofounded the IMPACT Repertory Theatre, a Harlem-based youth theater company and a key expression of Walker-Joseph's lifetime of being, as she calls it, an "artivist." To many young Black girls and women growing up in the 1970s, she was affirmation that they too were beautiful enough to grace the cover of a mainstream magazine. And her legacy is a reminder of the courageous Black women that have paved the way for where we are today.

Jada Jackson *Can you tell me about how you came to be a model, and in particular what led up to being on the cover of* Seventeen?

Joyce Walker-Joseph Well, I'm one of those who didn't always want to be a model. As a matter of fact, I didn't want to model. I went kicking and screaming, you can call it. I had just graduated college with a degree in philosophy, and I was a member of NEC, the Negro Ensemble Company, and had been in a play called *The Penny Wars* on Broadway, so I was an actress, really. I did a film in Europe called *Welcome to the Club*.

Everything was happening at the same time. I came back to the States and a friend of mine took me to a photo shoot, and I started modeling. I really didn't want to model; I was told that I wouldn't be able to model unless I cooperated on the casting couch, as it were, and I said no way would this be possible for me. I went to a second agency, and they told me

they already had a Black girl. Then I went to Ford, and they put me on the boards. Within a week, I got *Look* magazine—and this was not a fashion magazine. They were doing a "Black is Beautiful" issue, and I got the centerfold. I had a short, cropped Afro then, and they took a shears and they just *zzzzzz* with my Afro because they didn't know what else to do with it. They made a poster of it and it became an international success in Europe, and all the magazines saw it and were clamoring for me. My agency, Ford, took me aside and said, "Well, they're looking for you, and I advise you to go with *Seventeen* because they're the youngest magazine, and you can always grow into the other magazines."

What do you think compelled Seventeen *to have you on the cover at the time?*

I definitely believe it was the civil rights movement and Black Power movement that pushed *Seventeen* and other media to include Black people in their ads

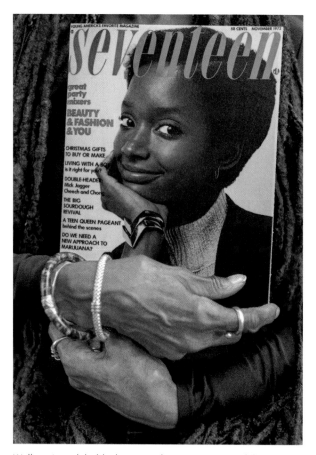

Walker-Joseph holds the November 1972 issue with her picture on the cover.

straightening it every two weeks and burning our hair. I just didn't understand it. Growing up, I investigated *National Geographic,* looking at it in the doctor's office. I was seeing our beautiful African queens with their beautiful hair and their Afros, and their locks, and the dung in their hair, and I just was very influenced by that. And then I saw Cicely Tyson on TV with her beautiful hair, and I said, I want to do that. So back in '67 I just wore an Afro. I just washed my hair.

I didn't allow hairdressers to mess with my hair after a few months, because all they did was use shears. As a matter of fact, I had them hire a young lady to come on set with me, and come on trips, and she would do African styles and cornrows for my hair, so that we would be able to inspire Black girls to do other kinds of hairstyles with natural hair and put different-color parts in their hair.

Do you believe the "Black is Beautiful" movement helped to redefine beauty standards of the time? Also, how did it influence the media to become more forthcoming in showcasing different forms of Black beauty?

Of course, the "Black is Beautiful" movement helped out a lot; it moved many things forward, and it helped define a lot of the culture. Also, it wasn't only in America; it was happening throughout the continents. There was also an economic factor to this: It certainly affected magazines' approach to diversity, because if they saw that diversity was selling, then that would help shape the content within some magazines.

Did you have issues with discrimination on set?

In the beginning they didn't know how to light us. And you'd be shot on the end of a shoot. There would be a line of models, and you'd be put on the end so that they could cut you out, so they could send the shot to the Midwest. Especially for catalogs.

and outreach. Much the same as how Black Lives Matter has created more space for Black and in general BIPOC representation in all forms of media.

I saw in all of the cover shoots that you had your natural hair. Was that something that you wanted to make a statement with, or was it just something that was already a part of your style, just you being you?

That's my personal style. That's something that I always wanted to do. Because I was always teased as a child about my kinky hair, and I couldn't understand why people had straight hair. I didn't understand how everyone around me had "good" hair, as they called it, and why we had to go through

The inside pages of Walker-Joseph's breakthrough November 1972 *Seventeen* portfolio.

That's horrible.

But you got paid. It's a business: Give me my money.

Did you ever feel that the industry was exploitative toward you as a Black woman? Or was it just something that was inherently exploitative just to women in general at the time?

I never felt exploited. I guess I rose too high. If anything made me feel uncomfortable, I walked off the set. It was my prerogative. I said, "Talk to my agent. That's what they're for."

What kind of advice would you give to a young Black model or creative person trying to get into the entertainment field?

Stay true to yourself. All of what I did was a surprise to me. I was very shy. I never had a goal to be on a cover of this or do any of that. It all happened, and that was so glorious. I was full of joy, and it opened up for me, and I really appreciated it. And I think because I had that attitude, it came to me, and it came true, and that, to me, was what it was about.

Do you believe your life and career have been intricately tied in with activism?

I left the safety of home at 19 to do grassroots theater at Negro Ensemble Company, to eat brown rice in unheated apartments with young revolutionaries, to give aid to the movement in any way I could. My struggle for survival and identity happened in the context of the broader liberation struggle.

I would also like to emphasize that my success was not absent of the struggles that many Black women face. I feel the murders of Sandra Bland and Brianna Talyor deep in my soul. I have had my door kicked in by a SWAT team, M16s pointed at my head, and a 200-pound FBI agent sitting on my back when I was four months pregnant. And my husband, Jamal, in the other room with multiple guns pointed at him. And I was terrified, but not terrified, because something comes over you when your adrenaline comes in. They don't want to hear you, and you want to just save your baby.

I went from law school student to prison wife and activist fighting for my husband, and sleepless mother caring for my son, Jamal Jr., who was battling sickle-cell anemia. For six years my life

"

I still get stopped by women who recognize me and tell me, 'I had your picture on the wall of my dorm room in college.' It was a reflection of the beauty they could see when they looked in the mirror. My smile was their smile; the look of light and hope in my eyes reflected some of their hopes and dreams."

was lived in prison visiting rooms and emergency rooms. My salvation became writing. I wrote plays produced Off Broadway by Woody King and Joseph Papp. And with my mother's childcare help I also acted in plays produced by Woody King at the New Federal Theater.

How did those experiences shape you to be who you are right now?

Well, I've learned always to keep on with the struggle—and it never ends—and to keep strong. My sons and daughter, who are now adults and college-educated, were raised in Harlem, where my boys were stopped and frisked and where I read my daughter bedtime stories over the sounds of gunshots from the police and warring drug gangs.

We are the founders of IMPACT Repertory Company, an Artivist group in Harlem teaching Black girls arts and entertainment and giving back to the community. Like many of my sisters, I have survived the lash of oppression, and though my scars are not visible on my back, they have wounded my heart. But hope endures and love heals.

What has it been like to have lived through the social unrest of the 1960s and '70s and now to see these same kinds of inequality and injustice re-emerge in this era?

It has not re-emerged—it has always been there, ugly and with consistency. Clifford Glover, Amadou Diallo, Rodney King, Eleanor Bumpers—all murdered by police. We see the image of countless other Black people running from bullets. The difference today is that the power of cellphones and digital media allows the world to see the injustice and brutality. It's painful that here we are, 50 years later, still going through that. And it's also hopeful, because people like you are coming to the elders and asking questions. I've gone through such a metamorphosis and now it's a new generation, and it's a new language, almost. It's a new generation of revolutionaries. I'd like to see it as more of a renaissance. ∎

André De Shields

CHAPTER 2
Creativity

ANNA BAILEY

First Black Vegas Showgirl, 95, Las Vegas

Interview by Rachel Williams
Portrait by Da'Shaunae Marisa

Anna Bailey first performed onstage as a dancer as a teenager at the Apollo Theater in Harlem. In 1955, she and her husband, Bob Bailey, moved to Las Vegas to perform at the Moulin Rouge, and in the early 1960s she became the first Black woman to work as a dancer on the Las Vegas Strip, at the Flamingo hotel and casino. The couple went on to open successful clubs in Vegas, including the Sugar Hill and Baby Grand lounges.

Rachel Williams *You were performing at the Apollo at a very young age. Did you have any influences, or people teaching around you, who made an impact on you?*

Anna Bailey I hate to name-drop, but Pearl Bailey was a great influence. Even though my last name is Bailey, we're not related, but she would call my husband "Cuz" and me "Cuz." And she always told me to go to Las Vegas, because that's where you need to go if you're going to stay in the business. Her brother, Bill Bailey, always would tell me if I was dancing before the music, if I was dancing too fast, or if I wasn't dancing on time.

How did you rise so quickly in your business?

I think I was just at the right place at the right time, and I never really had any kind of problems. You know, if I was booked, I would just go and I was always on time, and worked my hardest, so people were always glad to hire me. And I stayed busy until 1955. That's why I was booked in Las Vegas at the Moulin Rouge, and then I was really blessed to integrate some of the shows at the Dunes and the Flamingo Hotel. So, I never really had

any problems. I went from one job to the next job. Sometimes I wouldn't even answer my phone because I might want to stay home a little bit!

What inspired you to move to Las Vegas?

Well, we were in Buffalo, New York, and we were with the Clarence Robinson Show, and Pearl, like I said, had always told us about going there, and then when Clarence came in and said we were booked in Las Vegas, we were just thrilled. And they flew us out, and we got off the plane, the photographers were there, and then we went to the Strip, and we thought that's where the Moulin Rouge was, and then when it turned left and went under the bypass and the railroad tracks, we said, "Uh-oh"—we were just really kind of nervous. But then, when we saw the Moulin Rouge, it was just beautiful. The best lighting. The best showers in the dressing room. It was lovely. And I just can't understand today why it closed. It was packed every single night.

But I think that the Mafia, that was definitely there then, and I think they had something to do with us closing kind of early. We were the only ones that did a 2:30 show, because they just did an 8 and 12 and

Bailey poolside at the first integrated hotel in the country, The Moulin Rouge Hotel & Casino, in 1955.

What was life like for African Americans in Las Vegas at the time?

Oh, girl. That's a good question. Very hostile. But they could tell by the way we walked, the way we carried ourselves, the way we were dressed when we would go downtown, that we didn't have any problems. We had little problems with the dress shops and things like that shops and theaters were segregated there. Like Woolworth, places like that, eating at the counter. The environment was very hostile, but there were very nice people too. There's good and bad, no matter where you go.

Did you face any specific hardships being in the entertainment business in Las Vegas, as a Black couple at the time?

Yes. We did go to the Sands hotel one time, and we were really looking pretty good. We were young and really dressed, and the security guard took it on himself to stop us at the door. And this is really the truth: Frank Sinatra did come and get us, and took us over to Sammy Davis's table, and he was just beating on the table because he was just so embarrassed for us. But we were young, and we weren't embarrassed at all. We just laughed it off—we were just so happy to be with Sammy.

we did a 2:30, and the Strip was empty, and they just couldn't have that. So, in six months, we were closed.

Kimberly Bailey-Tureaud [Anna's daughter]: The Moulin Rouge was white-owned by these two guys, and Clarence Robinson told them that he wanted my parents to be a part of the show. This was the first integrated hotel in the country, the Moulin Rouge. And so he told my mother and my father, in New York, that he wanted them to be a part of the show.

Kimberly: My father talked in his book, *Looking Up! Finding My Voice in Las Vegas*, about how he and Nat King Cole once tried to go into a club on the Strip, at one of the hotels, and they denied them entry. And my father said, "Well, this is Nat King Cole," and the doorman said, "I don't care if he's Black Jesus. He's not coming in here."

After you left the Moulin Rouge, you went to start auditioning to be a dancer?

Oh, no. I'd been dancing for a while. I'd been to Europe and everything. So I went into the Dunes, and then, after that, I integrated the show with Pearl Bailey at the Flamingo hotel and worked about five years there.

"When we did the can-can, it was much more explosive than the ones they were doing at the Tropicana. Because we were really spinning and sliding over each other's back into a split, or kicking high, and we danced really fast. Fast, fast, fast."

Being a showgirl is all about glamour and beauty, but Black women, especially at that time, were sometimes seen as less attractive, because they didn't fit society's typical beauty standards. Did that affect you at all?

No, because we would wake up and make up. Put on those eyelashes and just go for it, and the designer clothes from that time. I don't bother with it too much now, but during that time, we were really high-fashion.

Were your experiences working these clubs different from those of the other women?

Yes, let me tell you something that I was really so happy about: Some of the white ladies that were in the show, they had to mix afterward. They'd have to go to the casino and act like they were playing the games at the gaming tables. But me being of color, I didn't have to do that, because they were segregated. So that was a blessing for me. Every time after the show, I'd say, "Bye-bye, I'm going," and they would be so envious of me leaving. That's one thing I really remember that I didn't have to deal with, and that's at the Flamingo and the Dunes and the Rouge.

With all your experience, what are you most grateful for?

Oh, I'm just grateful to be alive. All my friends—I look at my little scrapbook and I look at my telephone numbers—they all kind of left me. All the dancers. We were like family. If you're in a show for three months or a year, you're family, so I'm grateful for that experience that I had, and the lifestyle that I have. We're not rich or anything, but I'm happy to be in California now, and I can go back between La Jolla and Las Vegas. And then I can still talk to you and put one foot in front of the other—I'm grateful for that. God is good.

How has the art form of dance shaped your reality?

Well, it gave us a sense of confidence that we can walk into a place anywhere, with our chin up, shoulders back, stomach in, and walk with a little attitude. Show business was good training for me, to learn how to just meet and greet people of all levels. It was like a school, and the people that you meet all over the world, and that's when you're on tour, you're everywhere. You're down South—that's another story—and you're going coast to coast, and you're going to Europe, you're going to South Africa.

Producer Larry Stelle at the Dunes Hotel in Las Vegas in 1957. Bailey is the dancer on the far right.

Kimberly: She remembers knocking on doors in the South to have a place to stay when they were on the road to see if they could sleep there, because the hotels wouldn't allow African Americans to sleep in the hotels.

And I think back on those days, how, the nerve we had to knock on someone's door and ask if we could stay! But they had billboards that told everybody that we were coming to town, so they were aware that we were there, and then we paid them. But to bring strange people in your house like that, and we had the nerve to go and sleep in someone's home.

That was in the Shuffle Along show. I don't know if you've heard of Shuffle Along. You're too young for that. That's way back, you know.

What I'm hearing is that although you were able to live out your passion, dance, travel, and would do it all over again if you could, there was still a level of adversity that you faced. I believe adversity is directly related to change. What are some of the adversities that made you who you are?

I went to a theater one time, and the Blacks had to go upstairs, and for some reason, I don't know what got into me, maybe I was young, I went downstairs and sat there. I couldn't enjoy the movie because I was waiting for somebody to tap me on my shoulder. That's the stuff you have to go through, and that's the part I didn't like too much. That's why I just enjoyed, so much, growing up in Brooklyn, because I didn't feel that, really, until I went to the South or when I went west. I didn't feel it in New York.

And when there was an audition, you'd just go. The only thing I didn't make—I was passed over by Radio City Music Hall, but I was a little ahead of my time.

Kimberly: You wanted to be a Rockette.

I wanted to be a Rockette. I did. I wanted to be one so bad. But like I said, I worked on Broadway a lot. I worked on Broadway more than I did anywhere else.

Kimberly: She can still break out in a time step.

And I believe it, too. What message would you send to young Black performers today?

I would say to do the best you can when you go out on that stage. Be ready. Have your routine together. And work your hardest. You get a good job, keep it. Just work hard and save your money.

Kimberly: Emphasis on *Save your money*. My mother hasn't told you, but many of the businesses, really all the businesses my dad opened, my dad was so busy doing so many other things, but she's a businesswoman. She's the one who did all the accounting. She counted the money every day. I grew up behind a bar, and I'm just saying, she was an A1 entrepreneur, every check. I just remember her counting all of that money, but everyone, even though it was situated in the historic Black Las Vegas of the west side of the city, everyone treated her, even to this day, like royalty, because of the way she carried herself. And she would go into that bar, and they might be alcoholics, or people acting crazy, but they would straighten up when she would come in.

Now that you have gotten the chance to do everything you could imagine you wanted to do, what do you enjoy doing now?

Well, now, I still like to travel. I'd like to go to Argentina. I'd like to go to Havana. I want to go to Cuba.

Kimberly: And she wants to meet Oprah Winfrey. That's always been in her wish list.

It is, but I don't think I'll be able to talk to her. I'd be so nervous. But she's made me so relaxed. I'm proud of what she did with her life. ∎

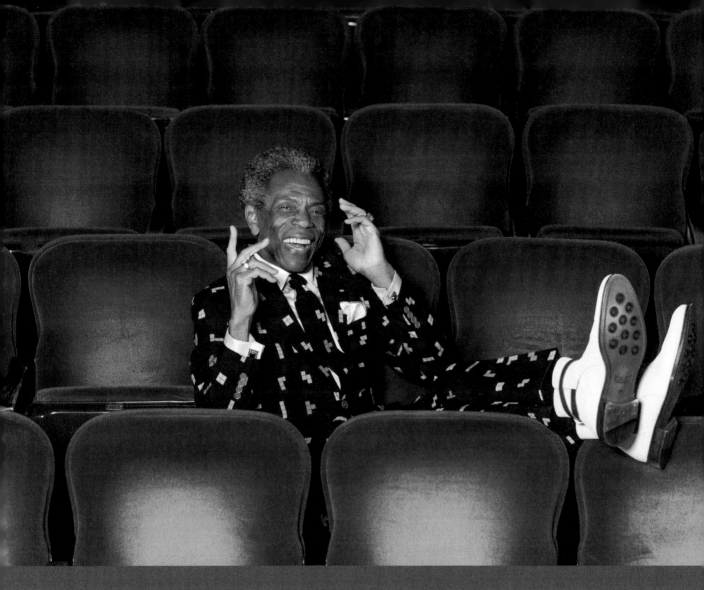

ANDRÉ DE SHIELDS

Actor, 76, New York City

Interview by Kenia Mazariegos
Portrait by Flo Ngala

André De Shields made his professional acting debut in a 1969 production of *Hair* in Chicago and has been a mainstay on and off Broadway for five decades, with lead roles in *The Wiz*, *The Full Monty*, *Ain't Misbehavin'*, and many more. He won the 2019 Tony Award for Best Featured Actor in a Musical for his performance as Hermes in *Hadestown*. His podcast, *Live from Mount Olympus*, uses Greek mythology to teach life lessons to young people.

Kenia Mazariegos *You're an actor, a dancer, a performer. You've been in many Broadway plays. You've even won Emmys and Tonys.*

André De Shields And the Grammy Award.

Ah, right, sorry! And so, I have a burning question to ask you, someone with so much talent: What's the best song to sing in the shower when you need a mood lift?

Well, I'll tell you, you must be familiar with the hymn that we sometimes refer to as the Black National Anthem, "Lift Every Voice and Sing." That always shifts my mood, and even when the mood starts off as good, it just gets better. [Sings] "Lift every voice and sing / Till Earth and heaven ring / Ring with the harmonies of liberty / Let our rejoicing rise / High as the listening skies / Let it resound loud as the rolling sea / Sing a song full of the faith that the dark past has taught us / Sing a song full of the hope that the present has brought us / Facing the rising sun of our new day begun / Let us march on till victory is won." Now is the mood better?

That was absolutely amazing! But seriously, all jokes aside—

That was no joke.

So much of your life revolves around music and acting. What was a defining moment in your childhood that ignited your passion for performing?

I have to say that the journey that I'm on, the destiny that continues to unfold before me, is sourced in the dream that my mother had. She revealed to me when I was old enough to have an adult conversation with her that she had always wanted to dance, but being born at the turn of the 20th century, that was not considered a decent career for a young colored woman, so my maternal grandparents, her parents, said, "No, that is not what you're going to do with your life." Now, similarly, my father, he wanted to sing. His parents said, "That's not a responsible way to be a bread-winner, to be a good husband." So my parents deferred their dreams.

I'm number nine of 11 children, so I consider myself lucky number nine, because the dreams that they couldn't make come true for themselves came true through me.

What are some of the most valuable lessons that you feel you've learned from your parents?

Many, but I think I can distill it to four lessons, and they would be: persistence, tenacity—and there's a difference between persistence and tenacity—deter-mination, and hardiness. Now, I know they all sound similar, but you cannot achieve your personal success just by being physically strong. You have to be emotionally strong; you have to be intellectually strong; you have to be spiritually strong. So those are the four life lessons that were exemplified by my parents and my older siblings, and they are the life lessons that keep me going today.

Do you think the lessons your parents instilled in you helped you growing up in a time of segregation in the 1940s?

Now, I was born in 1946, so I would move that to the following decade. But yes, those lessons helped me to get through the '50s. Now, we associate the

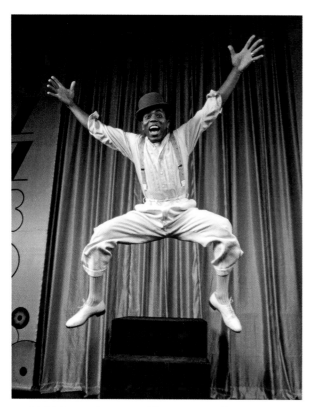

De Shields in a performance of "Jazzbo Brown from Memphis Town" in New York in 1980.

'50s into the '60s with the civil rights movement, but I'm part of that generation, the first generation that benefited from Thurgood Marshall's successful argument to the Supreme Court, which we know as *Brown v. Board of Education,* when we finally decided that the system of education in these United States of America had to stop being separate and unequal.

What I learned, as a very young child, is that I needed to master the English language so that I could understand what my would-be oppressors were saying to me and about me, and so that I could make myself understood to my would-be oppressors. So education has been a beacon in my life and career, and language has been very important for clarity.

People often idolize success, but they don't often think about the many mistakes it takes to get there. What are some of the mistakes you made that offered the most growth?

I didn't make any mistakes. I'm not sticking my chest out and boasting, but what I am saying is, if one wants to be sure about one's purpose in life and wants one's destiny to unfold in one golden step after the next, what's required is that you surrender.

I don't know if you're aware of my Tony acceptance speech, from June 9, 2019. We are cautioned that you only have 90 seconds to make your speech. I've seen too many of my colleagues try to thank 100 people in 90 seconds; it's not possible. And, certainly since 9/11, we've been taught "If you see something, say something," but I believe "If you know something, share something." So when I was fortunate enough to win the Tony, I dropped this wisdom bomb of the three cardinal rules that would explain sustainability and longevity in the career; this is how you avoid the mistakes. The first rule is "Surround yourself with people whose eyes light up when they see you coming." So that means there's someone there who's always got your back, who's always being the wind beneath your wings. The second rule is "Slowly is the fastest way to get to where you want to be." Our parents have always said to us "Haste makes waste," and then there's that parable of the race between the tortoise and the hare, and one would think the hare, which is so fast, would win the race, but the tortoise won the race because the tortoise is slow and steady. And then the third rule is "The top of one mountain is the bottom of the next, so keep climbing." Personal success is not about the accumulation of things as much as it is the deeds that you have done to achieve the heights to which you can ascend. But don't spend time at the top of any one mountain: Take a moment, take in the panorama, take in the distance, take in the view, but then understand there's more work to do. Keep it in your heart, keep it in your mind, and keep going forward.

"You do your best work, you do your best acting, if you do it in service to others."

Many actors have criticized Hollywood for the lack of diversity. I don't know how you feel about this personally, but what's been your experience accessing non-Black roles as a Black actor?

I've been very blessed. I've been very fortunate. When people ask me, just even on a daily basis, "How you doing, André?" my response is, "I live an anointed life." Now, all of this goes back to keeping your eye on the prize. I believe that the universe recreates itself for our pleasure. I believe that the universe is a cornucopia and all it does is spill abundance. I believe there's no such thing as lack, there's no such thing as insufficiency, there's no such thing as inadequacy. There is enough for everybody regardless of your creed, your color, your religion, your nationality, your gender, etc. This is where we get into trouble, though; the rule is this: Pursue only those blessings or only that abundance that has your name on it.

Now, I'm not so Pollyannaish to think that there is not systemic racism in this country. Yes, there is, but the way to combat it, in addition to protesting, in addition to passing legislation, the way to combat it is to bring to the table your unique self, your authentic self. I'm not competing; I'm bringing my unique gift to the table. It's like a potluck dinner, right? You don't want everybody to bring salad to the dinner. You want someone to bring their best fried chicken, you want someone to bring macaroni and cheese, you want someone to bring some good cornbread. It has to be diverse; it has to be equitable; it has to be inclusive. But you can't look for that only in the external world if you don't understand first about yourself that you have to discover diversity there. We're always saying that African Americans do not constitute a monolithic culture, which is correct, but as an individual African American, I'm not monolithic either. I am many things, contradictions, talents, tools, ideas, concepts, so if I can't first discover diversity in myself, I'm not going to find it in the external world either. If I can't first find equity in myself, I'm not going to find it in the external world. If I can't first find inclusiveness in myself, I'm not going to find it in the external world. Because as it is above, so it is below; as it is inside, so it is outside.

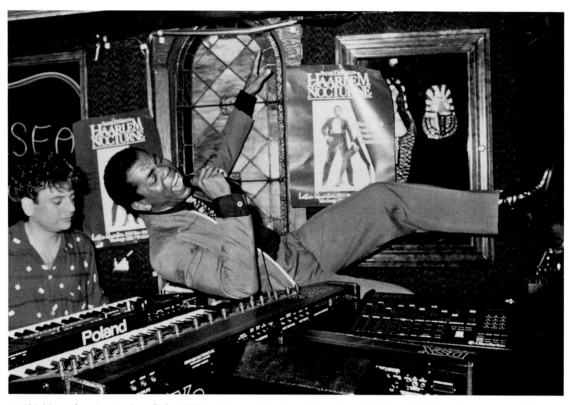

De Shields performing at a benefit for Children's Dance Theater on December 2, 1984, at Chelsea Place in New York City.

De Shields performing as Hermes in *Hadestown* on Broadway, for which he won the 2019 Tony Award for Best Actor in a Featured Role in a Musical.

That's beautiful. I do wonder, though: Statistically, there are fewer Black roles, and a lot of Black actors have felt that they don't fit in certain boxes, and so there have been discussions of quality of roles in terms of stereotypes, and also equality of pay. How does that make you feel, knowing that, statistically, this has been proven to be true?

It makes me feel that my work isn't over. It makes me understand that this idea that the United States of America is the greatest democracy in the history of the world is not true. It is a democracy, but it's an imperfect democracy for everybody, not just for those of us who are the recipients of discrimination. It's an imperfect democracy for those who would discriminate, but that's the reality. If we beg for crumbs from the table, then that's exactly what we're going to get, crumbs from the table. We are a unique culture, probably the most unique culture in the world, because African Americans are descendants of the Black Africans that were kidnapped from the west coast of Africa and brought to the New World as slaves, and what did we do? In one generation, we assimilated a new culture, a new religion, a new language—in one generation. Which is why we've been able to survive, thrive, and now we are beginning to prevail. We cannot undo that, but what we can do is continue to chip away at the stone mountain of white supremacy that is the cause of that discrimination. That's not going to happen overnight, it's not going to happen in a generation, it's going to happen generation after generation, so each of us has to recognize the uniqueness of our gifts, understand that before we ask for or even treat others with empathy and compassion, we must treat ourselves with empathy and compassion, and create where there has been none, but reconstruct where there has been Black civilization.

You won your first Tony Award in 2019 for Best Featured Actor in a Musical for your performance in Hadestown. *Was this the greatest accomplishment of your life?*

Well, the high point of my journey as an actor came in 1966. I was the first person in my family to go to college. When I arrived at Wilmington College, a drama teacher said, "Are you an actor?" I said, "That's what I want to be." He said, "Good, because I want to direct *A Raisin in the Sun* on campus, but there aren't enough Black actors." Long story short, I was 19, and he cast me as Walter Lee Younger. My parents got on a bus in Baltimore and came to Ohio to see me perform for the first time, finally understanding I did have talent and there was reason to encourage me as opposed to caution me.

Do you have any last words that you want our audience to remember?

What I'd like to leave with our beloveds who have joined us in this conversation is simply this: We are in this together; we have to celebrate our differences, not curse them; we have to look at the universe around us and imagine, if the universe were uniform, if the universe were monolithic, if the universe were homogenous, if the universe were one thing, it would be the most boring experience. The universe is diverse. The universe is inclusive. We are reflections of the universe, and we should surrender to that. We should respect—first recognize and then respect the beauty that is in each of us, and to be sure each of us is beautiful. There's a word I want to share with you that comes from the network of Bantu languages that's spoken in southeastern Africa. It is *ubuntu*, and it means "I am because you are." ∎

SIMON ESTES

Opera Singer, 84, Des Moines

Interview by Kayla James

Simon Estes is an internationally acclaimed bass-baritone opera singer. He's a graduate of the University of Iowa, as well as the Juilliard School of Music. He's currently a visiting professor at Iowa State University and Des Moines Area Community College, but before then, Estes performed in front of global leaders and taught at universities across the world. For years, though, he found it hard to perform in the United States due to the color of his skin. "I've lived in Europe more than I have in the United States because I started singing in 1965," Estes said. "I'm not saying there's no discrimination in Europe—there was. But the people there judged me like Martin Luther King Jr. said: on my character and on my talent, and not on my skin color. In the mid-'70s, I called my mother, I was crying, and I said, 'They won't let me sing at the Met. They won't let me sing at a lot of opera houses.' My mother said, 'Now, son. You just get down on your knees and pray.'"

Getting down on his knees to pray is an action he said he continues to do to this day. It's how his mother taught him to deal with any celebratory moments, as well as any trials and tribulations that came his way.

When Estes was finally able to perform throughout the United States, he remembers still facing discrimination. One incident he recalls took place in San Francisco, where he saw the difference in pay. "They were probably paid $15,000 to $28,000 a performance for singing the lead roles as tenors," Estes said. "They paid me $257 a performance."

Throughout his career, Estes has performed in front of several presidents. He has taken on over 100 roles in opera houses across the world. Estes sang for Nelson Mandela in 1990. His illustrious career has allowed him to perform on six of the world's seven continents, to receive numerous awards, and, in 2020, to be named to the inaugural class of the Opera Hall of Fame by Opera America.

Estes in 1997.

Estes and Grace Bumbry in a 1985 New York City Opera production of *Porgy and Bess.*

His time at the home of Coretta Scott King and her children is a fond memory Estes holds to this day. It takes him back to a time during the civil rights movement when he watched King help lead the effort to bring about equality. "I remember when King gave his great speech. Actually, I heard him speak in person when I was at the University of Iowa," Estes said. "Martin was somebody who really inspired me to treat hatred with love."

As someone who lived through the civil rights movement, Estes said seeing the killing of George Floyd, Breonna Taylor, Ahmaud Arbery, and others made 2020 a tough year. "I said to my wife, 'I'm tired,'" he said. "I'm just tired. They say we don't have any discrimination in America. It does still exist. The only way I think that we're going to reduce discrimination in the United States is parents need to start teaching their children at a very young age."

Estes said he knows how much can change. It's why he has hope in the current generation who marched and called for change after the killing of George Floyd, and for the generations that will follow. "You can only drive out hate with love," he said, "so my suggestion is, Let's give love a chance." ∎

MARY JACKSON

Basket Weaver, 77, Charleston, South Carolina

Interview by Danielle Harling
Portrait by Gavin McIntyre

"**I** wanted to do something different from what I had learned growing up. I decided to do something which came from my own ideas." That's how **Mary Jackson** developed her unique take on a sweetgrass basket weaving technique that dates back to her ancestors in Africa. The art form made its way to the American South during slavery; now Jackson practices it in her studio on Johns Island outside of Charleston, where a community of sweetgrass basket makers still thrives today.

Danielle Harling *How were you introduced to basket weaving?*

Mary Jackson It was passed down to me from my mother when I was a young child. My mother said I was around 4 years old when I was just curious to know what she was doing. She made her basket. So then she started teaching me at that age, but I grew up learning more and more from my mother.

What are the origins of basket weaving?

This basket weaving we call sweetgrass baskets originated in Africa. It was done by people who were ancestors of those brought here as slaves. They brought this tradition with them and continued making them for everyday life, whether it was on the plantation or in their own home environment. I'm a direct descendant of Africans who were brought here. My mother's mother taught her. Her mother taught her, and on from way back.

How would you describe your childhood?

It was very community oriented, because it was all of my father's brothers and their families all living in a small community, almost like a little circle, and walking from one house to the other. I came from a large family, but all the families had children. So, we interacted that way. That was our activities. We didn't have a summer camp or other summer activities, like community centers, where you can learn to swim and all of that. It was very isolated in that sense, but we had very good camaraderie as children, because we played together every day. And this was an activity that was among families. So I learned how to make baskets.

Where does your inspiration come from?

It comes from beautiful forms that have been passed down, like table baskets, like open trays for serving food, or fruit baskets. And my idea, after I learned the technique was that I wanted to do something different from what I had learned growing up, the traditional designs that were still in use. I decided to just do something from my own ideas.

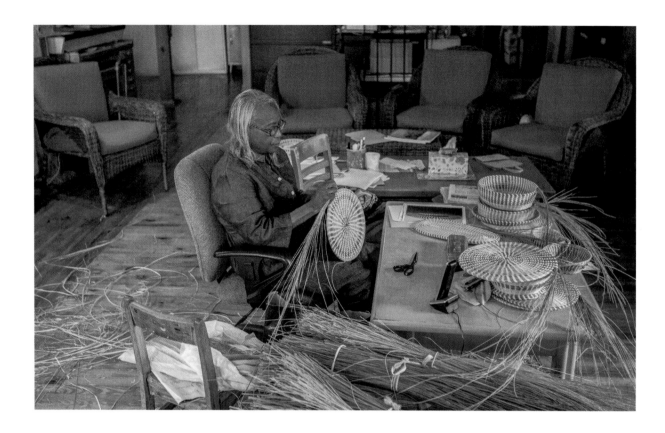

How do you hope people use your baskets? Or would you consider them to be more for display?

Oh, some designs are more functional. Some designs are sculptural. So, you know, people tend to not use them at all, because they think it's so beautiful. It's considered to be one of the oldest African art forms in this country. And it's only this basket that's made by people who are descendants of Africa, who kept the tradition alive. They're in museums all over the country and different parts of the world.

At what point do you think basket weaving became recognized as an art form, not just necessity?

I think in the early '50s it was first recognized by museums, and then they started collecting them for museum collections. Also, in exhibitions—like, in 1984, one of my baskets was sent to the Vatican for an exhibition, along with other art forms, as a collection of work from the state of South Carolina. It was displayed in one of the Vatican Museums. And in, I think it was 1986, the Prince of Wales, Prince Charles, came to Charleston for a visit. And the city of Charleston presented him with a gift from the city, and they gave him one of my baskets.

What do you believe your ancestors who started making these baskets—how do you think they would feel about these accomplishments you've made through basket weaving?

Well, my grandmother, my maternal grandmother, lived long enough to see some of the recognition that I was getting for my work, and she was very excited. She thought it was so wonderful. Beautiful.

"When they were brought here as slaves, they brought this tradition with them."

For your baskets, you use sweetgrass and pine needles?

Yes, and bulrush, which is also a traditional grass that men used to make agricultural baskets, for field work. Sweetgrass is the softer, pliable grass that was used by women to make baskets because it was easier to work with, easier on your hands. And that is still the same today.

Are these resources that will always be readily available? Could global warming affect the availability of these natural resources?

Global warming and development drastically affected these materials that have been used for centuries for making these baskets. We have historical records that show that these have been made for over 300 years. This community is now smaller than maybe 100 families. And changes to the coastline because of weather patterns affect the growth of these grasses. Also, development has taken over where these grasses grow because it's near the water, where they want to build large-scale development like hotels and resorts that overlook the water. That has been the trend for the last 30 years. Even as a young person, I can remember the older people talking about how these baskets would be disappearing because the grasses would not be available due to development. So it forced me, as a basket maker, along with some other friends, to get together and try to learn how to grow sweetgrass.

A horticulturalist from Clemson University, who lived in our area, helped us learn how to grow it—and he himself did not know how to do it, because no one had ever tried growing the grasses before. But we all learned how to grow it, and it became very successful.

Are there any life lessons you've learned through basket weaving?

That it is important to carry this tradition on so that we will always be in touch with our homeland. It keeps us in touch with how we came here. And when I said "we," our ancestors came as slaves. And we should never have that part of our history repeated. So, keeping the tradition going, it reminds us of our past. ∎

PATTI LABELLE
Singer-Songwriter, 77, Villanova, Pennsylvania

Interview by Danielle Harling
Portrait by Whitney Thomas

With five decades of hit songs to her credit, **Patti LaBelle** is internationally celebrated as a powerhouse singer. Her original group, Labelle, was the first African American act to be featured on the cover of *Rolling Stone* and the first pop group to perform at the Metropolitan Opera House. She has won two Grammy awards and been inducted into the Grammy Hall of Fame. She is also the author of four popular cookbooks and is particularly known for her sweet potato pies.

Danielle Harling *What's the most interesting thing about being your age?*

Patti LaBelle That all men look at me.

I love it.

No, the most, most interesting thing is that I feel like I'm 40. I'm 76 and I don't feel aged.

And what's your secret to feeling so youthful?

I like to be with people who are fun. And sometimes those people are not my age; the 76-year-old people that I know, they're not usually like—see, I love Tupac, I love "California Love" and "The Club" and "Ain't Nobody," I like dancing to those gangster songs, you know? And I think it keeps me going. My grandkids say, "Oh, Grandma, you know that song?" I say, "Yeah, girls, that's before your time." But they watch me for encouragement. As they turn 7 and 4, they'll say, "Oh, Grandma is old, but she doesn't act old." I feel that doing things like dancing and moving around and pranking and all the fun things that I do has kept me happy.

If you could go back to any age, what would it be? And why?

Oh, gosh, I probably would be 30, when my sisters were all living. Back in the day, when we had crab fights. We'd buy bushels of crabs from Baltimore, and then we would fight to get the biggest ones once a bushel was dumped. I miss fighting with my sisters. Oh, gosh, I miss everything we did together. My sister was my T-shirt vendor at most of the places I performed, she would sell her Patti stuff. And we just had fun doing things with my family. Even my father before he passed. He was a young father also. And we did competition—like, he was a singer, and I told him I could sing rings around him, and we would have father and daughter contests and stuff like that. So when I was 30, that was a good year, when everybody was living.

What is one of the greatest moments in history that you've lived through?

I think when Labelle played the Metropolitan Opera House, being the first Black woman to play the Opera House in New York, and the show was

LaBelle in performance in 1960.

so spectacular. It was a "wear something silver" event. Everybody wore silver. There were people with silver outfits with their butts hanging out, and Debbie Allen was there, Cher was there, it was just a wonderful thing that was historic to me, playing the Opera House.

Was there a decision you made, whether in your personal life or in your career, that shaped who you are today as a person?

Sure. When I was singing with Labelle, I was pregnant. And of course, there can't be three outra-geous-looking women with a nine-month stomach, you know, so that sort of tested me, because nobody really wanted me to become pregnant. And I did. So there's a choice, you stay pregnant and stay with the group or you have something bad done to yourself, which I would never do, and stay with the group for that reason. So, no, I had my baby. And it wasn't comfortable for most people, because I was on stage at eight months, singing at Radio City or someplace.

Having my baby was going to be a problem to some people. And I had my son, Zuri, who's—oh my God, my manager now—my best friend, my everything.

What was one piece of advice you received when you were younger that has been most impactful to you today?

When I was younger? Oh, when I was younger, I had a nose job. And the reason I had the nose job is—Stephanie Mills was a great, great friend of mine, and we had dinner at my house in West Philadelphia before I moved here back in the day. And she was a Patti fan and Patti friend and I was a fan of hers also. So we had dinner at my home. I said, "Steph-anie, something looks different on you." And she kept eating dinner. And at the end of the dinner, she said, "I had my nose done." I said, "Well, where?" And she told me where. I didn't go to her doctor, I found a doctor in Philadelphia, and I had my nose taken off, you know. So that was, that was inter-esting. I mean, if I hadn't seen her, I wouldn't have

done it. But seeing something in front of your face makes you say, "Well, I can look different also." It's not that she looked better with her nose done, nor that I looked better. It just made us feel better about ourselves. So that was something that happened in my younger years that I'm happy I did.

Whether we're famous or not famous, we all have a story to tell. What's your advice on making sure our stories aren't narrated by others? How do we get our story to be the one that comes across?

I think I can answer: We get our stories by telling them ourselves. That's the best way. I mean, it's like, I can tell my story better than you can. Because I'm a pro with that. I'm a pro with Patti's life, and everything that I've been through, so let me tell you my story. And a lot of people have problems with their story being told, and they had no say-so in that story being told, so they're messed up because some things came out that shouldn't have, or just ugliness comes out. So tell your own story, always.

When you first started your career, your music career, was longevity always a goal for you?

I had no time in mind, because when I started, I had no clue I was starting it. Longevity was not on my page at that time. I was just anxious, because I used to perform with the broom in the mirror at my mother's house and pretend that was a microphone, and always say, "Oh, girl, you have a good voice; hopefully one day people will hear that voice." I kept that voice to myself until I joined the choir. And I wanted to sing with the chorus, background only, and my choir director made me come out. I think that's why I'm Patti LaBelle today. Because she brought that shy Patti out into the world. And when I did my first solo, I got an "Amen" and a standing ovation. So thank God for Miss Chapman that I am who I am now, because I would have kept that to myself, I think, unless somebody had pulled it out of me. So if you have a talent, don't sit down on it,

honey, go out there and show people what you can do and who you are.

You have had this amazing, long career. Does it ever get exhausting?

Girl, how can I be exhausted by doing something I love? I do this in my sleep. The time with Covid crippled me and so many other people because we were stuck at home, you know, without a microphone, without a stage, and without an audience. And the longer I was in this situation, I think I got stronger as a performer. Because I messed around in my house, you know, pretending to have an audience. So I can say that I can never get tired of this, nor bored. I had to start trying to wear five- and six-inch heels again. I'll wear them around the house every now and then. Because I put them on for some occasion last month and could not walk, honey. So now I have to get back into the walk of those pumps.

How do you get into the feel of walking in five- to six-inch heels? I feel like that's just beyond.

Girl, that's what I do. All my life I've been walking in pumps, you know, sometimes seven inches, then I went down to six, down to five. Now it's four inches, but I prefer the block heel because they're easier instead of the stiletto skinny heel, although I still put those on because you got to be cute every now and then.

You have, of course, a ton of awards, accolades. Is there something that means more to you than a Grammy or AMA?

The birth of my son, Zuri. That's everything. And to have given birth to such a gentle man. Such a caring person. A person who loves to help people. He's a share person, a person who shares with people. And that was my greatest accolade.

> **"**
>
> I don't like the term diva. It's for great opera singers. I'm just a singer who sings well. So just call me Patti.

What are some similarities between the two of you?

We like the same foods; we cook the same. I mean, he embarrassed me a couple of weeks ago—he made this turkey chili. And I tasted it, and I said, "That's better than mine!" Right? It made me angry. Because, all my cookbooks—he looks at every one. And as a kid he watched me cook. So now he's cooking rings around me, but we love the same things. We love people the same kind of way. And we dislike people the same kind of way. We both love to dress, and he's so much like me and so much like his father also, so I think we're blessed by having Zuri as a son. So I'm blessed. I'm blessed.

Is there anything new in the works with Patti Pies at all?

There's a lot of new newness coming. A lot of new music also. I haven't recorded in about 100 years, honey. So I'm working on a new project. And you'll have new music, new items. More good stuff. I never stop working.

OK, I'm excited. Do you have a favorite barbecue or cookout memory?

Oh, God. Wow. Cookout memory. Well, yes, I use my frozen—oh, I have a lot of frozen items also—like the macaroni, black-eyed peas and corn, okra,

tomatoes. So, when we have our cookouts, nobody has to make veggies or sides, because I got 'em for you. The cookouts are fun because I have a swimming pool and—I can't swim, but my grandkids, they love to come. The 3-year-old, Layla, said to me last week, "Grandma, when is the pool gonna open?" What do you know about a pool opening, little girl? So they can't wait for water, fun, and barbecues.

Looking back at the life you've lived, are you satisfied? Are there any regrets at all? Or do you just appreciate all of it?

I appreciate the regrets. If you have no regrets you can't go forward. You know, so, so many things that I wish had not happened—but they did, and I think it made me a stronger person for all the bad that I've been through. And I've been through. But I can say that it didn't break me. I think it made me.

If you could give one piece of advice just to Black women, what would that be?

Stay Black. Don't change, because being someone else is not who we really are. We're the authentic women. We've taken so many things and built from nothing. We mainly still have nothing, but we built from it. And proud: Stay proud, Black and fierce. ■

EARL THORPE

Musician, Cofounder of the Brothers, 84, Albany, New York

Interview by Jamel Mosely

A Florida native who moved to Albany as a young man, **Earl Thorpe** was a singer in the hit-making 1950s doo-wop group the Fidelitys, who became active in community organizing with the Trinity Institution in the city's South End. In 1966, he became one of the founders of the Brothers, a Black men's organization that would regularly protest against racism in hiring, police misconduct, and other forms of inequality.

Earl Thorpe I came out of Jacksonville, Florida, to do music. Had a scholarship at Morris Brown College in Atlanta, but I chose to come North because of all the racial tension that you had. I thought it would be best for me to come this way.

Jamel Mosely *Did you find it was better there?*

Yeah, it was much better. I was in the music, so a lot of things I didn't see right away, you know? We formed a group called the Fidelitys. And we went to New York to do the amateur hour at the Apollo. And we met some agents, Ben Bart and Joe Marsolais from the Universal Attractions Agency. And they said that we were definitely not amateurs. They signed us, put us to work right away. The first person who I worked with was Big Maybelle, a blues singer in Hackensack, New Jersey. And it just took off, you know? We had some major hits: We did "Walk With the Wind," "The Things I Love," "Memories of You," "Captain of My Ship." "The Things I Love" was the big one. The music is good; we were a cut above. I worked with everybody of my era–Jackie Wilson, the Dells, the Flamingos, Fats Domino, just to name a few.

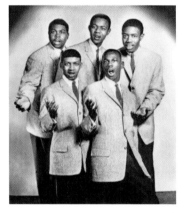

The Fidelitys—with Earl Thorpe on the upper right—were inducted into the Eddies Music Hall of Fame in 2020.

Who were the Brothers? What did you do?

The Brothers was a Black men's neighborhood group, and we fought for better jobs. We were the guys who stopped the $5 vote. My dad went to vote, and the guy said, "That's Earl Thorpe's dad–don't give him five bucks; it's a setup!" My dad came back, and he said, "You stopped me from getting my $5." I said, "Here, take this $5; this one's a better one. And you're not bought–it came from your son."

"You can't go home and expect to fight the fight from home. You got to be out in the community."

We picketed the Schaefer brewery. We stopped the trucks from coming in the inner city. We wanted to talk to [plant manager] Bill Schaefer; they sent a brother to come talk to us. We said, "You're not Bill Schaefer." Bill Schaefer came down to talk to us; we started getting hired through the beverage company. We picketed the state university [at Albany] when they broke ground. Everywhere there was to picket for better jobs, we did it. And we were able to get into the building trades.

We didn't only have Black people picketing, we had white people. And we got arrested. I had one white guy say, "Earl, I didn't get arrested." I said, "They didn't arrest you because they didn't know who your dad was. You might be a judge's son, you might be anybody's white son. They ain't gonna arrest you." Very few white people went to jail with us. They didn't keep you in jail long, but they made a point to arrest you.

I remember hearing a story about you advocating for better housing, and something about roaches.

I was into housing. All of my tenants had good housing, so why shouldn't everybody? We made landlords fix up a lot of places. There was a big roach problem; there was no trash removal, either. We got trash and took it to City Hall and dumped it on City Hall with roaches in it. Then we started getting free trash removal. People thought we were crazy: "Nobody does that!"

What does it mean to you to be an activist?

Well, I think I'm doing the work that I should be doing as a Black man—because the struggle will never be over. I'm not doing a lot of it now. I figure I had my time and my day. Got five kids out of school with master's degrees. But there's still a lot of work to be done. So I'm working on my grandkids now.

What would you say to someone who's new in this work?

Don't give up. Because there's enough work for everybody. So just keep the fight, you know? You got to be out there first. You can't go home and expect to fight the fight from home. You got to be out in the community. You got to be aware of what's going on, and you got to be able to reach families." ∎

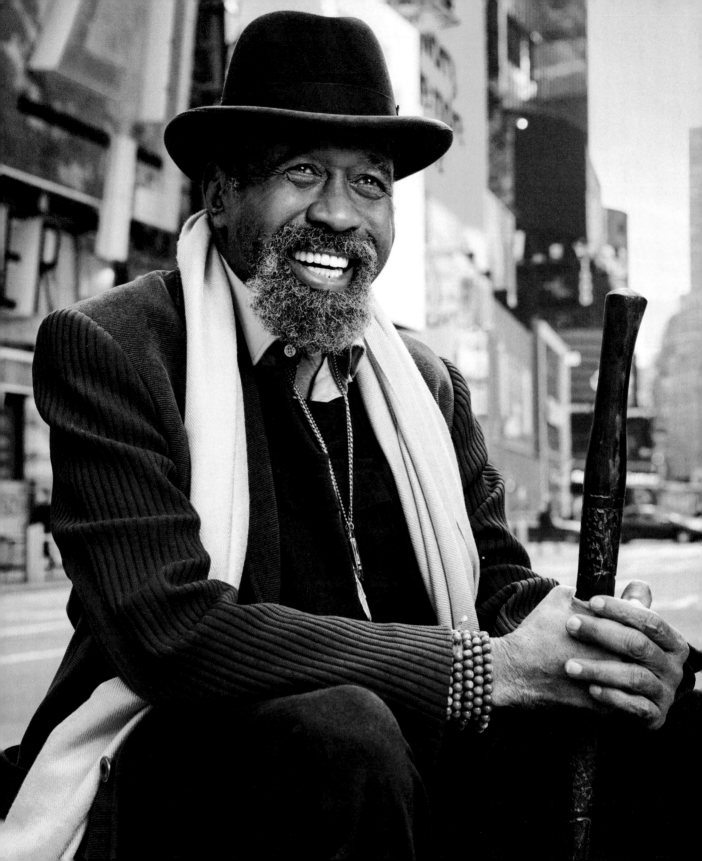

BEN VEREEN

Actor, 75, New York City

Interview by Danielle Harling
Portrait by Jai Lennard

For decades, award-winning actor **Ben Vereen**—a Florida native who originated roles on Broadway in *Jesus Christ Superstar* and *Pippin*, for which he won the 1973 Tony Award for Best Actor in a Musical, and was nominated for an Emmy for his portrayal of "Chicken" George Moore in 1977's landmark television adaptation of *Roots*—has proven to be a trifecta of talent, mastering film, television, and the stage.

Danielle Harling *What is the most surprising or interesting thing about being your age?*

Ben Vereen Well, one day you wake up, Danielle, and you realize that you're 75, and you go, "Where did the time go?" It's a shock to the brain. because my spirit, my inner being, still wants to do the things that I used to do, but my body says, No, you won't. You will not do those cartwheels and splits, you will not jump up over that fence, you will not do those things. But my spirit leaps boundaries, you know? That's what I find interesting about being my age.

And also, with it comes wisdom—waking up to knowing things from living through life that you can share with others and, hopefully, guide them. They have their own paths they're going to go through in life, but at least you can give them some idea of some of the pitfalls.

To rewind a bit: How would you describe your childhood?

My childhood was being blessed by people who had come into our lives. I call them the angels. When you come into this planet, we don't know that we're

bringing in the vibrations that we'll need in order to guide us along this journey called life. And my parents were wonderful angels. My parents, the people I've met, my godparents, my teachers, and friends. Singing with a quartet group called the Sensational Twilights of Brooklyn. Running with gangs when I was in Brooklyn, being called up the street to the High School of Performing Arts. Going from there to meeting a guy named Langston Hughes and doing his play *The Prodigal Son*. Vinnette Carroll, Bob Fosse, the list goes on and on.

My mother, God bless her, she didn't have much education—fourth grade—and she was from the South. But she had determination. She had tenacity for life, she had vision, and she wanted to do things for her son she didn't have in her life. She was the one that pushed me out the door when the guy came along the street and said "Startime Dance Studio!" she said, "Take him!"

We'd be sitting around a stove, a potbelly stove—I don't know if you know what that is. You're too young to know what a potbelly stove is. It's a stove with a potbelly and you put water in it. And we'd be sitting there, the rent wasn't paid, the gas was off,

Vereen and dancers rehearse for the hit musical *Pippin* at the Imperial Theatre in New York. Vereen went on to win a Tony Award for his performance.

The same thing with me. Someone once said this: The creator—God, Allah, Buddha, Jesus, the Great Divine—gives us a dash and he says, "I'll meet you at the other side of the dash. What you do with that dash, which is your life, is up to you. But I'll meet you on the other side." And those guides come along and help us. You've had guides in your life, haven't you?

Absolutely. Yes.

Teaching, inspirational—people who inspired you. You know. Look what you're doing today. Look at you, girl! You're bad!

Thank you! Would you say that you've been a guide to people as well?

I would like to think so. I've tried to give back what's been given to me. We are our brothers' and sisters' keepers. We help one another. Somebody said during the pandemic, we're in this together. We're in this life together. It's a beautiful thing, so let's help one another. You're helping my life be better right now by doing this interview.

Oh, I appreciate that. What is your advice to young people who want to pursue the arts?

I have a program I call Pathway to Excellence, and it works like this: I know young people want to be in the arts, and we welcome that because the arts are the source of our creation. See, in the beginning, it said God created, not God manufactured. Therefore, we are all creative aspects of that wonderful creation.

But sometimes when we throw ourselves into this business, we don't know what we're throwing ourselves into. All we want to do is sing, dance, act, say poetry, do music. But then you've got business, you've got health issues, you've got all sorts of unions—a lot of young people don't know about all that, so I try to prepare them.

the lights were off, and we'd be sitting there. And she'd look at me and she'd say, "Bunny"—she called me Bunny—she said, "All we have to eat is a donut. You'll eat the donut and I'll eat the hole, don't you worry about a thing, son." And that's the way I was raised. That's the way I was raised.

You've said that the spirit chose you to do what you do. What did that look like?

You have this vision. Where did that vision come from? Where did that instinct come from? You didn't just wake up one day and say, "Oh, I want to be a journalist." No, there's something inside of you, that hunger, and you followed that passion. That spirit—that's not intellectual, that's not a college degree. That is instinct, that is spirit that's calling you forth to who you are today.

"I'll tell you what. Let's you stop looking at me as a Black man and calling me Black, and I'll stop calling you a white person. We're all created from one creator."

I'll have a class where I'll have a lawyer come and teach kids how to read a contract, have an accountant come and teach them how to balance a checkbook, have a physical therapist come in and talk to them about taking care of their bodies. I'll have a director and an agent come in and tell them about what you have to do to get an agent.

Given what's happened with Covid, what do you see as far as the future of Broadway and theater? Will it ever be the same?

No, but it will be back. It'll come back with a new paradigm. It'll come back with a new expression. I just went and saw a show last night called *Blindness*, which was mainly just listening to someone read a story in lights, you know? People are looking for pop-up theater right now, which Nathan Lane did, and Savion Glover. We're trying to find new paradigms to try to reach our audiences. Theater will be back. It won't be like we knew it, but it'll be a new adventure, and that's exciting.

When you were in Roots *years ago, did you have any idea that it would be so impactful decades down the line?*

Of course not. I'll tell you a story. I was doing my act on the road, and I heard about this book called *Roots* that Alex Haley had written. It was in the *Reader's Digest*. ABC had decided it would do a

thing called a miniseries. I went down to Philadelphia to do a concert and I came back on a train and I'm reading this book. I went to my agent and said, "I want to do this. This is beautiful and important." And he looked at me and he said, "Ben, they're looking for actors." He said, "You're a song and dance man, so don't get your hopes up on this."

So I went off, you know, doing my song and dance act, and I was in Chicago one night, and I came off stage, I went to my room, and there was a knock on my door. A gentleman named Stan Margulies was there, and he said to me, "I'm here shooting a TV show called *Roots*. I'd like for you to be my Chicken George." I didn't know what a Chicken George was. I wanted to be a part of it. Why? Because of the importance of the document.

You see, my Jewish brothers and sisters had Hitler, who was a madman, who filmed everything. They have documents, but my people don't have documents. We don't have film. We have spoken word. So this was an opportunity for us to document the slavery story. That's why I did it. I'm sure if you speak to a lot of the cast members, they'll tell you that's the reason why we did it. We had no idea it was going to take off the way it did. We had no idea. We were so thankful that it did, for the fact of you and the children coming behind you to have some sort of document where you could say, "This happened."

Vereen (right) as Chicken George and Georg Stanford Brown (left) as Tom Harvey in *Roots*.

Vereen, Carol Burnett, and Dick Van Dyke performing on *The Carol Burnett Show*, November 4, 1977.

I feel like there's this debate now, or conversation, about how much Black trauma should be in film and television.

When I was growing up, every Sunday night on Channel 11 or Channel 9 in New York City there was a reminder that the Holocaust had happened. And now we're saying, Well, what about the Black holocaust? No, we haven't told all our story yet. We haven't talked about the brothers and sisters who ran off with Harriet Tubman to Canada and when they got there, turned around and came back when the Civil War started to free our people. They don't talk about the gentleman who bought 200 slaves in Alabama, took them all to Canada and said, I'm going to give you your freedom, but you've got to learn to work the land. We don't talk about that. We don't talk about Crispus Attucks, who was the first Black man to die for the liberation of this country.

I'm playing a guy named Frederick Douglass right now. You want to understand something? We were not allowed the English language. We were beaten and hanged if we tried to read. And here's a man who taught himself to read, to write, but he became the ambassador to Haiti, and he was a world-renowned scholar and speaker. We have a rich heritage. So, the debate on whether or not we should continue to tell our story? I say yes, because our story has not been truly told yet.

We have a lot of stories about violence and gangs and things of that nature. What about the source of our existence? What about the beginning from the beginning? What's the beginning back when it was the beginning? So that our children know whose foundation they are standing on. So that they no longer look to be a Superman. We've got Black Panther now, so why not have more? Now we're beginning to equalize.

What does equality for Black people look like?

We're all created from one creator. We're the bouquet. If you look at the fields of flowers, they're different flowers, but it makes up the bouquet of God's expression of life. Equality looks to me like that for men and women, Black and white.

I love that.

We've got to level the playing ground here for you and for your children, for my children and my grandchildren. You know, we've fought too hard, to where we almost died. Billie Holiday said, "strange fruit hanging from the poplar trees." A lot of us were hanging from poplar trees, but we're here today, you and I, talking.

I notice you have the ocean as your Zoom background. Why is that?

I sometimes sit and I meditate to the ocean. I look out at the endless possibilities it has to offer me, and I want to catch it before the sun goes down. I try and tell people, if you're going to walk along the sands of life, leave big footprints in the sand and look upon the sea to see your possibilities. ∎

DIONNE WARWICK
Singer, 81, South Orange, New Jersey

Interview by Mariah Campbell
Portrait by Kwaku Alston

From hits like "I Say a Little Prayer" to "I'll Never Fall in Love Again," **Dionne Warwick** has touched the hearts of many throughout a music career that has spanned over 60 years. The R&B vocalist started out singing with the Gospelaires along with her sister Dee Dee before releasing her first solo single in 1962, "Don't Make Me Over"—a song that foreshadowed her long commitment to remaining true to herself. Today, the Twitter community has welcomed the 80-year-old "Auntie Dionne," celebrating her wisdom and witty tweets.

Mariah Campbell You are absolutely hilarious on Twitter! Did it offend you when people started to think you weren't writing your own tweets?

Dionne Warwick No. You know, of course they're gonna think that. I want to have as much fun as anyone, and that's what I'm doing on Twitter.

And you sure are making it a good time for us, too.

Great! That's the important part.

As a child, was it your dream to become a singer, or did it just happen?

If I quote my mother, she says I came out singing. I come from a gospel-singing family, and you know the old saying, "The apple doesn't fall far from the tree"? Well, that proved true for me and everybody else in my family.

Would you say that gospel played a huge role in your life personally?

Oh, absolutely, and still does. It's the testament of my faith that I grew up knowing and believing and

honoring. It is something I don't think I could ever live without.

You sound like me! What was your childhood like?

My childhood was full of love and laughter and music. As I said, I come from a gospel-singing family, so I spent a majority of my life in church. My grandfather was a minister. So this was all I ever knew, and it's all I guess I ever want to know. I had a normal childhood like everybody else—I went to grammar school, and I walked to school with my friends and got into the little scrapes that we all get into every now and then when we're youngsters, and I've got the marks to prove it.

What was it like being a young Black woman in the music industry when you first started?

Coming from East Orange, New Jersey—Go Panthers!—what I experienced in the early part of my career and in the very early tours that I did in the southern region of our country, I saw a lot of stuff I never even knew existed because I didn't experience that where I came from. I lived on a block that I refer to this day as virtually being the United

Warwick, circa 1970.

Out of all of the songs that you've made, which one would you say is your favorite, and why?

I don't have a favorite of the songs I've sung; they're all my favorites. Each one of them I've grown with as they've grown with me lyrically. One's words take effect on you. At the tender age of 19 they meant one thing, and when I was 27 they meant another thing, and with each decade they meant something else.

You've broken so many barriers for African American women in the entertainment industry. How well do you think today's female artists have upheld that legacy?

I refer to my babies, that's how I refer to them all—they're all my babies. But their recordings are geared for younger ears than mine. Some of their lyrics I take very great offense at—I must say that—and I've voiced that on many occasions with those partic-ular artists. However, I don't listen to the artists of today that much, I really don't. I listen to my peers; I listen to the music that comforts me.

I think as my babies grow and get a little bit more age on them and have children of their own, maybe they'll begin to realize, Oh, wait a minute, maybe I shouldn't be expressing that as freely as I am.

Nations. We had every race, color, creed, and religion, and we interacted with each other on the basis of who we were, not what we were.

So it was interesting to see what is unfortunately occurring again today—the prejudice, and this nation of people being stupid. I guess that's what I'd call it, complete stupidity, because the color of my skin is not to your liking. I used to joke with some of my white friends: I'd say, "How stupid is it that you're going to judge me by the color of my skin, and every summer you slather yourself and lie out in the sun to get my color?" I never quite understood that. And so now with everybody plumping up their behinds and their lips and wanting to look like me, all of a sudden it's like, Whoa, wait a minute, what's going on? What happened?

I said to Snoop, "You know, you're going to grow up and you're going to find somebody you're going to fall in love with, and guess what? You're going to get married and you're going to have children, and you may have a little girl. And she's going to hear one of your songs one day and say, 'Daddy, is that you saying that?' What are you going to say to her?"

I said, "Your ears are going to grow up, and so is your mind and your heart, so be very careful." I learned a long, long time ago that we're messengers, and we have to be very, very careful of the message that we give to people.

Warwick on *The Glen Campbell Goodtime Hour,* September 24, 1970.

You have a tour planned. What do you still love about performing?

First of all, the fact that people want to hear me sing. They still put their butts in the seats, and that's important. As long as I am able to give the best that I can possibly give and feel satisfied that it is the best that I'm giving, that's how long I'll be doing this. When I feel that I'm faltering, that's when Dionne will hang up her ballet slippers and say adieu.

You have a very beautiful energy, a great spirit. What's the secret to staying youthful and energetic?

My parents instilled in me, as have my mentors: You be who you are. You cannot be anyone other than you, and I truly believe that, and as a matter of fact, I like me, so I don't have any reason to want to be anybody other than me.

What do you think it means to be successful?

Happy in your skin, I think. Knowing that you are achieving exactly what you're setting out to do. Your aspirations are being met, and if they aren't, then there's something else you have to do. And you have no reservations about doing that. And when you have completed something, you say, "Oh yeah, that's a good thing." Then on to the next, and you never stop. I don't ever stop. I have so much left to do, and I'm looking forward to it. ∎

BOB WESLEY
Architect, 84, Naples, Florida

Interview by DiVonta Palmer
Portrait by Octavio Jones

Growing up in Memphis, **Bob Wesley** would go door-to-door at Christmastime offering his services as a budding artist. "I would ask neighbors, 'Would you like me to draw a decoration in your window? You know, a bell, holly leaves, Santa Claus?'" he says. "I decorated lots of homes when I was a kid." That artistic passion, and an early revelation that it was possible (if rare) for a Black person to become an architect, set Wesley on a path that ultimately led to his becoming, in 1984, the first Black partner at the Chicago-based architecture giant Skidmore, Owings & Merrill. Last year the firm's foundation launched an academic grant program in Wesley's name to benefit BIPOC architecture, engineering, and planning students.

DiVonta Palmer *What was it like growing up in the segregated South?*

Bob Wesley I would say the experience I had is nothing like what exists today in the South. It was separate, totally separate living, and it wasn't equal. The Black people were in all-Black communities, and you could cross one street and then you would get into a white community. You only had Black neighbors. Schools were all-Black—principals, teachers, students. Your churches were all-Black, and so forth. And in some ways this was not a detriment, to be in that kind of an environment. But there were other civic components that you didn't get, that you weren't able to share, like parks, museums. If they had an exhibition of Van Gogh, I couldn't go there because my skin was Black. When you're growing up, you need that kind of exposure if you're going to compete on the world stage, so how is it "separate but equal" when you don't have these amenities? That was the Jim Crow South. But if you had a very strong family like I had, and a very strong community, you could be a survivor. And that's what you had to be if you wanted any kind of a lifestyle that was decent in the South.

What inspired you to be an architect?

When I was in about the seventh grade, my mother worked for Universal Life Insurance Company, which was an African American insurance firm in Memphis that had a new building built for them [designed by the Black-owned Nashville firm McKissack & McKissack]. I went to the opening, and I was just flabbergasted at the building. I'd never

been inside anything so nice. I got a chance to meet the architect and was very impressed. It was there that I found out about professional architecture. I didn't know the term that well, and here I had the chance to meet an African American architect! I did my research, as much as I could with books, and I thought that was what I wanted to be. It all started with seeing that building that day.

You are an alum of Tennessee State University. Can you tell me about your HBCU experience?

I was in the first class to be admitted at Tennessee State for an architectural engineering degree, a Bachelor of Science in Architectural Engineering. Again, this was in '55, so it was a year after the *Brown v. Board of Education* decision. I was trying to get to a school that had architecture, an accredited one. They tried to forgo the requirements for getting Blacks into the University of Tennessee by creating this program at Tennessee State University. Before that, you couldn't be educated in architecture. Fortunately, there was a department head, Leon Quincy Jackson, who was Black. He was really a good person, a very talented architect, and he was our leader. He worked us hard. When we were in school, we didn't like it because he was so tough, but at the end of the five years and afterwards I had a tremendous amount of respect for him.

The historically Black colleges and universities have produced some unbelievable alumni. I mean, we have a vice president who is a HBCU alumni, right? So, we're not at the bottom. We're up there with the big guys now. And that's why I mentioned Quincy

Wesley in his office at Skidmore, Owings & Merrill, in the late 1990s.

"Growing up in this Black, African American environment, we had people who genuinely cared for us, who wanted us to be good, productive citizens, and that counts."

Jackson. You have these mentors, and when I look back on my life, I really believe that if it wasn't for them, I just wouldn't have gotten where I did.

You worked on such projects as the Toledo Museum of Art, the Art Institute of Chicago and the Chicago Symphony Orchestra building. Which was the most memorable, and why?

You remember when we talked about when I was not able to go to museums and galleries and such things in the South? Well, I was fortunate to be able to work on some of Chicago's premier cultural institutions, the sorts of places I was denied in Memphis. The Art Institute of Chicago. The Field Museum. The Chicago Symphony Orchestra. Lyric Opera of Chicago, a major project there. These are world-class institutions. And the last project I worked on was Millennium Park. You may have seen it, with the big, shiny stainless-steel bean and everything; well, at one time it was just an open place where the trains would go through, covered in weeds, but it ended up being an extraordinary park. These civic structures, civic buildings, civic projects—these are what I am really proud of.

Your firm has created an award in your name to support BIPOC students in architecture, engineering, and planning programs. What can you tell me about that?

I can tell you I was totally shocked and surprised. This has just happened within the last year, and I'm extremely honored that they asked me if I would allow this program to be created by the SOM Foundation and named after me. I have always worked to support, especially, Black and Indigenous people and people of color. And the SOM Foundation wanted to support BIPOC students and help develop more students to get into the profession, because there aren't many. This program is one that helps a student in many ways, and one of the main ways is financially. It gives out three $10,000 awards annually. At our first jury, I was just shocked. I mean, these kids are so bright, and to think that they may not complete their education and become what they want to become because they don't have the financial support they need. The idea behind this SOM Robert L. Wesley Award is that this should not be a deterrent. I'm deeply honored, because it's such a needed program. ■

PAULA WHALEY

Sculptor, 78, Baltimore

Interview by Carly Olson
Portrait by Nate Palmer

Paula **Whaley** is something of a late bloomer. The Baltimore-based sculptor and doll-maker hasn't always identified as an artist and even struggled to envision life as an artist while she worked in fashion. But in 1987, she felt called to work with clay as a way of healing after the death of her older brother, writer and activist James Baldwin. Whaley was extremely close with "Jimmy," who encouraged her early on to make art and whose influence continues to shape her work and life. Today, Whaley is best known for her mixed-media doll sculptures, no two exactly alike. Formed of clay, wood, metal, fabric, and other materials, the closed-eye figures are clothed in intricate, textured garments and offer deep, expressive gestures, appearing at once at rest and in motion. As embodiments of familial and ancestral memory, the pieces are emblematic of Whaley's own spiritual connection to those who have come before her.

Carly Olson *I know that you and your brother, Jimmy, were quite close. What did you learn from him that sticks with you today?*

Paula Whaley It's about fear. Fear can paralyze you, and he always used to say, "Work on getting through, or over, your fear. When something is presented to you that you want, usually it's worth risking it all." I will be working on this forever. He believed in me in ways I didn't see. He kept saying, "I see you as an artist." I never saw that. I want to inspire, because that's what he gave me and anybody he was around. You could become hopeful if you had doubts. You could somehow get courage and move forward.

Are you hopeful right now?

I'm kind of back and forth, in and out, but it's interesting: Even with the pandemic we've been through, and in the midst of all this chaos and horror, I still am hopeful. I feel that things will never be the same again. It's a complete shift, and I think the younger people will be able to make that leap. You have to have a spiritual base. I've watched others come through things because they had something to fall back on. At some point, it's not all about you.

How do you connect with God? Do you pray?

Oh, yes, I meditate and I pray every day. It's the first thing I do, and that's what my mother did. It was a ritual. I laugh sometimes because it's amazing—the things that we didn't think we would do that we may have watched our parents do. But every day I get up, I meditate, and I'm thankful for the gifts that I have been given. And I really spend a lot of time—because of the work that I'm doing and want to continue—thanking my ancestors. I literally pray to my ancestors.

You told me that you also see your ancestors sometimes, right?

Yes. My father's sister at some point lived with us. I was close to her, and she couldn't hear. We lived in a railroad tenement. She and I would be in the back of the apartment, and when people knocked, I would have to lead her to the door. She comes to me a lot because of the time going up and down this hall. It may sound crazy, but sometimes I feel that I get more in meditation when I call on my ancestors than I would get from someone here in the physical.

I often hear people say that at the end of the day, all you have is yourself. What you're saying is the opposite of that.

No, no, no, no—I would never say all I have is myself. That would bother me or scare me, truthfully. That's why when I'm talking to young people, I always say it's about you and your art, but it's also bigger than that. You need something other than yourself to connect with.

One of Whaley's elaborately costumed mixed-media doll sculptures.

"Every day I get up, I meditate, and I'm thankful for the gifts that I have been given. And I spend a lot of time thanking my ancestors."

Did the pandemic time working from home help you remain connected to where you should be?

Definitely. It's interesting about this pandemic. It's all terrible and horrible, but I also think it's a wake-up call. And I think that for some of us, I'm probably one of them, you're getting another chance to work on getting where you may want to be. I'm really working toward my transition. I'm working on that. I'm trying to get right for that.

When you say transition, are you talking about death? How do you prepare? What do you want to leave behind?

Uh-huh! Just a couple of weeks ago I started labelling certain things that people have given to me and certain things that I want to be buried with me. But what I want to leave behind, and what I am leaving behind, is mainly the work that I've done. I hope that I will continue to inspire and give people a certain kind of peace. For me, it's about energy. And I want to have inspired the young people that I have been involved with.

What self-work do you think is worthwhile? What should we let go of?

It's interesting that you use the phrase *letting go*. It's been very interesting in this pandemic to watch people who have worked all their lives and acquired incredible things, but they cannot even stay in their homes. So who and what was it about? Was it for you, really? Because if it was for you, then you would be able to live with it. I think wherever you are, it should be your sanctuary. It should be a place that you can go to and be alone and be OK and let it be well with your soul.

What do you enjoy about your age?

I breathe differently. It's a kind of freedom—even sometimes feeling carefree. Sometimes a childlike feeling or spirit comes back. It's like I'm able to look or see or feel the child in me. I feel lighter. ∎

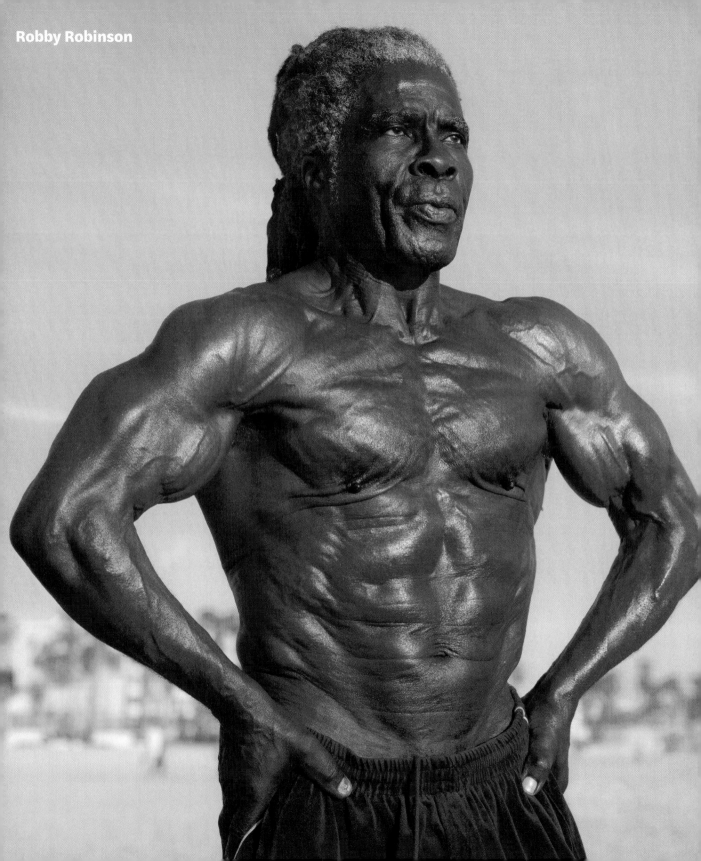

Robby Robinson

CHAPTER 3
Strength

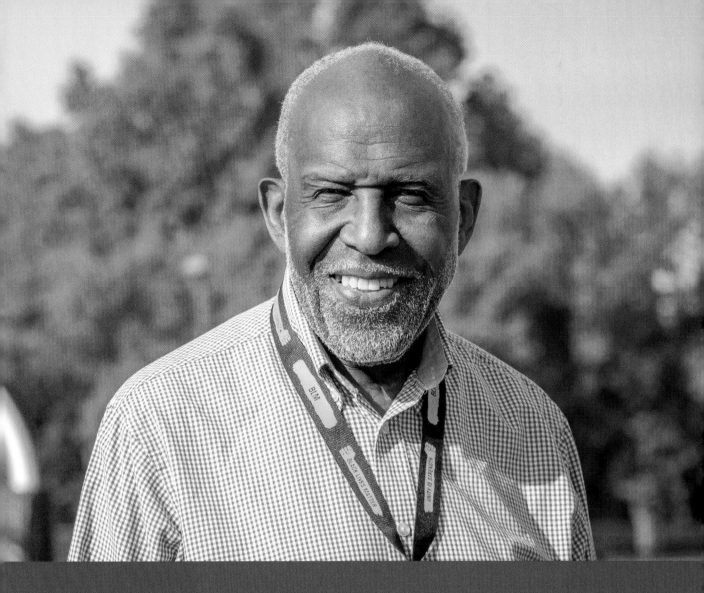

JAMES BARBER

Football and Track Coach, 83, Burlington, Connecticut

Interview by Quinton Hamilton
Portrait by Shaleah Williams

James Barber moved from Washington, D.C., to Connecticut in 1955 with his mother to start college. More than half a century later, he hasn't left. As a two-sport athlete at Southern Connecticut State College, Barber dominated on the offensive and defensive line on the football field, in the 120-yard-high hurdles, and in the 300- and 440-yard intermediate hurdles on the track.

Barber took his experience as an athlete and served on the coaching staff at Southern Connecticut State University for 43 years, coaching football from 1964-1976 and track and field from 1964-2007. He's in the SCSU Athletic Hall of Fame as a player and coach.

In his time at SCSU, Barber has advocated for inclusivity and equality, noticing a lack of diversity at the school. In 1971, he instituted SCSU's Summer Educational Opportunity Program, which aimed to increase the number of minority students at the school; a few years later he became the director of community and minority affairs, and in 1981, he was appointed to the position of director of affirmative action and equal opportunity employment. Today, he works as the director of community engagement for the school.

Quinton Hamilton *What was it like growing up as a Black person in Washington, D.C., when you did?*

James Barber [Laughs] I spent my formative years between Washington, D.C., and a rural town in Maryland, about 15 miles outside of Washington, and I'll tell you, back during those periods of time, it was a very segregated city even though it was the nation's capital. Students of color did not intermingle or go to school with white students. You had a whole different separate culture and a separate set of circumstances. Back in the early '40s you were still drinking from separate water fountains, you did not go to the same restaurants, you did not go to the same movies or any of those kinds of things.

So that was just normal for you. There was no sense of "different," right?

No, that was your everyday life. Public transportation in Washington was integrated, but if you took any public transportation that crossed over the boundaries of Washington going toward Virginia, then you had to be on the back of the bus.

Wow. So how did you and your family deal with that? Was there anything you thought you could do to kind of make a change, or was it just that's the way it was and you did it?

First of all, you're always looking to change. You're always looking to make a difference. But you also had to always be aware that, depending on where you were geographically, your life and welfare were always on the line. You did what you had to do to survive, you made what changes you could, and you realized that if you're in Washington or headed north that you had a lot more freedom to express yourself than if you were in Washington headed south. I mean, once you crossed over the 14th Street bridge into Virginia, it was a whole different world.

Being in the nation's capital, you would think America's supposed to be a "free country," but it sounds like that was one of the worst areas. What was that like, knowing America was supposed to be this great country but you were still having to deal with this?

The irony and the frustration is that you knew you were in the nation's capital. You read the Constitution; you knew what was supposed to happen. But you also knew that unless federal policies were changed—as they were in 1964 with the Civil Rights

Act—there were certain things that you were not going to be able to do. You ensured that your preparation for life was as comprehensive as it could possibly be, because you knew that as you moved forward into whatever career path you were going to take, you had to be even more prepared than individuals who were not individuals of color.

Exactly. That makes sense. So how did you get your start in sports? Was it the outlet you needed, or was it something you just picked up?

No, as a very young child I did not play organized sports at all. When I was in ninth grade, I began to play a little football with the neighborhood kids. My dad played football in high school; I just decided that was the thing to do. I just went out for the team and luckily I made the team, but that was kind of my introduction to organized sports.

Who were some of the major influences on your life who paved the way for how you live your life today?

The greatest influences during my formative years really were my grandmother, my mother, and then I had three older cousins who were like older brothers and sisters. So when I look back and realize just what a significant impact my grandmother had— you know, here's a lady who only had a formal sixth grade education for many, many years, but was an accomplished seamstress, a very talented poet. [She earned a college degree at age 75.] My mama was a domestic worker who had a ninth-grade formal education, but all of them were just so focused on education and getting as much out of our lives as we possibly could. There was not a community in which we lived that they didn't reach out and wrap their arms around other children and help them develop skills that they would not have had. Another thing that my grandmother, my mother, and my cousins stressed with me over and over was to never take a back seat to anybody.

How did you officially get into coaching? Is there a story behind that, or was it something you kind of just fell into?

I started coaching when I was 19. I pulled together I think it was 26 boys ages 9 to 15 in my neighborhood who had nothing to do. So I decided to pull all the boys together and start a baseball team. I never coached baseball before in my life. [Chuckles] Now, you've got to have something to work with, so I went down to a sporting goods store, and I bought two baseballs and a bat, and we'd practice. And it was funny because one of the Catholic high schools in the area allowed us to use their baseball field, but there was shrubbery and stuff around the baseball field. One of the priests at the church got interested in what I was doing with the kids, and he would come and park near the practice and watch. One day when I couldn't be at practice and the kids practiced on their own, he went to talk to the kids. I guess what they said really impressed him, so what he did was he came to talk to me and said he wanted to start a baseball league.

He helped organize a four-team league. He took my kids down to the sporting goods store and bought them warm-up jackets, and my catcher, he bought him an entire catcher's outfit, and we organized a team called the West Haven Junior Dodgers.

How did coaching at Southern come about? You had an amazing playing career, but how did you start coaching?

My senior year I had another year of eligibility. The football coach wanted me to play one more year. My life experiences said to me that I needed to get on with my career path. I said I could delay graduation for one more year, and during the summer I could step off the curb and get hit by a car and never play football again. Then here I am, without a degree, and not involved in sports. I said I'd be more than glad to come back as an assistant coach next year and contribute to the program, but I'm not going to delay graduating to stay another year, so he agreed.

"I came back to teach in 1969, and one of the things that I said to them is, 'Look, we need to get more students of color around the table, because if we don't have students around the table when decisions are being made, then nothing's gonna change.'"

You coached track too. How did you get into that?

The year I graduated, I started coaching track. As captain, I gave a lot of guidance to the sprinters and the hurdlers. As soon as football season was over, I was right into coaching.

In 1971 you launched the Summer Educational Program, which helped a large number of minority students. Could you explain where the idea for that impactful program came from?

When I graduated from Southern, I came back to coach. But when I was given an offer to come back and teach here in 1969, I had some pause.

Why was that?

There were only five students of color in my graduating class. I couldn't see the university really being at all aggressive about being intentional in changing what the landscape looked like. But I got a call from one of my mentors at Southern saying that there was going to be a position vacant, and he and the president of the university wanted to know if I would be interested in that position. I came back to teach in 1969, and one of the things that I said to them is, "Look, we need to get more students of color around the table, because if we don't have students around the table when decisions are being made, then nothing's gonna change." Part of that strategy was to get more students in the door. So I designed the Summer Education Opportunity Program and presented it to the cabinet and said, "I'm not saying that there's anything wrong with your admissions requirements, but I'm saying that there's something missing." One of the things that a hard copy cannot measure is motivation. ■

MYRTIS DIGHTMAN

Bull Rider, 86, Houston

Interview by Kristian Rhim
Portrait by Greg Noire

Nicknamed "the Jackie Robinson of Rodeo" in 1967 when he earned top ranking in the sport, **Myrtis Dightman** was the first Black bull rider with a shot at the world championship buckle. In 1967, he placed third in the Professional Rodeo Cowboys Association world standings. In 2016, he was inducted into both the ProRodeo Hall of Fame and the Bull Rider Hall of Fame.

Kristian Rhim *You were around 11 years old when Jackie Robinson broke the color barrier. What did seeing a Black man play in Major League Baseball mean to you?*

Myrtis Dightman It meant a whole lot. A lot of times, they say the "Blacks can't do that." Like me riding bulls. Back in that day there were no Blacks riding bulls. They thought all you could do was pick cotton and stuff like that, but I didn't want to be no cotton picker. I wanted to prove to the world that Blacks could ride bulls, and that's what I did.

Bull riding isn't a sport that you often hear encouraged in the Black community. How were you introduced to it?

I worked on a ranch, and I used to go up to the rodeos and watch. When I started out, I was a rodeo clown and I got to know a lot about bulls, you know, how to handle them. One day I said to myself, "Can I ride bulls?" So I got on two or three, a couple of folks helped me out, and I got to riding pretty good.

Did you ever feel isolated as a Black man in the sport?

No, all the white guys I rode with, they took a liking to me. They took me home with them and people tried to help me. I wasn't worried about what nobody had to say to me about nothing anyway—I worried about the bull.

Was there ever a time you were nervous to ride, or in your career generally?

Well, a lot of times I came up on a little hard luck, I needed some money, and I didn't think I was going to win. But I wanted the rodeo life, and I just had to work through it. The good Lord put everything in my favor. I had some good bulls, but there wasn't one I would get on that I couldn't ride, because I just figured I could do it.

Was there a moment in your life when you really felt like everything you were doing was correct?

I met a couple of Black people who wanted to ride, but they didn't have the nerve. Charlie Sampson was still in school when he saw me at a rodeo one day and said, "Mr. Dightman, I sure want to ride bulls." I says, "If you graduate, come back and I'll help you." When he was done with high school we traveled for about two years. We'd fly together, we'd catch the bus together, we'd drive together to whatever rodeo he wanted to go to, until I got him riding real good. It made me feel good just knowing somebody I was helping could do something. [In 1982, Sampson became the first African American to win the world championship in professional bull riding.]

There's a rich history of Black cowboy culture. How do you think bull riding could become more common in the Black community now?

I really don't know, because so many people are scared of bulls, and the most important thing is don't be scared of them—if you're scared, you already messed up. And most of these city slickers don't want to mess with bulls. They tell me, "I can't do it." But how do you know? You can't do it until you try. ■

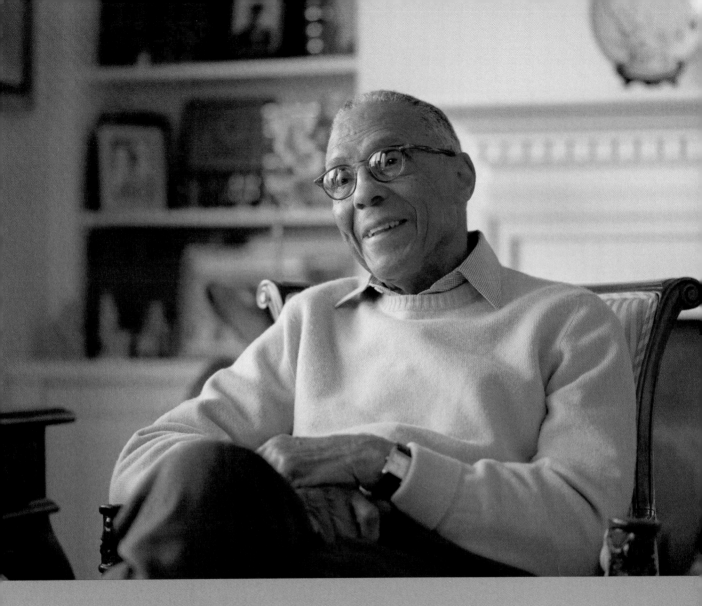

SKIP GRANT

Athletic Director, 86, Chevy Chase, Maryland

Interview by Kristian Rhim
Portrait by Nate Palmer

Skip Grant has mentored generations of young athletes on and off the field. For 23 years, he was director of what is now called the Skip Grant Program at the elite St. Alban's School in Washington, D.C., which helps guide students from underrepresented backgrounds to success. Alumni include Emmy and Tony winner Jeffrey Wright and Pro Football Hall of Famer Jonathan Ogden.

Kristian Rhim Brown v. Board of Education, *the Supreme Court decision eliminating the separate but equal doctrine for public schools, came down in 1954, after you were already out of school. Were the schools that you went to segregated?*

Skip Grant I lived in Washington, D.C., and it was a very segregated city. You couldn't go to certain restaurants. You couldn't go to certain movie theaters. All the schools I went to were segregated. And I must say, with great pride, I was taught by teachers of color who were outstanding. I didn't feel in any way deprived in terms of the way I was taught. The community was fully invested in education, and we were serious about that business. It was conveyed at home, it was conveyed at school, and it had a high priority in the development of the human being. There were cab drivers, domestic workers, schoolteachers, doctors, lawyers who, regardless of what their standing may be in terms of occupation and career, had the same value system. The idea of lifting up one another, doing things to respect each other—that coursed through the entire community. Yes, we were relegated to the margins, but that did not deter us from trying to be the best we could be.

Can you tell me how the Risk Program, now called the Skip Grant Program in your honor, began?

The program was started in 1968 by Canon Martin, who was the headmaster, and Brooks Johnson, the first Black teacher and coach at St. Albans. Brooks said to Canon Martin that we have a school here that is all basically 99 percent white—we're a Christian school, and we should be reaching out to the community and bringing in other people. So Canon Martin gave him that task, and Brooks said

it floored him, because that wasn't the answer he was expecting. I came in 1975 and took over that big responsibility, one that I cherish because of the interaction I had with the young men who were involved in the program. That was the year my son graduated, and it was probably better for both of us that he was graduating while I was coming in.

Do you think some of the young men in the program saw you as a father figure?

I think some of them did, yes. There were a good many boys who did not have a male presence at home to guide them. My mother and father divorced when I was 5 years old, and my grandmother and my mother basically were the people who raised me. However, I had the good fortune of having within my neighborhood extraordinary men that I observed. The Thompson family who lived next door to me had five children. Mr. Thompson used to take me to church with his family. A man named Alphonse Jones, who lived on our block, got a job for me as a messenger at the Smithsonian Institution. Mr. Jones had strong values about life, which he gave to me and other young men who were working in his presence, and I carry them with me to this day. There was another man named Reislin Henley who was one of the most extraordinary human beings I ever knew. He was the uncle of a dear friend of mine, and in the Second World War he was an officer in the Rangers. He was a well-educated man, and he was a great coach. Another man named Charles Sebree, who was a friend of our family, was a painter, and he introduced me to the arts and culture. So I had the benefit of being around men who had high ideals and values.

"**The idea of lifting up one another, doing things to respect each other—that coursed through the entire community. Yes, we were relegated to the margins, but that did not deter us from trying to be the best we could be.**"

Were there lessons you learned from those men that you specifically used in teaching the young men and boys in your program?

Yes, that a willingness to take on tough challenges is necessary to overcome adversity, particularly as a person of color. Whatever the challenge may be, it is always a little bit more difficult for folks of color. As a coach, I'd add intervals to workouts when athletes were tired, and they'd be amazed they were able to do it because they didn't think they had anything left. To me, the job of a coach or teacher is to be the person who says, "You're capable of doing even more than you think you can." I was always so impressed and inspired by their courage and resiliency. We built strength from each other.

You've lived through segregation, the civil rights movement of the '60s, the first Black president and vice president. How do all of your experiences shape the way you mentor?

Well, obviously there's lots of things that have improved in race relations, though we still have a long way to go. In 1963, I was there when Martin Luther King spoke at the March on Washington, but I still didn't ever think that we would have a Black president. People are still trying to figure out ways to keep Black people from voting, they're still trying to oppress them in other ways. It looks like we take two steps forward and one step backward. What I say to my children and other young people I am privileged to be around is that you have to create your own little microcosm of happiness; otherwise, you'll be stressed out all the time because it seems endless. Despite all sorts of oppression against us as a group, because of the resiliency, determination, and self-confidence that Black people have displayed, they have been able to forge a way for themselves. They will not be ignored, and they have made the country live up to its Constitution more than any other group of people.

In 85 years on the planet, what is the most important thing that you've learned?

I have a little motto: You have to earn the right to eat. There are probably a billion people in the world who work from the time they get up in the morning to the time they go to bed at night trying to figure out what they're going to do to keep a roof over their head and get something to eat and to survive, and many of those people have earned the right to eat but don't have the basic things that we take for granted. So, my feeling is that every day I should do something worthwhile, something that is of value to somebody else other than myself, something to improve myself in order to earn the right to eat and to earn the privileges that I have.

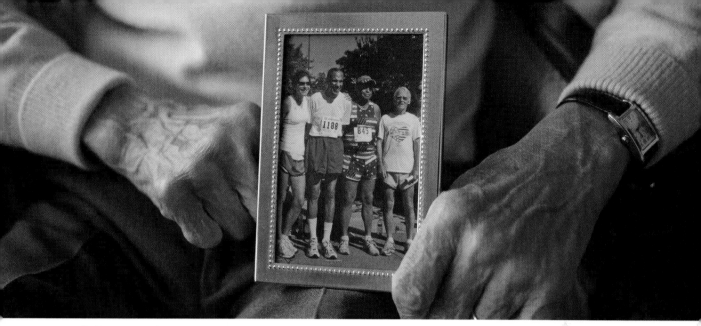

Grant holds an image from a 5K fundraiser autism in Potomac, Maryland, several years ago; he finished first in the 80-84 age group.

Was there a defining moment in your life?

Yes, when I met my wife. I'll be married 66 years come June. And when I had a child of my own things really got serious to me, because everything that evolved after that took on a seriousness and an importance that I had never experienced before.

How do you stay married – and connected – for 66 years?

You have to be very honest about marriage. You have to really sit down and look at the person that you're going to choose, and they have to look at you, and you have to be honest in your assessment of each other. My grandson had his lady friend for four years and he thought it was time that they married, so I said, "I'll give you a simple task. Get a big piece of paper, write down positives on one side and the things that you find negative on the other side. The positives should outweigh the negatives by far. Nobody's going to have all of the qualities that you're looking for, and you're not going to be satisfied with that person all the time, but there have to be enough positive things about that person that

those negative things won't be factors in eroding your marriage." My wife is my friend and the person I love more than anything in the world. If I had nothing, no material wealth, nothing, if I had my wife, that would be enough.

Is there anything we didn't touch on that you want to add?

Well, there is one thing that I would urge you to do. Keep yourself mentally and physically fit all your life. After talking with you, I'm going walking. I do weight work a couple times a week, and I've never done it where I didn't feel better after than before I did it. It keeps you fit. It makes you sharper mentally. God has given you a good body, an athletic body. That's a gift. Don't squander your mental or physical gifts. And don't get this idea in your mind that when you get a certain age you can't do those things. You do them until you fall out. As I said to my children, when I can't run anymore, I'll walk. If I can't walk anymore I'll try to crawl, but I'm not going to just roll over. You get one body. Use it wisely, and you'll fare very well. ■

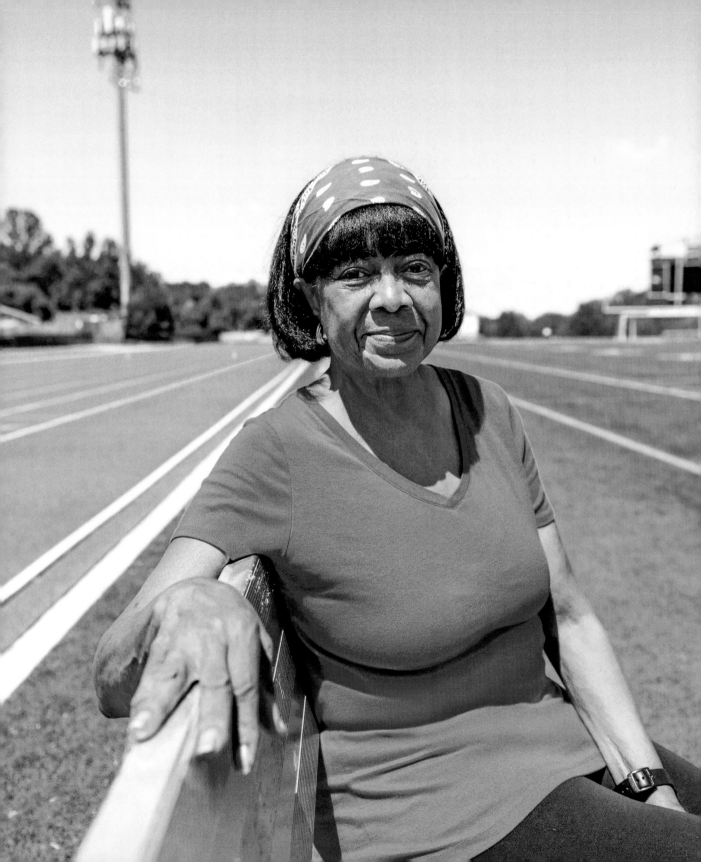

LILLIAN GREENE-CHAMBERLAIN

Olympic Runner, Educator, 81, Silver Spring, Maryland

Interview by Elizabeth Okosun
Portrait by Erin Douglas

When **Lillian Greene-Chamberlain** was a child growing up in Harlem in the late 1940s and early '50s, she was told she shouldn't compete in sports: "You can't do that; you can't play that; you might get hurt." She pushed past the opinions of naysayers and went on to become the first U.S. national champion in the 440-yard run, as well as the first African American woman to represent the United States in 400-meter and 800-meter races in international competition. Greene-Chamberlain, who later served as the first director of the physical education and sports program for the United Nations Educational, Scientific, and Cultural Organization (UNESCO), speaks fondly of her time breaking barriers alongside other female athletes. "We didn't have role models," she says. "We were our own role models. We stepped over hurdles. We supported each other, and we were fearless."

Elizabeth Okosun *Can you tell me a little bit about your childhood?*

Lillian Greene-Chamberlain My journey began at 8 years old when a New York City patrolman discovered me racing and beating the boys in my elementary schoolyard. He enrolled me in the Harlem Police Athletic League, and by the time I was 12, I received the PAL's Athlete of the Year award for participation in track and field, basketball, and softball.

What was it that made you choose track and field above the other sports?

Track was my opportunity to see the world, that's how I saw it. It was a sport where I could travel. Ice skating was more recreational. With basketball, you had to depend on various tournaments. Track and field was universal. There were many more opportunities to participate. In basketball, you're a

guard; you're a forward. In track, I could run, long jump, high jump, put the shot, throw the discus. And it was an opportunity to see the world, and to interact with people who were a lot different from you. I traveled all over the world: Russia, Poland, Hungary, Greece.

Those are very white countries you were going to in the '50s and '60s. How did they react to seeing a Black woman competing on their level?

They say the sun never sets on the British Empire, so in Great Britain, whether it's countries in Africa or the Caribbean, they were used to seeing people of color. But in Russia, Poland, and Hungary, I was an anomaly. I did my research and my homework. I asked questions, I read books. I learned Russian phrases phonetically to be able to communicate with the Soviet athletes and citizens. The athletes, both male and female, sought me out to communicate and seemed genuinely interested in the warm,

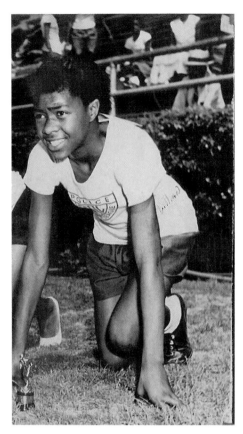

Greene at the 1952 New York City Police Athletics League Championships.

friendly way our integrated U.S. team worked out together. People stopped me to speak, touch my hair and skin, were shocked that I could speak their language, and left all kinds of gifts and souvenirs for me at our hotel.

What are some of the things that go through your mind as you're running?

I'm thinking about the state of the nation. I can't solve the problems when I'm running, but I can determine the way I allow them to affect me. I don't run with headphones on because I want to have a clear mind, since I plan when I'm running. In Paris, I used to love to do that every day. I like to run in the open air, where there's plants and clean air.

After competing in Europe, you attended Colorado State University. How did you end up there?

Although I had just made the U.S. team that competed in Russia, Poland, Hungary, and Greece, we were back in the United States the next year for the 1959 Pan American Games, which were held in Chicago. I won the exhibition 400-meter event, and I set an American record. A Colorado State University official was at the meet. She asked me if I would consider transferring to CSU to assist in establishing the first intercollegiate track team in the school's history. I realized that I would have to find a way to pay for my tuition by working on campus, because CSU didn't offer athletic scholarships to women. I said, "I'll come if you do two things. I want to learn how to ski, and if you get me a horse, I want to learn how to ride." And they agreed.

Why those two things, skiing and getting a horse?

In Harlem, where do you learn to ski? In Harlem, where would I ever get to ride a horse? I wanted that experience. Colorado? That's horse country. Skiing? Aspen, Colorado.

How did it feel knowing that you were so instrumental in starting their first-ever women's track and field team, but they wouldn't give you a scholarship?

It's not that they wouldn't give it to me. When I arrived at CSU, there were only two colleges in the United States that offered track and field scholarships to females: Tuskegee University in Alabama and Tennessee State University in Nashville. Women's athletics at CSU were primarily intramural rather than intercollegiate. So I worked in my dorm's cafeteria to support my education. In 1962 I was placed on the dean's list, and I earned the first athletic scholarship for a female athlete in CSU's history. And the Lillian Greene Scholarship Fund was established with the assistance of the *Denver Post*, a group of sororities, and individual donors.

I graduated in 1963 with a bachelor of science degree in exercise and sport science. In 1993, I was inducted into the CSU Sports Hall of Fame. I returned to deliver the commencement address to doctoral and master's degree graduates in 1994, and I talked to them about the world that doesn't include you or doesn't see you. I wanted them to see that I looked beyond the obvious stumbling blocks in my way because I didn't see them as stumbling blocks: They were stepping stones. Those were hurdles that I just flew over.

Nowadays it's the norm for athletes to receive scholarships while they attend college. There are people saying that college athletes deserve to get paid. What are your thoughts on that?

Many 17-year-olds can't even manage $5. Give a 17-year-old $5,000 and see what they do with it. Before you just roll out the money, there has to be a coherent plan so that you're not just spoiling young people. But we also have to make the schools responsible and ensure that they're being fair to the young people.

You were the UNESCO director of physical education and sports for ten years. What kinds of things did you implement during your time there?

I built schools, I trained teachers, I wrote curriculums for governments. I was responsible for the conception, planning, development, and implementation of all projects, programs, and activities related to physical education and sport in the 161 UNESCO member nations throughout the world.

Did you ever meet with resistance when you were sent to help in these countries?

Oh, yes. And that's where you don't dictate; you have to understand. If I'm in China, I can't impose America's values, customs, and norms. It's important

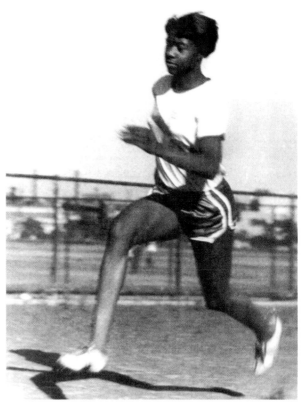

Greene at a competition in 1963.

to understand the politics, norms, and religion of the country, in terms of setting up the program, knowing if people are comfortable, and how cultural elements interact with what will be allowed. My decade-long tenure was notable for the challenges I faced in carrying out my duties as a female working in a predominantly all-male bastion.

What was the most life-changing thing you did for the people you served?

I can't say one in particular, but I would say getting to open the eyes of the elders, because it's difficult to effect change in customs and culture. I came into this world with an assignment, and I can't see a problem that I won't try to remedy.

"

Don't be afraid to be the first one to try to accomplish something. When you are the first to achieve something, you can't really make a mistake, because no one has done it before.

You said you came into this world with an assignment. What do you think that assignment is?

My assignment is to give, to be kind, to assist, be considerate, helpful, respectful, gracious, patient, and generous.

Do you think you've completed your assignment to the best of your ability?

My assignment stops when I stop breathing. My assignment has been so multifaceted, with so many aspects that I never imagined. Living in Paris and working for the United Nations for a decade, being of service to so many different cultures—do you know how fortunate I am? When you receive that kind of blessing, you have to share. And the more I share, the more I receive.

What are three pieces of advice that you would give Black female athletes trying to make a way in their chosen sport?

Just because a door is closed today, don't assume it'll be closed tomorrow. Be strong and push it open. Don't cut corners. Also, you have to prepare for when the cheering stops.

What about for young Black people in general who need advice for the future?

Don't be afraid to embrace this rapidly changing world. Be courageous, creative, and steadfast in pursuit of solutions to the enormous issues that you will be facing. Don't be afraid to ask questions. It's all right to stand out from the crowd; that could be a good thing, if it's a good thing that you're doing. Find a deeper connection with people who have been successful. Pay attention to details. Be reliable. Do not lose your sense of curiosity. Test your limits. Keep an open mind. Be of service to your community and strive to give something back to society. Participating in sports gave me confidence, self-esteem, and a sense of empowerment that I could be successful in anything that I attempted, through realistic goal setting, hard work, persistence, and courage. It prepared me for the serious competition of life, and I used the lessons I learned as tools to succeed in progressing from the classroom to the locker room to the boardroom. ■

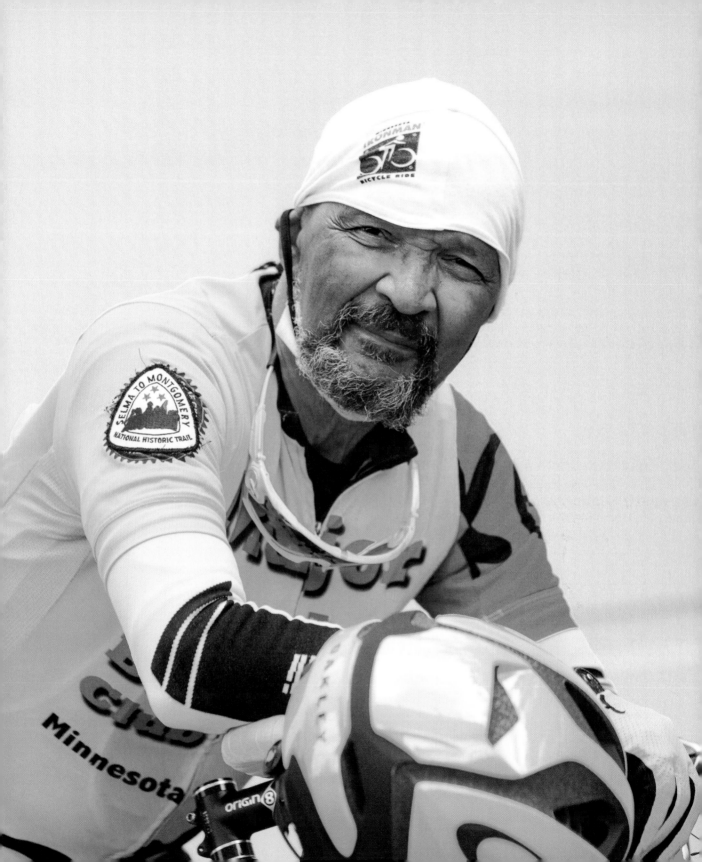

LOUIS MOORE
Cyclist, 81, Minneapolis

Interview by Jada Jackson
Portrait by Nancy Musinguzi

Minneapolis is a utopia of cycling lanes, rail trails, and bike shares. It is also, of course, the city where George Floyd was murdered on May 25, 2020, sparking a nationwide reckoning with racism. Longtime bike advocate **Louis Moore** is intimately familiar with both sides of the city as well as where and how they intersect. He is a champion of the city's cycling infrastructure and one of the founders of the Major Taylor Bicycling Club of Minnesota, an organization dedicated to promoting bicycle use in the Black communities of Minneapolis and St. Paul.

Jada Jackson *How have you infused cycling with activism over the years you've been in the sport?*

Louis Moore Well, I'll start out by saying my house is located six blocks from the corner where George Floyd was killed. After the killing, we did a ride and came back through the memorial and took a picture that we distributed nationwide through Facebook to let people know that Major Taylor is in full support of justice for George Floyd.

That is an intersection that I had been going through for 50 years, and would go through every Wednesday or Saturday for a club ride. To have that happen in the community that I live in and not be able to even go through that area afterward was very difficult for me. [The intersection was for a time blocked off with memorials.]

We're doing what we can to educate people about what happened and about what's going on there now, and we'll continue to do that, but we want to make sure people understand that this was a tragic situation that should have never happened and is not a true reflection of Minneapolis.

As a Black cyclist, do you feel like you've been racially profiled?

Yeah, it's definitely an issue. The first year that we were cycling as a club, we had some loud, screaming-yellow jerseys, which we deliberately got because we wanted to make sure everybody saw us. We were riding down one of the main thoroughfares here, Park Avenue. We stopped at a light, and one of Minneapolis's finest rode up alongside of us. He rolled down the window and said, "What is this?"

I said, "This is the Major Taylor Bicycling Club."

He looked for about 30 seconds. Then he said, "Well, that's a different kind of gang," and rolled up the window. The light changed, and he and the other officer in the car started laughing and drove off.

So we already had a pretty good idea of what people thought of us. If the police thought of us in that way, what do you think other people were thinking?

When I was doing some bike racing in the 1980s and early '90s, I did a one-day race across Minne-

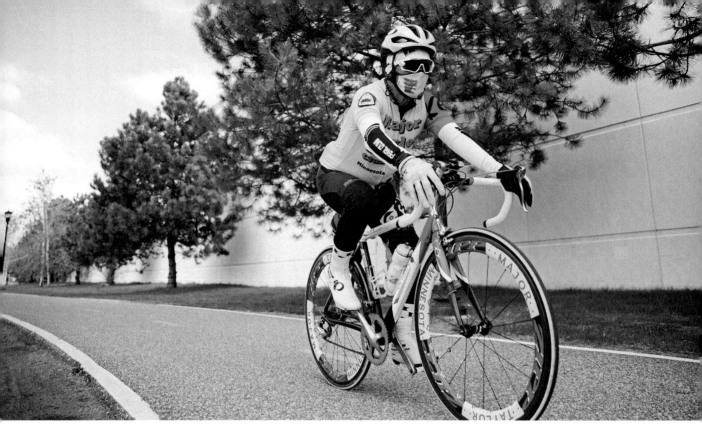

sota—120 or 130 miles. There were two of us Black cyclists riding together, and I remember passing a group of guys, and one looked over and said, "Wow, I've never seen you guys out here on bikes before. I thought you guys just played rap music and basketball." And I said, "No, we ride bicycles, too," and we just rode away from them. That gave me my first impression of rural Minnesota's bicycling community—it was lily white. They had never seen anybody of color until they saw the two of us out there that day, literally.

How has your club served as a connection point?

When we started the bike club, it was predominantly African American. We did that deliberately because we were trying to get people active and get them involved. But the club has attracted Caucasian people over the years, as well. In fact, we have quite a few in the club now, and I think that probably was a great connection with the community.

A lot of folks in Minnesota consider themselves liberal, consider themselves accepting, consider themselves to be people who, quote-unquote, aren't prejudiced—although they probably don't even know they are. Our white members have had an opportunity to spend time with others, to socialize, to do a lot of things, and I think that connection has not just made the bike club successful but enhanced our reputation throughout the whole metropolitan area.

What are some of the barriers that you see young Black cyclists facing?

The biggest barrier is the purchase of a road bike—being able to get a bike that's efficient but affordable.

The other part is really changing your mindset. A lot of Black folks never got involved in a sport like this because it's very physically taxing. You have to put out a lot of strength and energy, a lot of watts, when you ride. It's a sport that keeps you in shape, and convincing people of the benefits of that is difficult.

It's hard sometimes to convince them that they could really be good at this, starting at a young age. There's been a lot of success nationwide with Black cyclists, like Rahsaan Bahati out in California, who started racing on the track when he was 11 and now is one of the premier bike racers in the country. The Williams brothers, who were part of Major Taylor in L.A., are the same situation—they started as youngsters, and they've all made careers out of it.

What advice would you give to young Black people?

The first thing I would say is get an education. In today's society, you're dealing with all these high-tech jobs, and you have to understand those systems, you have to understand how they work, you have to understand how to be a part of them.

The other part is, I think it's important for them to understand that the things that they do, whether they're on the job or whether they're on the street, reflect on the community as a whole, and that is important. We're always going to be—I'm not going to say second-class, but we're all always going to be looked down upon.

Take a look at the political system during the years of the Trump presidency. You look at the amount of folks that voted for him, 74 million this last election, and you know that white America has a long way to go to understand what's going on in the Black community and what's going on with Black folks. It's extremely important that they do, and I think because of the Floyd issue that has come to light. I mean, I am just overwhelmed by the worldwide response to what happened to George Floyd.

What are some of the things you're working on right now?

In the club, we have noticed a large influx of African American women. We have six or seven members in our club. There's a lot of ladies in the African American community who are beginning to love cycling. I had the privilege of going to Selma, Alabama, in February 2020 for the ride from Selma to Montgomery. We celebrated the civil rights march that Martin Luther King led. So I had an opportunity to ride with a lot of Black female cyclists, and it's great to see that they ride, that they are physically fit, and that they are enthusiastic about doing it.

"

I've been in this house since 1965. When I moved into this community, it was a coveted community, which means that there were contracts out with the neighbors that said, 'Do not sell your house to anybody but white people.' I was the first Black person to move onto this block. I don't need to tell you it was two or three years before anybody ever talked to me."

How has Major Taylor inspired you?

His story is quite interesting because of when he raced—the late 1800s. He was the only Black racer on the circuit, and he would spend most of his time staying out front to avoid the white riders in the rear who were constantly trying to knock him off his bike, fence him in, run him into the rail—whatever they had to do to get rid of him. Out of 168 races, this man won 117. That's a very high percentage of wins in bike racing, but he had to do that in order to defend himself. He became world champion in 1899. I think that's an inspiration to anybody who's in the Black community.

When we got together to form the club, I brought up the story, and within two minutes, one of the ladies stopped me and said, "That's going to be the name of the club, period." Now, what we didn't know was there were another six to eight Major Taylor clubs in the country already. As the next few years went by, we all began to connect and decided we were going to do some events together. Today there are probably close to 70 Major Taylor clubs in the country. In the past five years, we've had just an explosion of interest in the Black community in cycling and an explosion in the community regarding the history of Major Taylor, so these clubs have just grown immensely.

What do you want your legacy to be?

The importance of physical fitness. At 80 years old, I can still ride 21, 22, 23 miles an hour on a bike. To know that I have the physical fitness to be able to do that, it means that I'm taking care of myself the way I should. And that's what we try to impress upon other people—to take care of yourself. Our community has just been decimated by diabetes, folks overweight, heart disease, sickle cell, all kinds of things, and if you're willing to take care of yourself physically, you can keep a lot of that at bay.

I think I already have kind of a legacy in the community for cycling just because I was probably the first. You know, when I was out riding 20 years ago, 25 years ago in Minneapolis, people were still astonished to see a person of color doing this sport, and I would talk to them often, and I would try to educate them as best I could. I feel good about that. ∎

ROBBY ROBINSON

Bodybuilder, 75, Venice Beach, California

Interview by Kristian Rhim
Photographs by Erik Carter

When **Robby Robinson** started bodybuilding at Venice Beach's Gold's Gym in 1975, he remembers being told that "Blacks don't get contracts" to compete. He was harassed at competitions and struggled with steroids and sickle cell anemia. Despite many wins, Robinson never captured the International Federation of Bodybuilding and Fitness's overall title, Mr. Olympia. After he complained about mistreatment, the IFBB suspended him, and he moved overseas to compete. He would eventually return to the United States in 1994, winning the first ever Mr. Olympia Masters, for athletes over 50, en route to three such titles. At age 75, Robinson is still an active bodybuilder.

MAKING THE LEAP

I went to what was basically an all-Black high school in Tallahassee, Florida, so I really didn't encounter that much racism. I lived in the swamps. Because everybody was poor, Blacks and whites, it didn't look like I was any better than you. The blacks and whites, they ate together, slept together, talked together, sat together, died together. So I didn't really get the blunt force of it, I guess, until I left the swamps. I never heard the word n-----until I came to California in '75. When I left the swamps, I realized, "Wow, life is gonna be hard out there." That's how I dealt with it.

BLOCKING OUT BIAS

I was doing well because I had a great body. I mean, that's just the hardcore facts. I had a great physique; I had a good, tough mindset. So I just didn't listen to all the negs. I think when you get caught up in the negs and just keep listening to it, it drains your ability to do whatever you want to do that's positive. I just didn't pay any attention to it.

BATTLING OTHER DEMONS

My first encounter with steroids was about two weeks before Mr. World [in 1979]. I remember taking a shot, walking home, collapsing in the door. My lady friend dragged me into the house. I collapsed because of the fact that when you take steroids, there can be blood-pressure issues. And for a person who has sickle cell, like I do, that's just not good. So I was getting no oxygen to the brain, no oxygen to the heart; I was probably going into a cardiac arrest. She was able to drag me to the bathtub and put cold water on me. Now, you might not believe it, but that saved my life. I went to New York and won Mr. World two weeks later, and I'm thinking, "This is madness!" I think back on it quite a bit. I look at it, and I say to myself, "You're lucky to be here. You're lucky to be alive."

COMING TO TERMS WITH STEROIDS

I thought to myself, "Never gonna do that again." And what I started doing was going to a doctor to help me monitor my body and my blood as I was going toward competitions. And then throughout my

"Racism can't stop you from chasing your dream. If you stop, you made that decision to stop."

career, I used it for eight weeks only. And I always used low dosages. And worked harder. But I did use it throughout my bodybuilding career, 27 years, on and off. And I can say I came out of it healthy, no health issues. I still go to the VA hospital every six months to get my blood work taken, check to make sure everything in my body is working right. And I don't think today's bodybuilders do that; they just take it gangster. All the kids, I go online and 90 percent of the guys want to know what drug program I can sell them. It doesn't make sense to me. Because to me it's more about health. That's what they should be really focusing on: trying to get their body healthy first, and then finding out through blood work whether steroids will work or it won't.

EXPERIENCING INJUSTICE

When I came to Los Angeles in 1975 from Florida, I was denied a professional contract. By the '80s, I'd moved to Europe, and I was based there basically my whole career, almost 13 years. Over there, I was treated completely differently. Nobody ever asked me for a passport, my identification. I never encoun-tered police saying anything to me. I was able to work and do exhibitions. I made enough money to buy a little home in Holland. So I think, something good, something bad—that's just how life is. It's not perfect; it doesn't make you any promises. You have to go in there and make life, whatever life you want, all on your own. Nobody's gonna give it to you. It inspired me, bro. I just kept working.

STAGING A COMEBACK

I came back in 1994 for the Masters Mr. Olympia. I was standing onstage and they announced, "The first Masters Mr. Olympia winner 1994, Robby Robinson." I remember all the obscenities I was called. I remember hearing all the fans—everybody booed. After the judging, after the show was over, they normally have a big banquet, and that night there was no banquet, there was no party, there was nothing. That hit me hard. And you're talking the auditorium is packed, thousands of people screaming and yelling, you know, for Lou [Ferrigno]. But when the judge said, "The first Masters Mr. Olympia is Robby Robinson," everybody let out boos.

BECOMING MORE VOCAL

You can't break me down mentally; the only person who can break me down is myself. And I just never listened to the negatives, I just kept working. You're not supposed to lie down and die. You're supposed to get up and fight. Use all the resources that you have, your mind, your body, your spirit, your soul, your vision, your dream. For the Masters Mr. Olympia, I knew that if I could go in there and get myself in great shape, that whatever competitors—whatever racism, discrimination was there—I thought my physique could take it down, and it did. I made it through all of that, and I just felt that you got to say something. [In the early '80s] I was suspended because of the fact I'd spoken out about "Hey, you know, listen, there's really no money here; people don't really care about you. If you don't care about yourself, you're not gonna make it."

STAYING READY FOR WHATEVER

You have your wishes and dreams, like to go to Hollywood and be welcomed into that world, like Arnold with Conan and Lou with the Hulk. I thought it would be a great thing to do. But naaah, they weren't ready for that. You know, out there in that world at that point in time, those doors were just not open. Today I'm in the process of doing a documentary on my life. I don't really have the desire to be a movie star now. But if someone came along and said, "Hey, listen, run over there and jump over that wall and fire your machine gun," I'd give it a try. ∎

HERMAN WILLIAMS

Basketball Coach, 76, Carbondale, Illinois

Interview by Allana Haynes
Portrait by Joe Martinez

Herman Williams grew up in Birmingham, Alabama, and was a star athlete. In 1969 he coached the first all-Black high school to the state championship in basketball. He later went on to help recruit Charles Barkley to play at Auburn University."I've gone through a lot, coming up in Alabama," he says. "The 16th Street Baptist Church, those sisters who were killed. I've been at football games where the police would have German shepherds they would turn loose. That's the way it was then."

Allana Haynes *When did you know you wanted to be a coach?*

Herman Williams I went to Parker High School in Birmingham. At that time it was one of the largest Black high schools in Alabama, and probably the United States. I had a great mom and dad, but I also had one of the best coaches in the world, Coach Brown. That's the reason I wanted to be a coach. There was so much trust between him and my teammates.

Did you have a big family?

I had two brothers and two sisters, and we all attended high school at Parker. I was lucky enough to get a football scholarship to Dillard University down in New Orleans, and after I finished Dillard, I went back to Birmingham. My oldest sister, she finished Miles College and taught in Birmingham for a while before moving to Los Angeles. The youngest sister, she finished Miles College and taught 30 years in Birmingham, and the brothers, one brother finished Miles also, and he ended up in Los Angeles working as a probation officer. And the other brother, he worked at Chrysler in Detroit, but me, I was always interested in sports, and that's where I got my break, and I loved it and I enjoyed it until I got out of it.

What else do you remember about Parker?

I went to high school with people like Angela Davis. She was right ahead of me. Her brother and I were in the same class. You're talking about real people when you talk about that time, where I grew up—

people who wanted to succeed. You have to start with an understanding of what we came up through. It was a lot different. The parents that we had and the lessons that we were taught—it was tough times, and you had to believe in what you were doing. You had to believe in your instructors, and you had to believe in your community.

Looking back now, are there any lessons that you wish you'd learned sooner?

Well, I think I learned all of it at the right time.

What's one of the greatest moments in history that you've lived through?

A Black president, number one.

But I guess it's the times that I spent when I was in Alabama coaching. I came through the times of, "Hey, you can't do this, you can't do that." Integration took place when I was coaching high school, and I was lucky enough to coach the first Black high school to a state championship in basketball. It was the first year they had a state tournament with all schools involved. And we did win it all. That was 1969, and then again in 1971.

We played all-Black and all-white schools. Our school was all-Black, but we played a team at the championship that had Black and white players. You had a few fights before the game, after the game, during the game—the same thing that happens today—but they were controlled eventually. You had problems then, you still have problems today.

"I went to high school with people like Angela Davis. She was right ahead of me. Her brother and I were in the same class. You're talking about real people when you talk about that time."

To win any time is great, but to win it all with the students that you have, the athletes that we had—you're very proud of them. A lot came out of that for me, and for some of my players. The first Black player to get a scholarship to the University of Alabama played on that high school team. The first Black kid to get a scholarship to the University of Alabama—that was a big thing. Wendell Hudson. He made all-everything in the SEC.

Amazing. After success like that, what next?

I was lucky enough to coach at Auburn University. The first year I went there, the coach that I went with, he was killed in a hotel fire. His name was Paul Lambert. The first two weeks we were working at a basketball clinic in Columbus, Georgia, and the hotel fire happened, and of all the people who were there, he was the only one killed. Smoke inhalation got him. He was a great man and a great coach.

I stayed at Auburn three more years, and luckily enough I was there when we recruited Charles Barkley. I was from Alabama, and Barkley was from Leeds, Alabama, and one thing led to another.

What do people my age not necessarily understand about those times?

I had to walk to school, and the white kids got bused. People should know, or should want to know, about those times. Those were trying and difficult times. The busing, you know? That's when the Black schools played football games on Monday nights. The white schools played on the weekends, Friday nights and Saturday. But during the off-season, some of the best games that we had were when the white players and the Black players would get together and play each other down at the park, against other football players at other high schools. And then on Mondays and Tuesdays, we were passing each other going to school—us walking, them on buses.

Though times have changed, do you see slivers of the world you knew growing up?

Yes, I do. A lot of it's still there. The racism—it's still there. Today people are angry. Just reading the newspaper and seeing the things you see on TV, things happening. The George Floyd situation, the Arbery kid in Georgia, and all the things that happen and the way it comes out. Police brutality. There's still racism going on in the country. And we're just tired. Some people are tired of it. We're tired of it, but it's still there. We have better opportunities today, but people are still trying to keep you down.

What advice would you give to young people as they're trying to navigate the world?

Well, as long as you can tell me the truth, we're going to continue to talk and get things done. Once you think you got to lie to me, don't tell me anything. Just don't say nothing. ∎

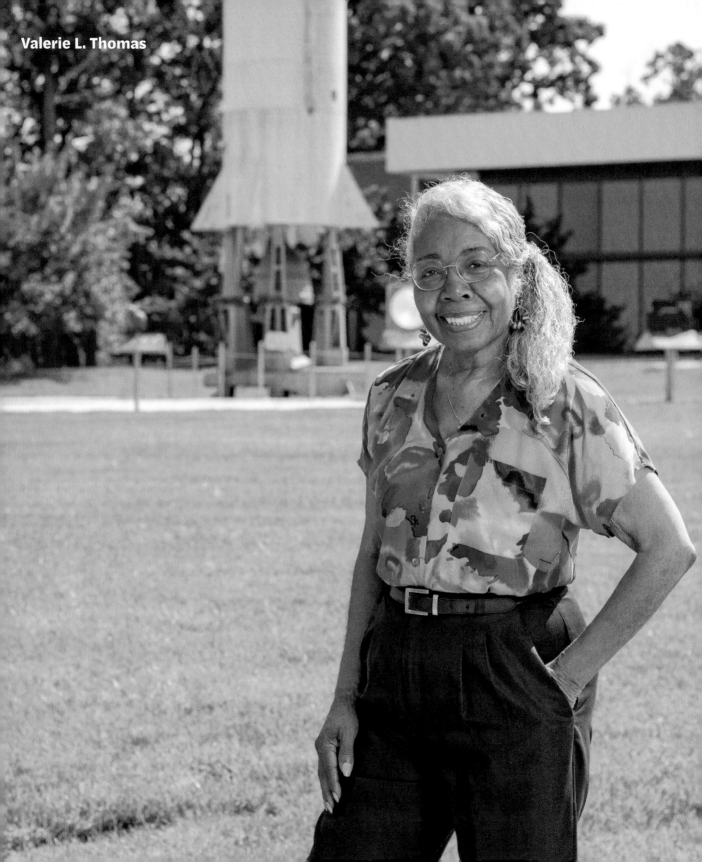
Valerie L. Thomas

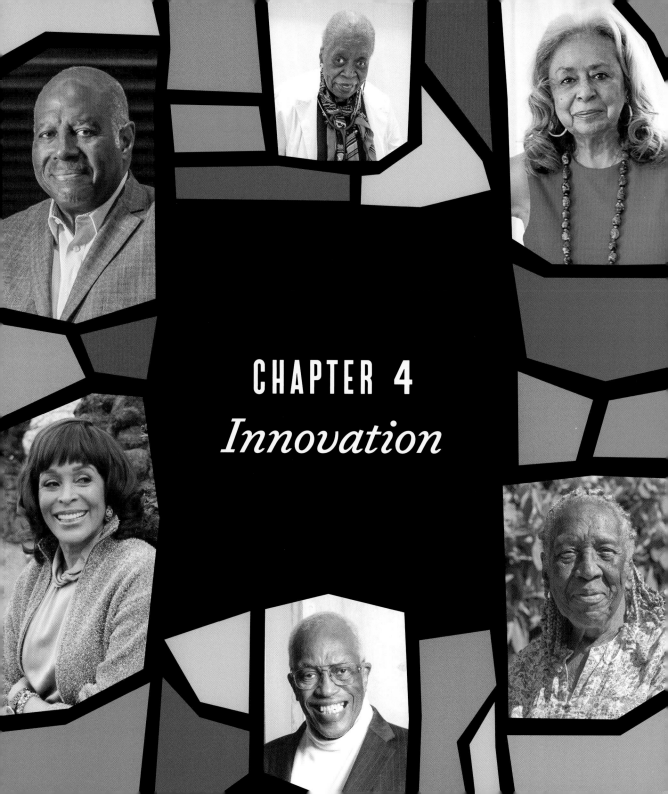

CHAPTER 4
Innovation

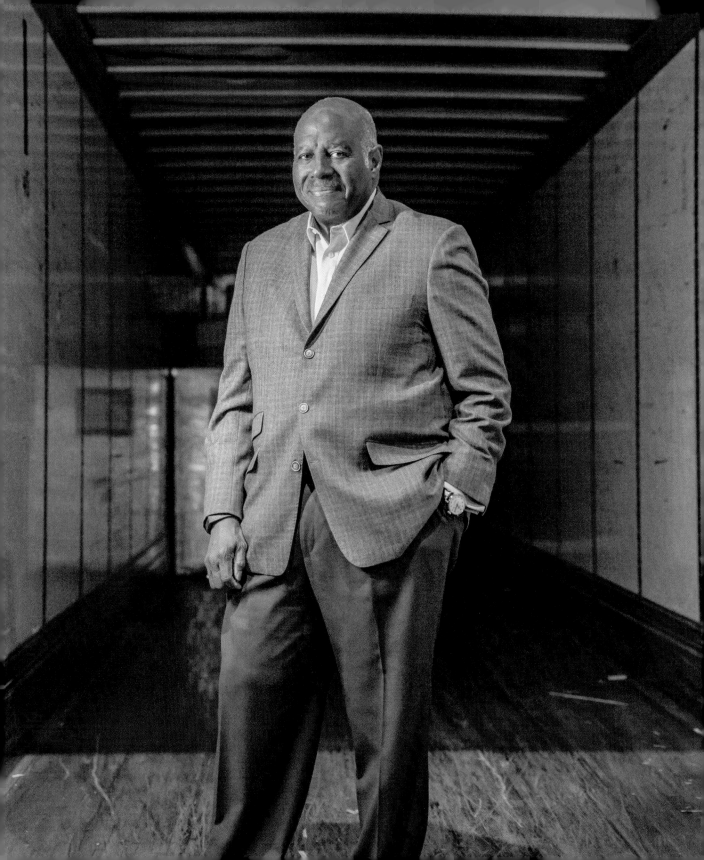

JOSEPH ANDERSON

CEO, Army Veteran, 79, Detroit

Interview by De'Aundre Barnes
Portrait by Valaurian Waller

A graduate of West Point, **Joseph Anderson** was awarded two Silver Stars, five Bronze Stars, three Army Commendation Medals, and 11 Air Medals during his military service in Vietnam. He went on to a successful career as an executive at General Motors before launching what became one of the largest holding companies in the automotive industry, TAG Holdings, which he continues to run as CEO.

De'Aundre Barnes *You were accepted into one of the most prestigious military academies in the country. When you saw that acceptance letter to West Point, how were you feeling?*

Joseph Anderson Well, I'd like to correct you. It's the most prestigious military academy in the United States, much more than the Naval Academy and Air Force [laughs]. I just want to make that clear on the record, De'Aundre.

Sorry about that!

I thought I was going to go to the University of Kansas for engineering. I participated in an American Legion program called Boys State, and while I went to Boys State I got selected for Boys Nation. And when I came back from Boys Nation in Washington, D.C., West Point sent me a postcard saying, congratulations on this honor, and you're the kind of young man that we'd like to have come to West Point. They sent me the requirements for application, and I did that. The senator from Kansas selected a principal person and then a first alternate, and I was a second alternate. And somehow the principal and first alternate didn't make it, so when I

got a call from the academy in June saying, "If you're still interested, show up in July," I was very excited. Part of it is, it was going to be a great educational experience, and, secondly, it was not going to be a financial burden on my family, my parents and so forth. But to be quite honest, I did not have any background or understanding or appreciation for the military, as is often the case with young men coming into the academies. But you learn very quickly, and it worked for me.

Did you always know that you wanted to serve your country, or did you have another plan for your life?

I had another plan. As I said, I thought I'd go into engineering. Now, did I know any Negro—at that time "Negro"—or African American or Black engineers? No, I didn't. But with the good grades I had I thought that would be the appropriate experience for me, so I anticipated doing that. I had an older brother, a lot older than me, who had been in Korea, and what I knew about him and Korea was he brought back these beautiful jackets with dragons on the back. And so that's all I understood about the military.

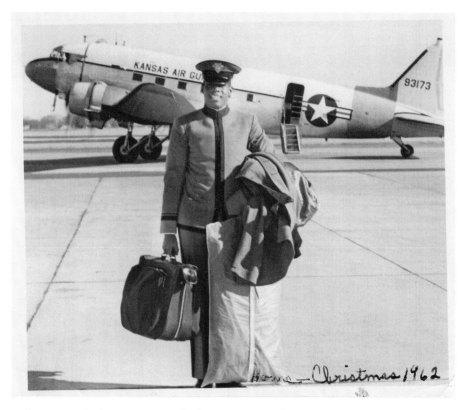

KANSAS AIR GU[...]

93173

Home—Christmas 1962

Anderson returning home to Kansas after being transported by the Kansas Air National Guard for Christmas break in 1962, during his sophomore year at West Point.

You're a highly decorated man. What was going through your mind when you received your first medal of honor?

Well, when I received my Silver Star for my first big combat operation, I had been there a very short time, and I just did what I needed to do to support and protect my soldiers, my platoon. You're not thinking about a medal at that time; you're thinking about coming out of it alive. And so, when I got back to base camp and was rewarded for that particular event, I was pleased—I was honored with the honor—but it was not something that you're there to do or gain or benefit from. You're there just to lead your platoon and get your folks home alive.

In 1966, the documentary The Anderson Platoon *was released to show what it was like during the Vietnam War. What persuaded you to participate in the documentary, and what did you want the outcome to be once it was released?*

In the Army, things are just given to you or directed toward you, De'Aundre. Coming back from that first event, where I had received the Silver Star, I had a lot of visibility and a high profile. So when this documentary crew from France came to my organization, the 1st Cavalry Division, and my brigade, they assigned them to me. I was an African American, I was a West Pointer, I had taken French in college at West Point, so they assigned them to me. I didn't ask for them. And quite frankly, I had

some reservations about them in that I didn't know who these three people were that were on this film crew. And I didn't know what they would do out in the field, maybe cause trouble and get us into difficulty, making noise at the wrong time or something. That turned out to be absolutely not the case, and they became lifelong friends. In fact, I visited Pierre Schoendoerffer, the producer, in France. So it was a great experience, but again, not one that I had any choice about. They said, "Lieutenant, these men are going to be assigned to your platoon." And that's the way the Army operates.

As it turned out, they were world travelers and had done a variety of things in difficult circumstances. Pierre himself had been captured and was a prisoner of war with the French Army in Vietnam, so he knew the country, knew the circumstances very well. He and his cameraman and sound man came to see what the Americans were doing in Vietnam, to carry that back to the French, who had been there earlier. But he did such a great job that the film just took the country by storm in France.

He showed it on French television in the first part of 1967. It was so well received it showed again three weeks later. CBS heard about it, brought him to New York to have him narrate the documentary in English, and it was shown on the Fourth of July in 1967 in the United States. The same thing happened: It just took the country by storm. It was shown again three weeks later, and it won both an Oscar and an Emmy in 1967.

The automotive industry, as I understand it, has not been the best as far as being racially accepting or progressive. What was your experience like rising through your career?

I was recruited out of the Army along with an Air Force two-star general. We were recruited to bring executive leadership in operations and manufacturing into the auto industry. I was interviewed by both Ford and General Motors with that goal in mind on their part. I made the decision to go with General Motors and started out with Pontiac Motor Division, in manufacturing, again leading people.

The auto industry has been a source of employment for minorities, for African Americans, for many generations coming out the South. When I came in, in the late '70s, early '80s, we were the first African Americans in the executive group in manufacturing and operations. Of course, subsequent to that time there have been a number of other high-level African American men and women in a variety of positions, and they've had African Americans on the board of directors. So from where they were, they've come a long way. Are they where they can be and should be? Not until there is an African American chairman of the board or an African American CEO. Then we'll know we've arrived.

Can you tell me how TAG Holdings, the company you run as CEO, came to be?

Well, when I bought my first company in 1994 after leaving General Motors, I partnered with a gentleman for a couple of months and then decided to do it on my own. TAG Holdings, standing for the Anderson Group, was the organizational structure I created. As I would acquire companies, they would be under TAG Holdings. Over the course of the years, I've bought and been majority owner of about 15 different companies. And they come and go in terms of me owning them, and then selling them.

What would you say is the most challenging part about being a Black CEO, especially with the social justice climate we're experiencing today?

I find it challenging, because the social justice issues are real. Every single day of my life I wake up I'm a Black man in America, there's no two ways about that, and those realities face us. You watch the news every night and you see the issues that are going on, and it's challenging, to say the least. Nonetheless, in terms of the things that I do every day—operating my

"

Don't focus on where others have been; identify the opportunities in the future. Engage and create a circumstance for yourself. Opportunities are going to open up, because the marketplace likes winners.

businesses, mentoring young men and women who ask how can they do what I do, serving on boards like the Federal Reserve Bank board—those are all activities and responsibilities that I have assumed in spite of some of the issues and challenges that still exist about race in this country.

What's the future for companies like yours as the industry consolidates brands and platforms, creates more global conglomerates, and shifts to simpler electric vehicles with fewer parts?

I think in this era right now, the automobile industry is doing its thing, relative to electric vehicles and so forth, and that is not going to go away anytime soon. The challenge for companies like mine is to stay current and get ahead of the technology and innovation that's required to be competitive. But additionally, companies like mine, which are minority-certified and veteran-owned-certified, have the opportunity in this environment of diversity and inclusion to grow with the auto companies and with other industries also.

You're a successful African American man who drives nice cars. Have you ever felt that people—especially police officers—felt you didn't belong in those cars because of your skin color?

In this calendar year, I've had two incidents. One, I was doing a little bit over the speed limit, I won't say how much, but a female police officer pulled me over and told me how fast I was going, and she went back to her car and did her thing and came back and she said, "OK, I'm just going to give you a warning, because it was your birthday last week." And so, what can I say except she treated me very nicely? I was stopped another time, I was driving my Escalade, and he pulled me over and said, "You

did a rolling stop with the traffic light." I said, "Well, officer, nobody's around and I was just turning right." He did give me a ticket. So I guess that was a big deal, a Black man in an Escalade not stopping the vehicle fully. Should I stop fully? Obviously. Is that something that everybody gets stopped for? I don't know. But these are the kinds of issues and challenges that clearly come into your mind when driving while Black.

You say you've personally experienced few instances of overt racism, but you lived through the civil rights movement. Does America seem more inclusive today than it did in the '60s, or do the problems look the same now as then?

In terms of today's environment as an African American, as compared to the past, clearly individuals like myself, who are business owners, there are more and more of us, and African Americans who are serving on public boards. Those numbers have increased dramatically. There was a network of African Americans who collaborated together called the Executive Leadership Council, which was formed to help us mentor each other on how to be senior executives in major corporations. Subsequent to that there was an organization formed called the Black Corporate Directors Conference, and that was put together to help us mentor each other on how to serve on boards. But there's no question that there is still a gap in terms of those who are having those kinds of successes. And the masses and majority of African Americans with lower incomes, and levels of homeownership—all those things are dramatically behind the average for the country as a whole. So we've still got a lot of work to do. There's been some progress, without question, but there's still a lot of work left to do. ∎

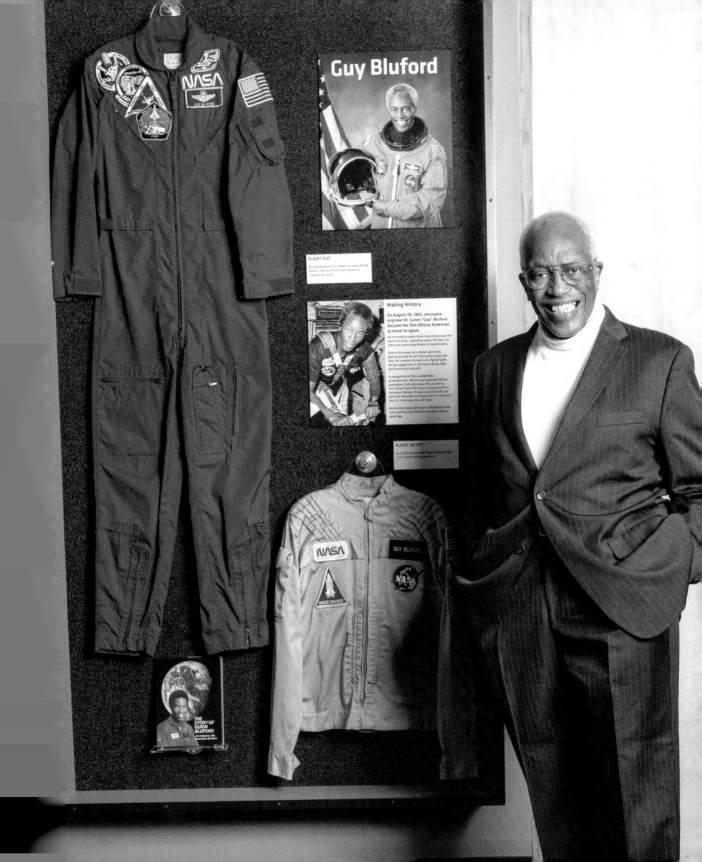

Guy Bluford

FLIGHT SUIT

Guy Bluford wore this flight suit while flying NASA T-38 aircraft and training for his missions to space.

Making History

On August 30, 1983, aerospace engineer Dr. Guion "Guy" Bluford became the first African American to travel to space.

He returned to space three more times over the next nine years, spending nearly 700 hours in orbit and conducting dozens of experiments.

Prior to his career as a NASA astronaut, Bluford earned his Air Force pilot wings and flew 144 combat missions as a fighter pilot. He has logged over 5,200 hours flying high-performance jet aircraft.

In recognition of his considerable achievements, Bluford was awarded NASA's prestigious Gold Astronaut Pin as well as the United States Air Force's Command Pilot Astronaut Wings. He was also inducted into both the International Space Hall of Fame and the U.S. Astronaut Hall of Fame.

Bluford has lived right here in Northwest Ohio since retiring from NASA more than twenty years ago.

FLIGHT JACKET

Guy Bluford wore this flight jacket during space flight training sessions.

GUION "GUY" BLUFORD

Astronaut, 79, Westlake, Ohio

Interview by De'Aundre Barnes
Portrait by Amber N. Ford

On August 30, 1983, **Guion (better known as Guy) Bluford** was a crew member aboard the Space Shuttle Challenger when it launched from Kennedy Space Station on its third mission, making Bluford the first Black astronaut to fly to space."I was very fortunate," he says. "Eight thousand people applied, and 35 of us were selected."

De'Aundre Barnes *What would you tell someone who wants to pursue a career as an astronaut or in aerospace engineering?*

Guy Bluford I tell kids to chase their passions. I did not know as a kid that I would want to be an astronaut. I didn't even think about flying. But I did find that I was passionate about airplanes. I wanted to learn as much as I could about them. And my whole career has been geared toward learning as much as possible about airplanes and spacecraft.

The possibility of being an astronaut is very small. NASA just selected new astronauts a couple of years ago; 18,000 people applied, and only 12 got selected. So you want to make sure that you're doing a job that you really enjoy, even if you don't become an astronaut.

You enlisted in the United States Air Force after college. What inspired you to do that?

Male students going to Penn State had to take two years of ROTC I took Air Force ROTC After two years, I elected to continue and go advanced ROTC The advanced program teaches military tactics and leadership and comes with a commitment to serve

as a military officer after graduation. It gave me an opportunity to satisfy my draft requirements as well as serve my country. I thought that I would spend four or five years in the Air Force and then get out and become an aerospace engineer.

But between my junior and senior year, I went to ROTC summer camp and found out that I could fly airplanes. So I decided to go into the Air Force as a pilot, with the thought that I would learn how to be a better aerospace engineer if I flew airplanes. In my senior year, I learned to fly a Cessna 150. And in 1964, I graduated from Penn State with a degree in aerospace engineering, a commission in the Air Force, and a private pilot's license.

What was it like to be selected for NASA?

I was surprised that I got selected. I've spoken with people at NASA, and I asked them, why did they select me? And they basically said I was tough.

In 1977, NASA started going through their 8,000 people, and they would send out letters to those eliminated. For most of '77, I sat around waiting for my letter. In the middle of that year, NASA started selecting finalists in groups of 20. So every

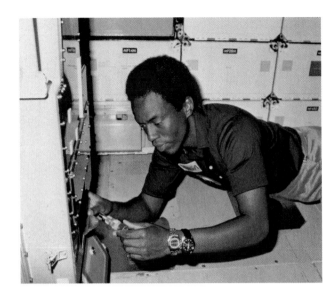

Bluford, a mission specialist on STS-8, the third flight of the Orbiter Challenger, in 1983, inspects an experiment on the ship's mid-deck.

week you'd see 20 to 40 names of people NASA had selected to bring to Houston. In October or November, I was in Washington, D.C., on a business trip, and I came back to my hotel room and found a note that said "Contact NASA." I called, and the guy said, "You've been selected as a finalist; we'd like to have you in Houston." I spent a week in Houston. I saw the 19 other people in my group of 20, and they were strong people. We all went through a physical—I've never had a physical that thorough—and a psychiatric exam. And I got an opportunity to meet astronauts, which was exciting. But you didn't know if you were going to make it or not.

In January, I was driving to work in Ohio, and I heard on the radio that NASA had selected 35 astronauts. So I assumed that I hadn't gotten my rejection letter yet. But I got to work, and at about 10 o'clock I got a call from NASA. And this guy asked me what the weather was like in Dayton. And I'll tell you, the weather was miserable. So I complained about that. And he calmly said, "You know, it doesn't snow in Houston; would you like to come to Houston?" And so that was the call that told me that I had been selected for the astronaut program.

Did you ever experience racism or racial profiling in your career?

I'm pretty sure all African Americans see that. I didn't let it bother me. I grew up in a world where I felt I could do anything I wanted to do through hard work. And I was able to do that over the years.

What were some of the challenges you faced being the first African American man to fly in space?

When I came into the program, there were six women in our class. And you had me and Ron McNair and Fred Gregory, three African Americans. And one Asian American, Ellis Onizuka. So, we recognized that we were breaking the mold, with reference to astronauts who are primarily male and white. We knew that one of us would eventually get selected—first woman, first African American. Ellis Onizuka didn't have any competition for first Asian American. I didn't anticipate being selected.

In 1982, I was happy to learn I would fly as part of STS-8. And it just so happened to be a historic mission, in reference to being the first African American to fly in space. I feel honored to be in

> "I think I was imprinted by my father with a preference for doing things that really excite you. And my career has been driven by doing things that are exciting."

that role. Once I got down, I wanted to fly a second time, which I did, in 1985. And then we had the Challenger accident in 1986, and we lost Ron McNair and company. I wanted to stay around, and I flew a third and fourth time.

One of the things that I really wanted to do was not only to break the mold, but to help pull other African Americans into the program and get them to fly. I feel honored with reference to not only leading the charge, but helping a bunch of other African Americans who came behind me. I take a great deal of pride in that.

How did you do that?

One of the things that I tried to do was just do the best I could. Whatever advice I could provide to those who came behind me, I would try it. But encouragement, opening the way for other African Americans, I thought was my responsibility. With African American organizations, we help those that come behind. Victor Glover just got down from flying in space. He will go and try to help Jeanette Epps. Jeanette Epps will help Jessica Watkins, and so forth and so on. Once you get down, try and help the team behind you.

How would you sum up your life?

I've been a fighter pilot with over 5,200 hours of jet time and a commercial pilot's license. I've been an astronaut; I've flown four times in space. I've got four earned degrees and 14 honorary doctorate degrees. I've been inducted into three halls of fame. I've been a researcher on both the aero side and the space side. I've been a senior aerospace engineering executive with three different companies. And I'm an explorer—I've scuba-dived all over the world. But I am basically a kid who grew up in West Philadelphia, got interested in airplanes, and has had an exciting career as an aerospace engineer. I'm an aerospace engineer who has found something that he enjoys doing. ∎

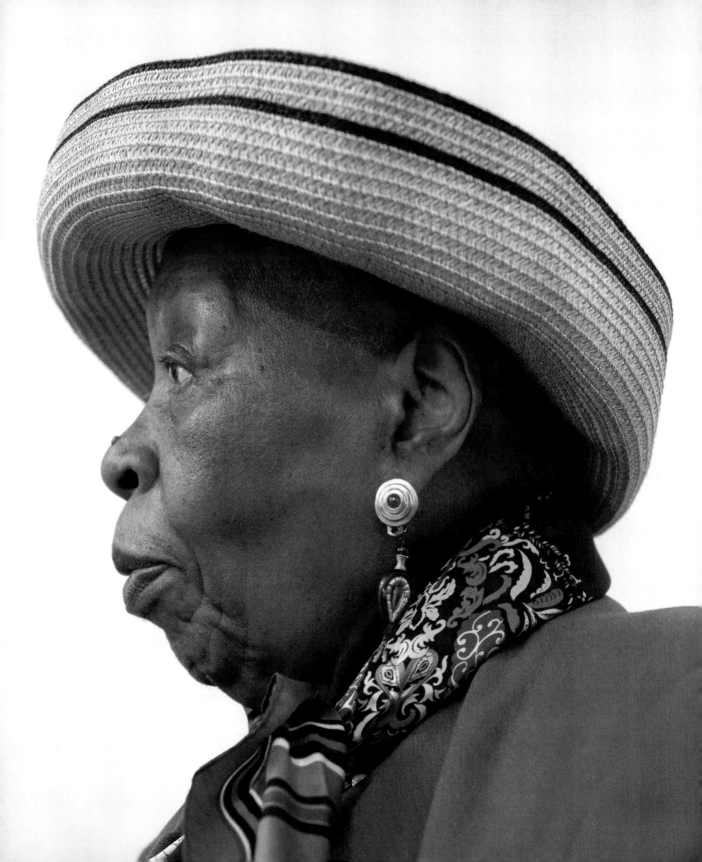

MELISSA FREEMAN

Practicing Physician, 96, New York City

Interview by Allana Haynes
Portrait by Vonecia Carswell

Melissa Freeman, MD, was raised in the Williamsbridge neighborhood of the Bronx, growing up in the house of her grandfather, who had been born into slavery. She became a doctor with a particular focus on the treatment of drug addiction and still maintains her private medical practice in Harlem."I don't see the need to retire," she says. "I still have energy, and I still plan to continue as long as I have energy."

Allana Haynes *Your grandfather was enslaved. Were you close with him?*

Melissa Freeman Well, he was a slow man. He didn't do a lot of talking to us, but he must've talked to his children. My mother, and his daughters—he told them his story. He never talked to us. He told them that he was taken away from his mother in the South, in Virginia, when he was a small boy. Sold away. Fortunately, when the Emancipation was signed he was 11 years old, and he was told he could go back to his mother. He was fortunate in that he knew where she was. He went back to her, and they stayed together all the rest of her life. He was a quiet man, and he made certain that the grounds around the property were always kept neat. He planted flowers—peonies and white roses. He planted those around the front of the house and in the backyard of the house.

How does the granddaughter of a formerly enslaved man become interested in medicine?

I was really interested in biology. I had taken a class in biology, and I'd taken classes in dissection of animals and so forth—which doesn't sound very

Freeman as a graduate of Howard University Medical School, 1955.

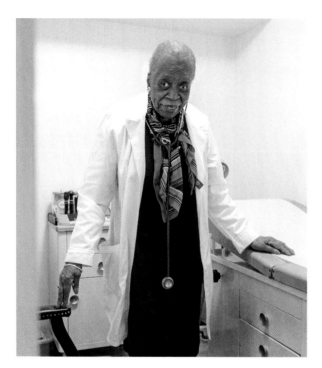

interesting, but it became the moment of thinking about possibly going into medicine. I eventually went into the field of what they call internal medicine. I did my internship at one of the local city hospitals in Brooklyn.

What are your memories about the early years of your career?

Once, during my internship at Kings County Hospital, I went to the pediatric ward, and a little fellow was there. I think he was about 5 years old. He said, "What's your name?" I told him I was Dr. Freeman. He said, "You're a doctor?" He said, "I never heard of a lady doctor." He thought that was funny. Then he just asked me, "What do lady doctors wear?" At that time we wore skirts and jackets and so forth. He was just curious, I think.

After I completed my internship and my residency, I worked in a hospital in Manhattan, and two of the doctors there were looking for physicians who would be interested in working with patients who were addicted to narcotics. I had had exposure some

time before to a woman, one of the social workers in the hospital, who had once walked with someone into my office and said that she was addicted to narcotics and was there anything we could do? At that time there was nothing much we really could do, except to get them admitted to the inpatient division—but it was only to get the patients in, get them off the drug, and let them go. I started working at that time in the field of drug addiction, managing the use of other medication to treat people who were addicted to drugs, particularly young women.

I'm wondering, how did being a woman—and being a woman of color—affect your career?

I don't think it bothered me in any way. I went straight through. I did my internship, I went into another hospital out on Long Island, and I didn't find any particular problem. I didn't find many prejudices necessarily as a consequence of being a female and a female of color.

What's something that has motivated you to keep going through such a long career?

Well, I had opened an office in Harlem, and I treated people there, and it's very challenging to work with people, and certainly people of color, Black people, helping them to defeat the areas of medicine that have unfortunately taken us away from life—hypertension and diabetes, kidney disease, joint pain. All these areas I find very challenging and very—for me, something that I wanted to do and have continued to do.

Have you ever thought about retiring?

Not at this time, no. I'm not of a young age, of course, but I still have energy, and I still am able to open the doors of my practice and take in people as they come. If they want me to help them attack a particular problem that they have, I'm certainly more than willing to try to do it, and I do.

"We were fortunate in that my parents and the parents of my cousins all taught that you have to go to school, you have to finish high school, you have to go to college."

What is something you hope generations behind you will learn from your career, and your life?

Well, when I see young people who may consider the possibility of going to medical school, I try to tell them, "Have you ever thought of going to medical school?" I try to convince them to enter medical school, going into pre-medicine in their high school, in their colleges, and then from there going into medical school, and then ultimately going into areas that will treat our people in these areas or problems that many of our people face. And I think that that's something that all of us, many of our doctors, are doing and many of our physicians of color are doing. There's a program that one of my friends runs every year where she introduces young people to the possibility of studying medicine. She has classes where doctors attend, and young people can come and talk with us about what we do, why did we do it, where did we do it. I think that's a wonderful thing. It helps young people to consider the advantage of taking care of and healing our people who find themselves with ailments that need to be treated if we were not there to do it.

The other thing that I think is important—if a young person does not find themselves interested particularly in medicine, I think it's a very vital thing for our people to be encouraging youngsters to go to college, to get an education, complete high school and enter college, and consider maybe not medicine, but some other field, at least to go on into college and get an education.

You've lived through a lot of history. What are a couple of moments you've witnessed that stand out?

The treatment of young people who are addicted to drugs and learning the importance of getting them into treatment, which we now have available more so than we did some years ago. And then, somebody asked me, what have I seen through my life that I found interesting? When I was a kid and living in the Bronx, somehow I guess my parents found out that a German airship known as a zeppelin was going to fly over the Bronx, over our houses. That was an interesting thing to just see that. It had come from Germany and came over the Bronx and over our homes and flew over into Jersey. Unfortunately, it crashed and was demolished. It was a German zeppelin known as the Hindenburg, and we were all looking up at the sky to see this fascinating object flying overhead. ■

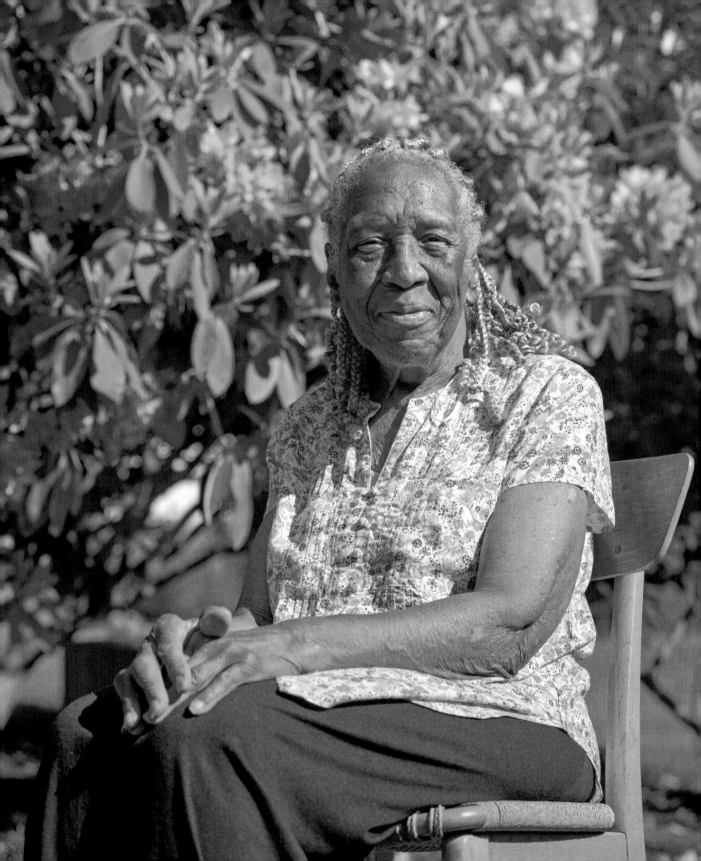

GLADYS JENNINGS

Nutritionist, 96, Mill Creek, Washington

Interview by Melanie Curry
Portrait by Meron Menghistab

Gladys Jennings, RD, has won numerous awards for her pioneering work in the field of nutrition and dietetics. In the 1960s, she was one of the first to examine the socioeconomic factors affecting nutritional health in Black communities. Among other things, she says, "we need to think more about getting people back to growing some of their own food."

HER EDUCATIONAL INSPIRATION

My maternal grandmother was born enslaved in the U.S. Her job was to keep the master's child comfortable while she was having school lessons. So my grandmother subconsciously got some education. She was about 11 years old when the Emancipation Proclamation came, and, because she could read and write, was enlisted to teach the adult former slaves. Her mother had to be the enforcer of discipline in the classroom because, you know, adults aren't gonna listen to no kid. Other people took interest in her afterwards, and she was educated and trained. Much later in life, she would go around and visit her different daughters and would tell her story. Of course, as kids, after we heard Great Granny Jones's story once, we didn't want to really keep hearing it, so I didn't appreciate her until much later. But my parents' mantra was "You must get an education to get ahead, and you must be a credit to your race." It was my grandmother's influence, I'm sure.

MAKING FOOD A CAREER

When I was in high school, I liked to cook fancy stuff. I was very much influenced by women's magazines like *McCall's*. My family members would tease me and ask, "What magazine are we eating from today?" So when I was deciding what I would major in at college, I knew I wanted to do something with foods. Dietetics was coming into the fore as a field associated with foods, so that's what I ended up majoring in.

WHAT MILLENNIALS GET RIGHT

I was only the second generation out of slavery. I'm a child of the Depression, born in 1925, and we were poor. It's difficult not to have a Depression mentality. You went through a lot of who-shot-John, enduring whatever they wanted to dole out, because you were just happy to have a job. My granddaughters are millennials, and they'll say to me, "This is the 21st century. People still go through a lot of who-shot-John, but it's different; you don't have to." There's such a difference in the outlook.

ON HER OWN JOURNEY TO "WOKENESS"

In the 1960s my sociologist cousin gave me two books: One I remember to this day was *An American Dilemma*, and the other was on institutionalized racism. Through reading those and discussions with my cousin, I started to understand why Black people are treated the way we are, and my whole sense of value and worth changed. When we

> **Our bodies were intended for use, not for pushing a button. The more that you can use your body physically, the better off you are.**

got a Black studies department at Washington State University, where I was a professor at the time, I said I would teach about Black community health and nutrition and the outside factors that influence them. I also developed another course in international nutrition, which was concerned with why, with so much food being grown in different parts of Africa, there was still a lot of malnutrition. They have the knowledge to produce on the land they have, so why are people who are not Caucasian at such a disadvantage? I remember being inspired by the fact that the Black Panthers in the Seattle area brought in resources like school lunches and breakfast. It was a revolutionary time, and we were all trying to effect some change and get resources devoted to understanding society.

ON SHAKING UP HISTORY

I recently talked with some interracial groups that are beginning to write a curriculum on Black history. They're beginning to say, "We do need to put this in." Now's the time to rattle some trees. I am a little bit about destruction—sometimes you have to burn some things to get something new. The history I learned in school was the Boston Tea Party and Plymouth Rock, but whenever I would go to conventions, I would always try to do something to find out about the African American community in the area to learn a little more about people like me. My first time in Boston, I went to a historic African Methodist Episcopal church. In Denver, there was a Black museum. And in Houston, we went to a Black restaurant. You have to be interested in our history because nobody's going to hand it to us.

MISCONCEPTIONS ABOUT SOUL FOOD

People who were enslaved existed on a high-fat diet, but it also had a lot of homegrown produce. Some enslaved people were permitted to grow vegetables.

The cooking had to be something that's put on and left there while the work is done in the fields. It was a combination of African eating patterns and availability. The stews of mostly vegetables and pot liquor were nutritious. That translates today. If we are interested in helping people with their health and well-being, it's not a matter of going in and saying, "Oh, you're eating all wrong." It should be a matter of seeing, What can I learn from you and how can we work together to bring the best for you?

MOST IMPORTANT WORK ACHIEVEMENT

Part of my focus was working with students, and I look at what I've contributed through them. One of my students became president of the Academy of Nutrition and Dietetics. Another one started a nonprofit to foster good nutrition and development in rural areas of Malawi. I've had people come up to me in a store and say, "You taught me nutrition. This is what it's meant to me and my family." I feel privileged to have been able to support so many young people.

ON THE SECRET TO LONGEVITY

It's not just the eating, it's also about lifestyle. Our bodies were intended for use, not for pushing a button. The more that you can use your body physically, the better off you are. I came to driving late, so I was really a reluctant driver. I've always felt that some of my longevity is due to using my body as it was intended—to walk. Your body needs to move about, and your body needs to have sunlight. Your body needs to have peace of mind. ■

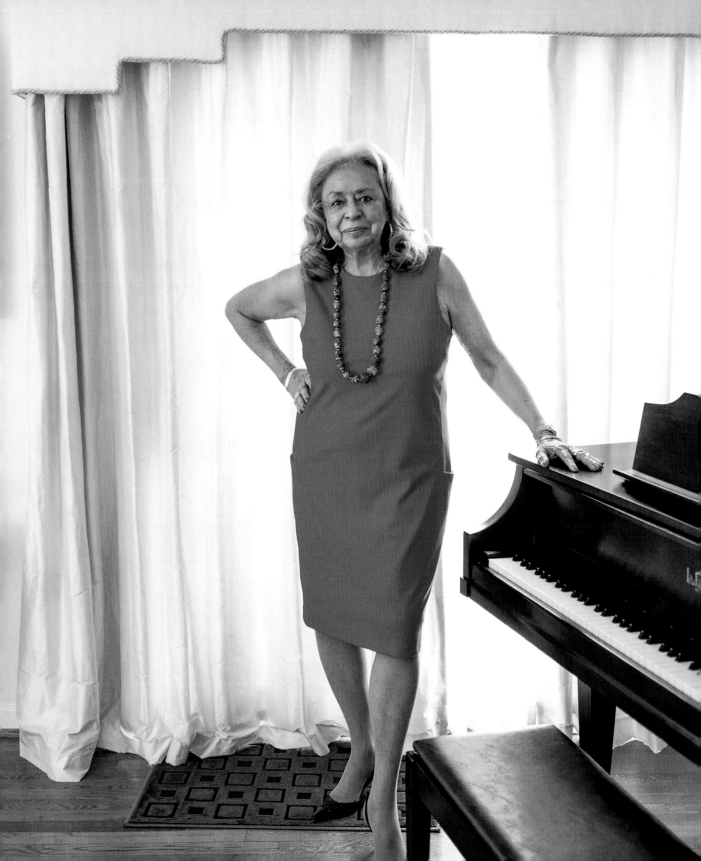

VIVIAN PINN

First Director, Office of Research on Women's Health, 81, Washington, D.C.

As told to Melanie Curry
Portrait by Cheriss May

Firsts define **Vivian Pinn's** career: She was the only Black person and the only woman to graduate from her medical school class; the first Black woman to chair an academic pathology department in the United States (at Howard University School of Medicine); and the first full-time director of the Office of Research on Women's Health at the National Institutes of Health. She is known for her advocacy of women's health issues, and for encouraging young women to pursue careers in science and medicine.

I became interested in medicine when I was young, growing up in Virginia. My grandparents were both ill—cancer and diabetes—and I watched my father, who was not a physician, take care of them. And those were the days when doctors made house calls, and I noticed that whenever the doctor came to visit, my grandparents felt better, and the family felt better because everybody felt better. Then in college, my mom's doctor treated her for bad posture after her complaints of back pain. He never took an X-ray and ultimately missed her actual issue: bone cancer. I took a semester off to care for her during her final days. These experiences made me determined to go into medicine, as I realized how important it was for patients to truly be listened to. I carried that concept with me going forward.

After spending nearly 30 years as a pathologist and professor, I was at a meeting at the National Institutes of Health in 1991, and they talked about a new office of research on women's health that was being established. At the time, women's health was really just thought of as reproductive health, and research on women was related to that and breast cancer

only. The director of the NIH asked me to come out and head up this new office. My initial response was no—I didn't come up in government, and I liked to speak my mind, which wasn't something I thought would work there. But she insisted I try it, so I did, and I've spent the past 30 years in women's health, advocating for studies to include women and understanding sex-specific differences.

Now I'm grateful that she pushed me. We talk a lot about mentors today, but when I was coming up in this world, there were so few women role models. In medical school, I'd go home and vent to my father, who would listen and encourage me. So when I got into my residency and early years of teaching, students would come talk to me, and I didn't think I could not take the time with them. While I was at the NIH—I'm retired—we put together programs for women in biomedical sciences and built mentoring in, because it was so important. I know what a difference it can make to have someone you can relate to. Sometimes you can solve your own problems just by talking about them.

"

One of the points I always tried to make to my students was to not feel that because they had an M.D. degree they knew everything, but to listen, especially to women, and to pay attention to women's health.

The University of Virginia School of Medicine, 1967 senior class: Pinn is circled.

I was in a meeting recently and somebody brought up the idea of burnout among young physicians. I said, "If you've been doing this for a few years and you're tired, think about somebody like me who's been at it for 50 years!" We get tired.

That's why we have to take care of ourselves. You can't be everything for everyone else if you don't look out for yourself. I say that to so many women who are carrying careers, taking care of kids and parents, being active in the church. They're trying to do it all, and they're wearing themselves out. So there is going to be some burnout, and if you feel that coming on, you have to take a break. Play the piano. Play tennis. I read mystery novels as a balance to the heavy science stuff I consume all day. That's my outlet.

Looking back, I never thought about being a pathologist. I never thought about government work. I never thought about being in women's health. The opportunities came, and I took advantage of them, often with someone spurring me on and a "Why not try?" attitude. You have to make up your mind if you're going to be someone who talks about things or someone who takes action, and I've always believed in actions. ∎

HERLDA SENHOUSE

Jazz Club Founder, 111, Wellesley, Massachusetts

Interview by Rhondella Richardson

The story of Black America is very much about attitude and making a way. The oldest resident of Wellesley, Massachusetts, is 110 years old and has stories you will want your children to hear and remember. So when Rhondella Richardson got the chance to interview **Herlda Senhouse** at the Myrtle Baptist Church, one of the oldest Black churches in the state, she made sure to bring her 17-year-old daughter, Rhylee, along with her.

While civil rights leaders marched in the 1960s for equality and against racism, Senhouse created her own brand of activism through her jazz dance shows. She founded what was Boston's Clique Club, a social club of dancers and musicians to help educate Black students, through which she helped countless Black students pay for everything from books to college tuition.

Before her joyous jazz days, she experienced some blues. Both her parents died by the time Senhouse was 6. Half of her nine siblings were dead by then, too. "We didn't have any adults to raise us, so we had to raise ourselves," Senhouse said, adding that her older sisters did a great job going to work and raising her at the same time.

At age 16, Senhouse moved to Woburn, Massachusetts, to an aunt's house. In 1931, she became the first in her family to graduate from high school. "There were only two Blacks in the school," she said, "but I got along with everyone."

After her parents died, she wanted to pursue a career in medicine. "I was interested in health care," she said, "but I couldn't be a nurse." When she

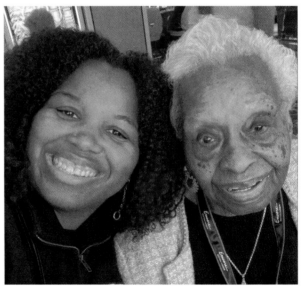

Senhouse (right) smiles for a selfie with her close friend Veronica Chapman on her birthday in October 2021.

applied to what was then the Boston Medical Center nursing program, she was told they were only taking two Black applicants and she need not apply.

She was not in a rush to marry, and married William Senhouse when she was 25. Neither had jobs, but they decided to work together as domestics. It

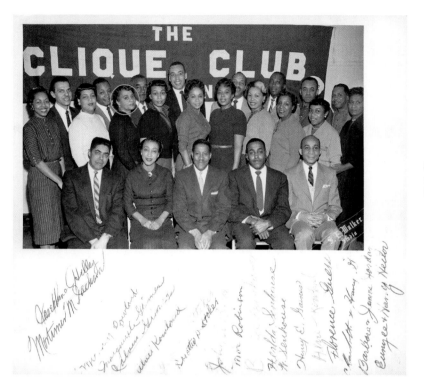

Senhouse (circled) and other members of the Clique Club pose for a formal group shot.

was her fallback plan after her nursing hopes were dashed. Senhouse valued family above all, so the couple bonded with their employers' families. That empowered them. "My husband was a chauffeur, and the lady we were working with would sit in the front seat with him," she said. "The cops stopped them, and the cops said, 'Get in the back seat,' and she said, 'This is my car. I'll sit where I want.'"

"I traveled with my first family when they vacationed to St. Petersburg, Florida," Senhouse said. "The law was for the Black help to sleep in a cubbyhole-size room, and I said, 'No way.' And the lady of the house asked what I was going to do about it, and I said we'd drive back to Boston. She instead let us stay in the big house with them."

"Auntie Herlda," as she is known to all her friends, eagerly shared what she remembers from childhood,

including the Spanish flu pandemic of 1918. She held her own through the coronavirus pandemic, too, she said. As she paged through her Clique Club jazz dance photos and school graduation photos, her memory was as sharp as if the 1931 class picture was yesterday. "You should have seen me trying to get my hair together for this picture. I put my head on the ironing board," she said, breaking into laughter. "My aunt would use the iron on my hair."

As for advice for living a happy, healthy, long life? Senhouse says do your best to resolve issues, but if you can't fix it, forget it, let it go—that's how you get through life. Limit the stress.

"I don't know what's going to happen after 110," the oldest resident of Wellesley said. "Remember, anything you have today is a privilege to have it." ∎

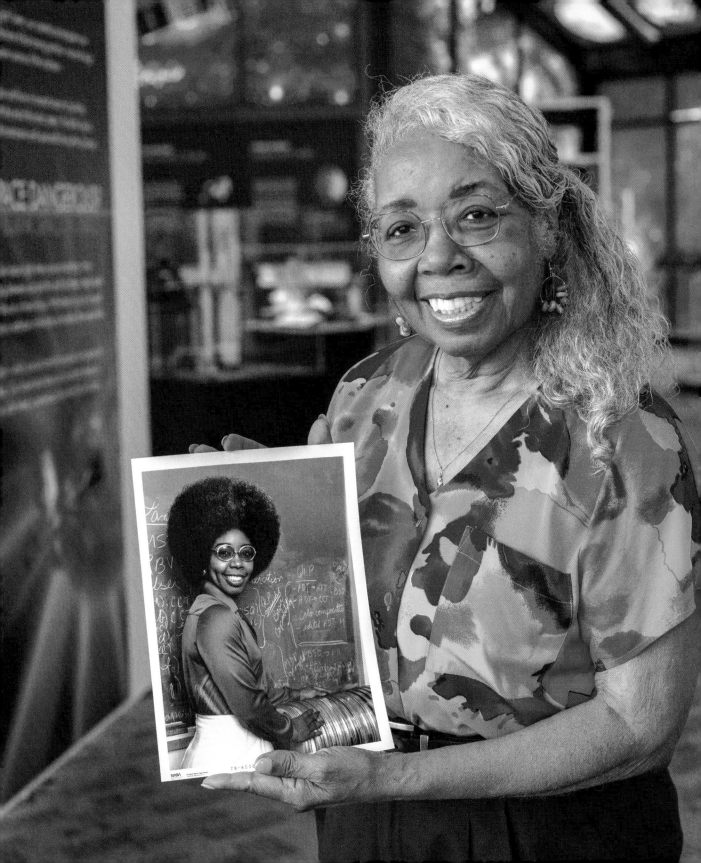

VALERIE L. THOMAS

NASA Scientist, Inventor, 79, Prince George's County, Maryland

As told to by Sara Bey
Portrait by Sahar Coston-Hardy

In 1995, **Valerie L. Thomas** retired as associate chief of NASA's Space Science Data Operations Office. She invented technology that led to the development of 3-D imaging, but is most proud of the work she's done to help fellow Black scientists—and future scientists—succeed. "I had not thought about my legacy before," she says, "but now as I look back on the things that I have done, I think my biggest legacy is the positive impact that I've had on people."

When I was young, TVs were much different. The TV we had was in a big box and had tubes in it that were sort of like lightbulbs. When they blew out, the TV didn't work. When my father would open the box up, I could see these mechanical parts and the tubes, and I thought, How do these mechanical parts result in an image on the screen? I never asked my father, but I was curious about that.

We didn't always have a library in my community, but when they finally opened one, I went and was looking around for some books to get, and I came across one that really captured my attention. I'm turning the pages and I can see these designs, like illustrations of actual projects you could make. I was so excited. I could not wait to get home and show it to my father so he could show me how to make these projects. The book was called *The Boys' First Book of Electronics*. I took it home, showed it to my father, and he said, "Oh, I can do that. I can do that, and that." He did not show me how to do anything. So the book just sat until it was time to return it to the library. When I went to the library to return my books, and I was looking around for more, I came across another book that caught my attention, and I took that home. That book was called *The*

Boys' Second Book of Electronics, and the same thing happened. So I got the indirect hint: Electronics is not for girls. Go sew with your mother, or do hair like your mother. I decided to, you know, master my sewing. I taught myself how to do hair. However, I still wanted to know about electronics. I thought maybe when I get to junior high school I'll learn about electronics.

When I got to junior high school, there were no classes on electronics. When I got to high school, there were no classes on electronics, so I sort of gave up. Then I took a class in physics, and it helped to answer the question that I'd always had: What makes things tick? So in my senior year, when I was trying to decide on what I wanted to major in, I figured physics would be what I needed to pursue. I went to Morgan State, and while I was there, they started offering a new mathematics course, Abstract Algebra, that students had to get permission from the head of the department to take. First day of class, the professor was going over his lesson, and when I opened the textbook, it looked like Greek to me. The professor was going over this mathematical proof, and he says, ". . . and this is true by induction." My hand goes up. "What's induction?" Well,

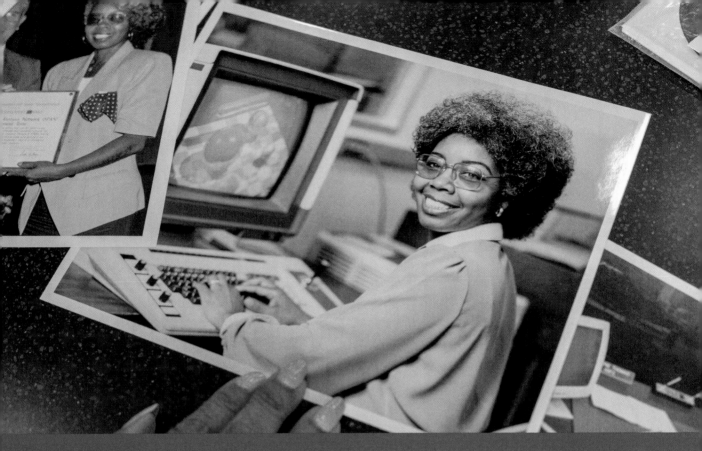

> When I started, I had to write programs for computers—I had never seen a computer before in my life except in science fiction movies.

it turns out induction had several steps that if you already knew wouldn't be put in the proof. He wrote in three additional lines explaining what induction was, and continued. Then he says, ". . . and this is intuitively clear." My hand goes up. "What's intuitive?" Same thing. I'm sure the other students did not understand what the professor was talking about either. They didn't ask the questions. I asked the questions. I got the answer for all of us, and it turns out I aced the course.

During my senior year, recruiters came out, and I was telling them that I was going to grad school, so not one of them called me back. However, as I got closer to graduation I decided I needed to get a job instead, and I finally heard from NASA. The person asked me when did I want to start work, and I said Monday after graduation. He said, "Don't you want to take a vacation first?" I mean, I didn't have any money for a vacation. I hadn't even thought about a vacation. So I said "OK, the second Monday after graduation." And that's when I started work at NASA as a mathematician data analyst.

I felt like I had gone from one college campus to another. When I started, I had to write programs for computers—I had never seen a computer before in my life except in science fiction movies. I decided that I was going to learn everything I could about computers, inside and out. I always wanted to learn and figure things out myself; at NASA, I had a lot of opportunities to do that. Being in an environment where everybody's smart was really gratifying. I enjoyed working on things that hadn't been done before and getting to be in charge of some of those things. But I wasn't getting promoted, and other African Americans were going through the same thing. So I had to fight the good fight, in a positive way. I was part of creating an organization called Humanitarian United Effort. We put together informal activities that would allow these African

Americans who were coming in and doing a good job but were in the shadows and high-level managers to get to know each other. I also worked with one of the higher-ups who was interested in diversity to pull together a group representing African American women, Hispanics, and people with disabilities that would give presentations to managers on the importance of diversity. Those are soft, positive ways of addressing the issue, and they helped.

I also took every opportunity I had to let young people know how important it was to take advanced mathematics courses in high school, because nobody had ever told me. So I would go out to talk with students and sign up to be a mentor to interns. I would get some of the other employees to be mentors through all kinds of programs. I became president of the National Technical Association, which focused on helping African Americans progress in the science and technology fields. Then I went on to lead SMART, which focused on education outreach about the space sciences. Now I'm director of a chapter of Shades of Blue, which prepares young people for careers in aviation.

I recently gave a Zoom presentation to a class at a math and science school in the Bronx. The video wasn't working, so I could see them, but they couldn't see me. I started telling my stories and I could see that they were doing what I did when I was growing up listening to the radio—they were visualizing in their mind, and that will have a great impact on them. There was something that clicked with that presentation. That's the kind of legacy I'm proud of. My purpose in life is to help people and cause positive things to happen. Like, now I'm helping design a science center that's a combination space port and theme park. It's going to have a lot of information on contributions by African Americans. It's exciting! ■

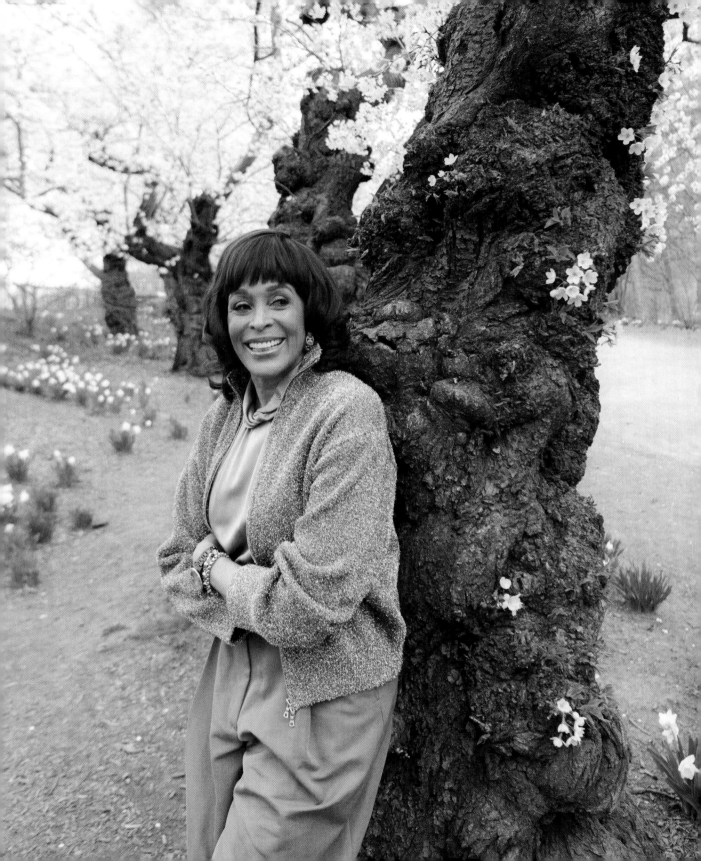

FAYE WATTLETON

Reproductive Rights Activist, 78, New York City

Interview by Rachel Williams
Portrait by Tiffany L. Clark

In 1978, **Faye Wattleton** was named president of Planned Parenthood, the first Black person to serve in that position, which she held until 1992. She has spent her career advocating for women's health and reproductive rights. "There is no question," she says, "that as we go backward, those who will be most harmed are the people who don't have the resources to overcome these obstacles, particularly women of color."

Rachel Williams *Did growing up in a strict religious household affect your views around sex and sex education?*

Faye Wattleton The Bible says to be fruitful and multiply, so there was really no sex education within my family, and at school, what passed for sex education focused on menstruation and not sexual development or healthy sexuality. Sex outside of marriage was viewed as sinful and condemned. But all of that did inform how I work to oppose the people who want to overturn reproductive rights—I understand their vernacular and way of thinking.

How was your activism impacted by your education and time as a nurse?

Had I not pursued the medical degrees and career that I did, I might have taken a very different path and probably wouldn't have been open to a wider point of view and a world beyond my very strict, narrow religious upbringing.

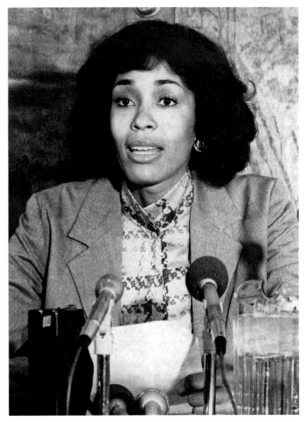

Wattleton in 1980, when she was president of Planned Parenthood.

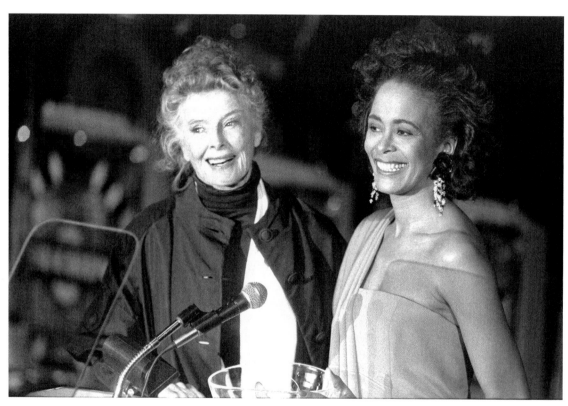

Wattleton in 1988, giving an award to Katharine Hepburn for her support of abortion rights and access to family planning for poor women.

> **"Just because we're pregnant, we have the capacity to bear children, doesn't mean that we're all crazy and need mental health intervention if we decide that we don't want to give our body over to that purpose."**

Religion can be a factor for many people in the reproductive rights discussion. What's your point of view on that?

What I think is worth highlighting is that the teaching of my mother, who was a pastor, wasn't that the government should impose its will. I never once heard her suggest that there should be laws to enforce religious tenets. But religion is still being used to circumscribe women's behavior. As a nurse and midwife in the 1960s, I was exposed to low-income women at a time when they were injured and killed in an effort to control fertility—something to which it seems politicians today want to see us return.

As president of Planned Parenthood, you made a lot of strides, but it seems like there is still so much to do. What now?

I think we really need to maintain perspective about how long this area of a woman's life has been under attack. And it's really important not to see this as a Planned Parenthood issue. It's incumbent on every woman to see this as her issue. We're not without power to change things, but we really have to take responsibility and get engaged to directly hold public officials accountable for stepping away from women's bodies and leaving us to make the best decisions for our own lives.

Another area of women's health where we see a lot of disparity is maternal mortality and how it disproportionately affects Black women. Can you speak to that?

We have to take a more holistic approach to maternal mortality. The focus shouldn't only be on childbearing as a woman's role; it should look at health inequities across the board and how that foundation affects pregnancy. There is no reason for there to be a gap between those who have good health care and those who do not.

What message do you want to send to women coming behind you who continue to fight for their rights?

Recognize the long, difficult, and dangerous journey so far, and that there's a great debt to pay. People have died defending and working to protect a woman's right to control our own fertility. You can march, write to politicians, or give a few dollars, but each of us has the responsibility to take it up in whatever way we can. ∎

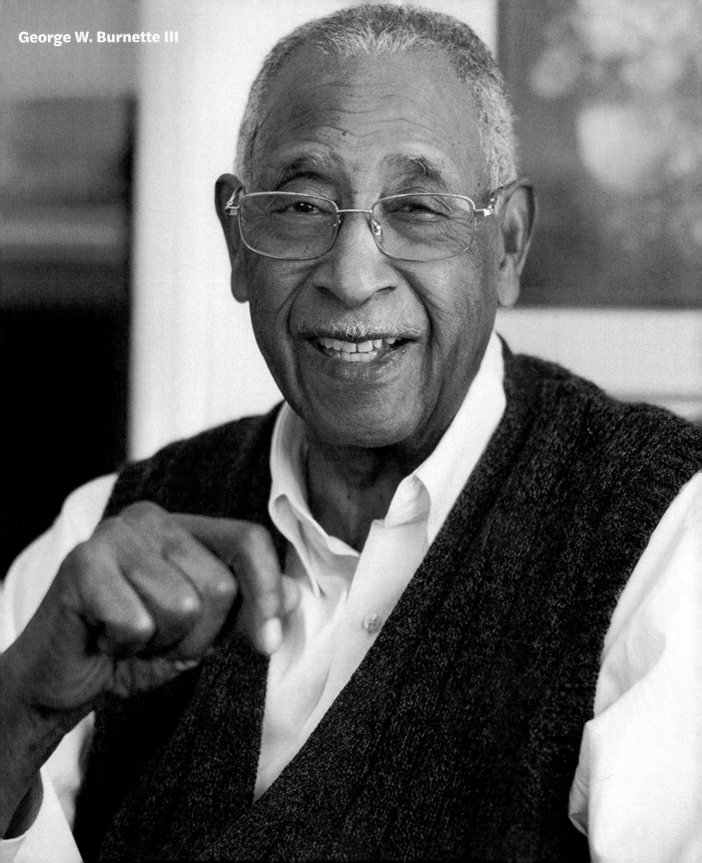

George W. Burnette III

CHAPTER 5
Inspiration

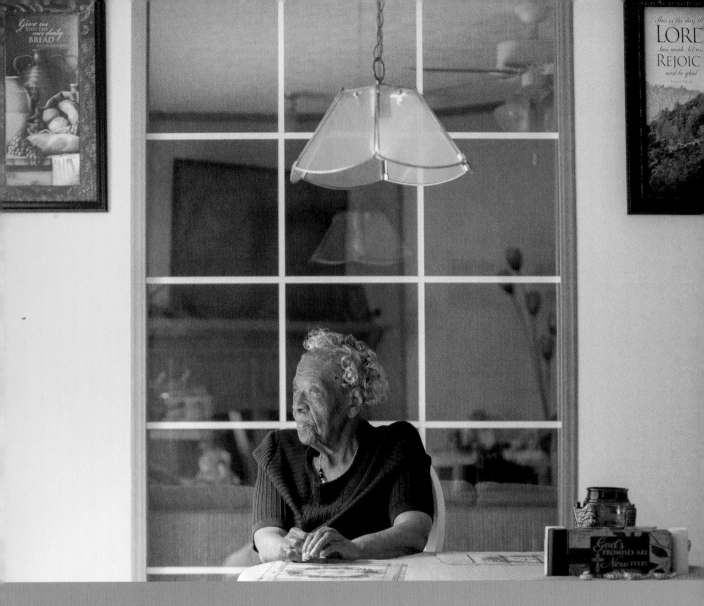

NINA BELLAMY
Caretaker, 98, Little River, South Carolina

Interview by Jaliah Robinson
Portrait by Gavin McIntyre

Nina Bellamy raised 13 children and has 28 grandchildren, 57 great-grandchildren, and 30 great-great-grandchildren. When she was in the thick of it as a working mother, she also helped care for sick kids in the neighborhood whose parents couldn't afford to take them to the doctor. "Some people ask me things and I ask the Lord, 'Wonder why they asking me?'" she says. "But I be ready to talk. If I know anything I'll tell it."

Jaliah Robinson *In all your years of living, what is the most important thing you've learned?*

Nina Bellamy I started working when I was young, when I was still in school. I stringed tobacco on a farm. Back in them days, when you got paid you brought the money home to your parents, you didn't go and spend it and do what you wanted to do. And I am thankful for that today. It learned me not to make plans with money till I get it in my hands. It learned me to take care with it.

Have you ever had a day where you felt like nothing was going your way?

I've had plenty of days like that. A lot of days it seemed like nothing would work. I've had some hard times, but I pray to the Lord and ask Him to keep me. One time I caught on fire. I was going to go pick the apple tree and I didn't want my baby to catch a cold, so I put her down and went to turn on the heater. Honey, my gown caught on fire! We had a slop bucket, and I said, "Throw it on me, throw anything to smother the fire!" I stayed in Conway Hospital for three months. I think I made it because of the Lord.

Is there a person who you would say if not for them, you wouldn't be who you are today?

I had a sister who just looked like she didn't want to take no mess. Her name was Emily. She didn't mind fighting for her rights. I had a good daddy and a good momma. They taught me the importance of church. My daddy was a preacher. He would go to Sumter to preach and travel to different conferences. My mother worked in the church and taught Sunday school. She'd say, "Where you think you're going? You going to church tonight."

Why do you think this younger generation isn't as present in church?

I think about that a lot. Children don't like to be corrected these days. When I see people doing wrong, I just got to tell them. And you can be grown and be wrong. If somebody keeps saying you are wrong but you think you are right, it's a problem. You need to listen.

You used to help take care of the sick children in the community. Are there any home remedies that you remember using?

Well, there wasn't no going to a doctor. You make a tea of tobacco—boil it, put a little bit of sugar in it, and drink it down, and that's good for a cold. For a fever, go to the store and get cough syrup and castor oil, and put onions in your socks. When kids would get colic, I'd give them soda water.

What advice would you give this upcoming generation of young Black Americans?

Why grab at everything? It's not good. And you can go wrong so long you can't stop. They know what to do, they just don't want to. Pray for understanding. They need to say, "Show me, Lord, the way, guide me on home, don't let me go astray."

What do you think is the key to living a long and healthy life?

God and family. I have been through thick and thin, but the Lord has brought me through. ∎

ALVIN BROOKS

Police Officer, 89, Kansas City, Missouri

Interview by Jackson Kurtz

Alvin Brooks has been a Kansas City leader since becoming one of the city's first Black police officers in the 1950s. After his time in the police department, Brooks went on to become one of the city's few Black elected officials and was later a civil rights activist for decades. He set up Kansas City's first human relations department and became its first Black human relations director.

Brooks began our conversation by recalling an encounter he had with a white police officer when he was only 9 years old. "A police car and five of us came to the bottom of Brighton Street hill. One officer, he's been drinking, he pulled his gun and popped it. He said, n- - - - - , you see that hill? If you can make it up to the top of that hill before I shoot your n- - - - - Black ass, you're a free n- - - - -. Get to running!"

"I guess the question today is, How far have we come?" Brooks said. "Not far. Not far enough."

Brooks's parents were only teenagers when his mother became pregnant with him. "My mother was sent to live with her sister in Little Rock, Arkansas, who lived across the road from the Brookses," he said. "She then left me with the Brookses."

He was born in 1933 in Little Rock before coming to Kansas City. "My dad killed a white man, at a moonshine still. He got away—didn't escape, but something in between happened that he was told he had to get out of Arkansas, and they brought me."

The Kansas City that Brooks found himself in was booming but segregated. "Living in an all-Black

Brooks, circled, was the only Black cadet in his class at the Kansas City police academy.

community, going to an all-Black school, and having relationships with white folks was only when you went to the big stores—downtown Kansas City," he said. "We couldn't eat but one place. I always kinda wondered at 9 or 10 years old, 'Momma, why can't we eat there?' And she never said why."

After starting a family, Brooks would join a mostly white police force. "I worked with gangs, I was the gang person, and I had a good relationship with them," he said.

"I guess the question today is, How far have we come? Not far. Not far enough."

Brooks joined the police department to make a difference and be unlike the officers he encountered earlier in his life. In one of the earlier incidents Brooks described, a police officer mistreated him, his cousin, and a couple of friends. "Police car drove up with two white police officers. He grabbed my cousin with his right hand, twisted him over the police car."

Years later, Brooks would see that officer when he became his coworker. "I join the police department, lo and behold, here comes this officer. I said, 'Do you remember stopping five or six Black kids who had three horses?' No. And I said, 'You don't remember that?' 'No, it wasn't me.' I said, 'Yes, it was you.' I said, 'Listen, don't worry.' I patted him on the arm and said, 'I got your back.' Blood rushed to my brain, you know. But I had to be cool."

After leaving the police department, Brooks went into city government. In 1977, he founded the Ad Hoc Group Against Crime, which responded to violent crimes in the Black community. He also spent time helping drug users in the city, which later landed him a position on President George H.W. Bush's National Drug Advisory Council, where he served a three-year term. He was named one of America's 1,000 Points of Light by Bush in 1989.

In 1999, Brooks was elected to the Kansas City Council representing the 6th District At-Large and was appointed mayor pro-tem. He was re-elected in 2003. In 2010, he was appointed to the Kansas City Police Department's Board of Police Commissioners and served as president for two years.

During his life of serving others, Brooks has received numerous awards: the Carl R. Johnson Humanitarian Award from the NAACP in 2001, the annual Peace Award from the Crescent Peace Society in 2007, the Harry S Truman Service Award from the City of Independence in 2016, and the Kansas Citian of the Year Award by the Greater Kansas City Chamber of Commerce in 2019. In 2016, the Kansas City Council declared May 3 Alvin L. Brooks Day.

Looking back at the summer of 2020 and how far we've come as a nation in regard to race, Brooks said there is still so much for us to do to be truly united. "So, who has the power in America? It's not us—people of color. It's white America," he said. "I wonder how many men, Black men, died falsely—and I guess people can say that's history, it doesn't happen anymore, but, ah, yes it does. We can pass laws, have slogans, have marches, and all those things are important because they do make a difference, but the question becomes, how do they impact America's structural racist system?

"I pray for us every night, as a people and as a nation, that the 28 days of Black history month will mean more than just a month. It'll be a pathway to understanding, a pathway to freedom, justice, equality, understanding, human understanding, reconciliation—everything that makes good for us as a people of God." ∎

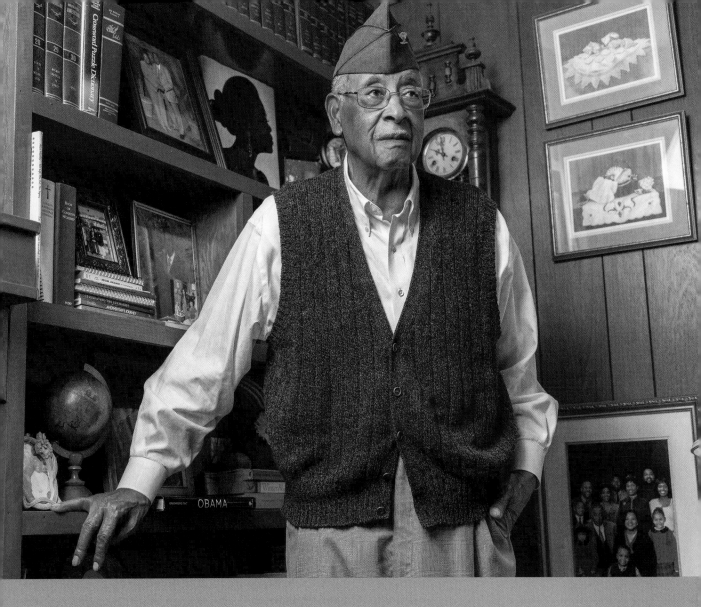

GEORGE W. BURNETTE III

FAA Recruiter, Veteran, BBQ Chef, 88, Atlanta

Interview by Kristian Rhim
Portrait by Lynsey Weatherspoon

George W. Burnette III served two tours of duty in Vietnam and retired as a colonel from the U.S. Army. As a human resources specialist at the Federal Aviation Administration, he recruited many Black and minority air traffic controllers. He is renowned for his barbecue sauce, which won the 100 Black Women of Atlanta's Annual Gourmet Gents Best in Show Award for several years running.

Kristian Rhim *You served two tours in Vietnam during the 1960s, and in America during the '60s, young Black Americans began challenging racism in the country, and we saw the height of the civil rights movement at that time. What was it like for you fighting in the Army for America as a Black man while Black people were protesting in the streets back home?*

George Burnette That was my chance to go to college. If you joined a service and you did the time, good time, got a discharge, you went to college. That's the only way I could go to college. I was going to go to college on a pilot work plan, Tuskegee University had one, but I couldn't get the money I'd earned to go to school; that's why I joined the Army.

In your time at the FAA, you recruited more Black air traffic controllers than anyone else. Why did you think it was important to bring young Black people into the aviation field?

Well, there weren't that many who were qualified. We started a program, signed an agreement with the historically Black colleges. From that point on, we began to bring Blacks into the FAA. Even today, 40 years later, 30 years later, I got a few people I recruited who are still working as air traffic controllers. Most of them are supervisors now. I'm proud knowing how many folks I've put to work at FAA, and they're happy, too. As a matter of fact, they had a dinner once a year, a big dinner, and they named that dinner in my honor.

Is there a defining experience that you've had that was a struggle? Maybe something that you thought you wouldn't make it through, but it actually made you stronger?

Yes, I had a struggle in life. I was born on a slave plantation. My whole life, I went farm to farm, and I thought I'd never get out of it. In sixth grade, I had to plow a mule every day six straight weeks. And I was getting to think, How am I going to make it through life, without education? So I started studying at night. I would study at night, every night from the fifth grade through high school. I would plow all day and study at night. And I managed to get through high school.

I wanted to go for Tuskegee for school. So I applied to Tuskegee under the family work plan. They sent me a catalog and paperwork to fill out. My Dada made me a promise that spring: "I'm going to give you some money this year, I'm going to plow like a slave." But he changed his mind. He gave me 20 bucks. And told me, "Wait till next year." So then I joined the Army. And after the Army, I managed to get into Tuskegee. And I didn't know anything, so I took English over and over, three times. I took math three times. After one term I was on probation, my grades were so low. But I studied night and day, night and day. And I finally got off of probation. I couldn't sing in the choir, couldn't do nothing, my grades were so low. But I managed to finish Tuskegee in four years.

That's why I wrote a book. I want my kids to see that wherever you come from in this world, if you give folks a vision, you can get somewhere with your life. The title of my book is *It's Not Where You're From but Where You Wish to Go.* ∎

NORMAN C. FRANCIS

President of Xavier University, 91, New Orleans

Interview by Christina Watkins

Norman C. Francis was born March 30, 1931, in Lafayette, Louisiana. He came to New Orleans in 1948. Though his parents didn't graduate from high school, Francis credits them for teaching him how to live, respect people, always remember who you are, and make a living. Over a lifetime of service, Francis has received 40 honorary degrees and at least 20 major awards to recognize his leadership in education.

The army veteran was the first Black law student at Loyola University in New Orleans. He also served as president of Xavier University of Louisiana—the nation's only historically Black Catholic university—for 47 years. "The best things that could happen to me were to have had a law degree and be president of a university," Francis said.

He became president during the height of the civil rights era in 1968, housing the Freedom Riders on their stop in New Orleans. Francis shared what it was like then compared to what he sees now. "Unlike some of what we're going through right now, and I say this in all honesty, people haven't really yet dealt with racism," he said. "In part, yes, but in totality to the sense that each would respect each other, it's not there yet. We're not going back, but we got to know how to handle that, and what we've seen lately, we held our own, like Martin Luther King would have done—hold your ground, wait till your time comes."

While president at Xavier, Francis also worked as a civil rights lawyer, getting young Black men and women out of jail. "There were a number of organizations that all did God's work in getting freedom for people who didn't have money, who were being put in jail, and shouldn't have been put in jail," he said.

During his tenure at Xavier, more of the school's Black graduates attended, and graduated from, medical school than from any other institution in the nation. More than Harvard, Yale, Michigan, and Florida, to name a few. Francis said he remembers all of his students throughout those years.

In 2006, President George W. Bush awarded Francis with the Presidential Medal of Freedom, the nation's highest civilian honor. In January 2021, the city of New Orleans renamed a street in his honor, changing Jefferson Davis Parkway to Norman C. Francis Parkway.

Reflecting on his time as president of a historically Black university, and on seeing the injustices still happening, he said there's one way to a better America, and it's education. "We've got to have people who believe that education belongs to everybody," he said. "We have to learn from our history. We couldn't even be taught how to read or write during segregation. The future is education for our kids to start early. Let them know about Blacks who made history and did it from their own belief in themselves, and belief in we got to make a change." ∎

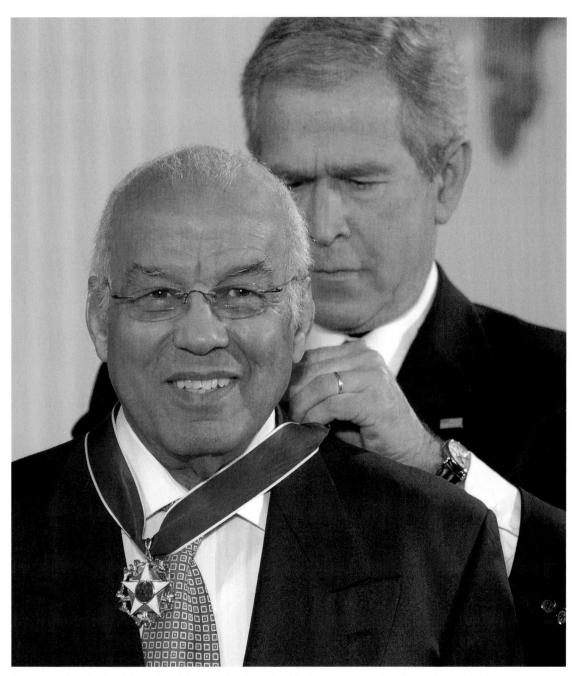

Francis receives the Presidential Medal of Freedom from President George W. Bush on December 15, 2006.

CLARICE FREEMAN

Educator and Community Leader, 101, Houston

Interview by Mariah Campbell
Portrait by Michael Starghill

From 1942 to 1945, **Clarice Freeman** was the only Black student at Eastern Illinois University (formerly Eastern Illinois State Teachers College). In 1953, she married Thomas F. Freeman, and the couple moved to Houston, where her husband became a renowned debate coach and philosophy professor and she made a name for herself as a prominent educator and community leader.

ON FINDING PURPOSE

My purpose is to shine my light and to be an example for others. That's what we're all supposed to be. These days, I'm always the oldest around. After I've spoken to high school kids, somebody always comes up to me and says, "Ms. Freeman, when I grow up, I want to be just like you." I think to myself, OK, I guess I've accomplished what I was supposed to accomplish.

ON EARLY LESSONS ABOUT RACE

As kids, we had no knowledge of what was going on with Blacks in America, because there was little to nothing in our textbooks about Black people—and if there was, it was that they had done something bad. I remember one lesson referred to slaves as thieves. But my grandpa taught us that they weren't stealing anything; they were creating. They helped raise the livestock on the farms. My grandmother, who was a slave, became very good at sewing, crocheting, and knitting.

Clarice and Thomas Freeman's wedding photo, August 2, 1953.

Freeman was honored with a car parade—a surprise—in the Riverside Terrace neighborhood of Houston on her 100th birthday, August 14, 2020.

"I remember one lesson referred to slaves as thieves. But my grandpa taught us that they weren't stealing anything; they were creating."

ON THE FIGHT FOR EQUALITY

After college, I joined the Congress of Racial Equality, or CORE. One of my first experiences with that group was shutting down a restaurant. A group of us decided to go have dinner at this place. And, of course, the manager met us at the door and told us, "No Blacks." We said, "We're hungry. We're not going away until you let us in." The manager closed the door and locked it, not allowing any customers in, including white people. Another time, we were fundraising, and I asked a local CEO for a donation. He looked at me and said, "When are you people going to stop begging and support yourselves?" I said, "Well, when we become CEOs just like you, when we have jobs that pay us just like you pay your employees, maybe we will have enough money to support ourselves."

ON READING AND DREAMING

When I was a kid, there was an old tree in our backyard, and many of the branches hung over into the yard next door, where my best friend, Pat, lived with her grandmother. That tree became a meeting spot for us. We would climb up in the apple tree and discuss the books we read and let our imaginations run wild. We talked about what we would become when we grew up. We had a lot of grandiose ideas—we were going to be known all over the world; we were going to be very wealthy and live in mansions. [Freeman's friend Pat is Patricia Roberts Harris, who went on to serve as U.S. Secretary of Housing and Urban Development under Jimmy Carter.]

ON 70 YEARS OF MARRIAGE

One reason I was able to stay married to Tom for so long was that I didn't depend on him to make me happy. We respected the fact that we were both educated; we felt secure because we could each make our own way. We didn't have to depend on each other for anything, really, only what we chose. We never had an argument—not once did he raise his voice to me.

ON HOW TO LIVE A LONG, HAPPY LIFE

Life can slap you down sometimes. But if you take care of yourself, if you have a sense of humor, if you live a good life, if you love yourself, you're going to be happy. And others are going to see that joy. My advice is to develop a strong spiritual life, choose your friends wisely—and love, just love. ∎

PEARLIE HARRIS

Teacher, 86, Greenville, South Carolina

Interview by Destiny Chance

Retired educator **Pearlie Harris** has been honored dozens of times in her community, including with the Bon Secours Pearlie Harris Center for Breast Health and on a massive mural project on the Canvas Tower in Greenville. "I'm amazed by all the things that have happened in my life," she said. "I didn't expect any of it."

Harris grew up in Saluda, North Carolina, moved to Hendersonville, and ended up in Greenville. "I came back here because my husband loved this place—because Greenville was a nice small town to raise children—but when I first came to Greenville I was afraid," she said. "I mean I was really afraid. I had to get on the city bus, I didn't see any Black people but me, and it was really frightful."

For 30 years, she taught in Greenville County schools. "Greenville was highly segregated back in the day, too," Harris said. "I had a teacher in fifth grade who was really mean to me, and I didn't decide to become a teacher until after I talked to my principal. He was responsible for me going to college. When I graduated, I went back to that teacher and told her I was going to be a better teacher than she was. Had some nerve, didn't I?"

A former student, Barbara Reeves, said Harris inspired her to become a teacher. "She was always happy, always smiling, singing, and made every day fun," Reeves said. "And in school, as a fifth grader, school is not so fun at some times. She made it fun, and I just remember wanting to go every day to be around her. She was just very animated, up walking around the room, like I said, singing. She would

teach us little rhymes to remember things and just be happy. She was genuinely happy to be at school. And wanted us to be happy. She genuinely wanted us to be successful."

Harris said that her experiences as an educator in the Greenville schools were not as sunny as her disposition might have made them seem. "I was

Harris is featured on a mural by Guido van Helten painted to commemorate the 50th anniversary of the desegregation of the Greenville County schools.

among the teachers who were selected to go into the all-white schools in Greenville," she said. "The superintendent approached me and said, 'We're going to send you to a new school next year and it will be all-white,' and he said, 'How do you think you'll do?' I said, 'I'll do fine, children are children.' And it was neither hard nor easy, but the children literally called me a n-----. And the parents did too. Big PTA meetings, they'd say, 'We never wanted a n----- to teach our children because they don't know what the white teachers know and they don't have the education.'

"My husband was overseas in Vietnam, and I decided, 'This year will be the best year these children ever will have in school the rest of their lives,'" Harris said. "And I was determined to be the best teacher in that school because I was Black. And I always felt we had to do 10 times more. We had an art show, and the parents were wowed; they didn't believe the students did that."

Harris also reminisced about some more positive moments. "Having a parent call me and apologize for calling me n-----, that was one of my best memories," she said. "It brought me to tears. I told her, 'This is exceptional. Because, who calls someone 20 years later to apologize for something they said that hurt your feelings, and now you're conscious of the fact that you did this?' I said, 'Why are you

doing this?' and she said she was becoming a teacher in her later years and 'I want to be the person you were.' You always have to take the higher ground. So I thought, 'Take the upper road and the people that talked—let them talk.' And I had children by this time, I have two sons, and I thought, 'I want someone to be nice to my children, so I'm not going to take it out on the children, I'm just going to smile and move on.' And that's what I did."

Harris also reflected on the unveiling of the Canvas Tower Mural and Bons Secours Breast Health Center: "Diversity, unity, love, compassion, heart—you have to have a love for children and people to be a teacher and to stretch yourself out in the community. I was going to do something different when I retired but I didn't know what, and all of this had fallen into my lap. I didn't even dream of sitting here with you today. I'm like, 'Where did it come from? What is happening, and what did I do to deserve all of this?' But I'm proud of the fact that it is me, and I hope it can be a part of what Greenville can say, 'She made us proud.'"

Harris has advice for educators: "Love what you do; if you don't enjoy teaching, don't do it. And become the best teacher you can be because your children come first." She added, "I'll say I've been successful at a lot of things, but I'm standing on the shoulders of a lot of people, and they're still lifting me up." ■

OTIS JOHNSON
Former Mayor, 80, Savannah, Georgia

Interview by Danae Bucci

Former Savannah Mayor **Otis Johnson** has had a front-row seat to history. Mayor Johnson was born in 1942, and government-mandated segregation was still the status quo when he graduated from Beach High School. The effects of that followed him off the school grounds. "We would go down to Broughton Street, which was the main shopping district, and we couldn't eat at any of the restaurants down there," he said.

Johnson's comfort zone rested within his community, where people looked, talked, and thought like him. "When we went outside of our bubble and got into the 'white community,' then there was always this tension of not knowing what to expect," he said. "And wanting to get back into the bubble as quickly as possible."

Even though he was secluded in a parallel world where he and likely many others were comfortable, Johnson says he always knew the fight for equality was important. "It's when we start breaking down segregation that we begin to see opportunities to be first," the two-term mayor says. "And we have worked that 'first' thing to death."

Another first, of course, is Vice President Kamala Harris, the first female, Black, and Indian American vice president in the nation's history—a feat thought to be impossible not that long ago. "I never thought I would see a Black president in my lifetime," Johnson said when asked about the election of President Barack Obama. "I didn't believe in my early years that I would live to see that. And to live to see him reelected. And to see him now in a place of honor. It's just, just so rewarding."

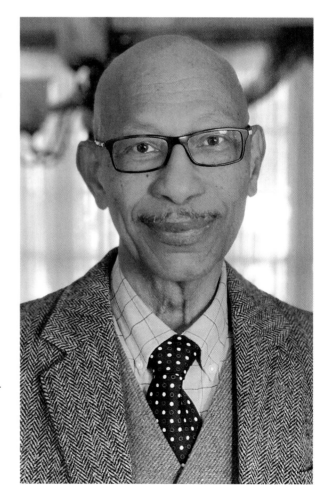

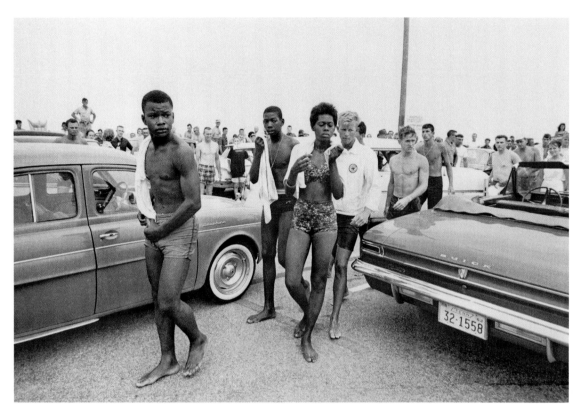

In July 1963, when Johnson was 21, three Black protesters were arrested for trying to integrate Savannah Beach.

All these firsts can foster the illusion of outright equality, which, Johnson said, is still far from being the case. "Blacks are more likely to die earlier, from preventable conditions, because they can't access affordable health care," he said. "We're more likely not to be college graduates, or graduates of technical schools that allow us to plant our feet in the economic sector, where we can earn a decent living and accumulate wealth.

"So yes, we have these one-offs all the time. I've been a lot of one-offs. But I don't take any pleasure in being the 'first' or the 'only,' because I look around and I see my people. And the condition of the collective is not what it ought to be. And until it is what it ought to be, I will never be satisfied with just being the one-off." ■

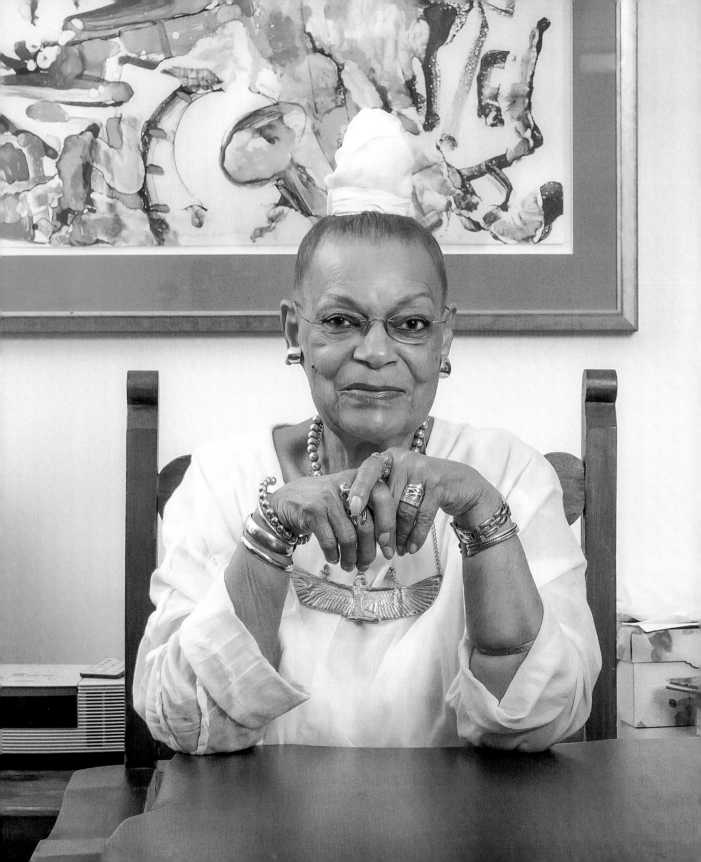

DOLLIE McLEAN

Dancer, Arts Educator, 86, Hartford, Connecticut

Interview by Jamiah Bennett
Portrait by Shaleah Williams

Dollie McLean's love for the arts started when she was a young girl growing up in New York. Because of her deep love and appreciation for the city, and the abundant resources available there for artists, she was hesitant to move to Hartford when her late husband, renowned alto saxophonist Jackie McLean, was offered the opportunity to teach at the Hartford Hart School of Music. She eventually agreed and was able to bring her appreciation for art to Connecticut through the development of the Artists Collective.

Jamiah Bennett *In one sentence, how would you describe the Artists Collective?*

Dollie McLean The Artists Collective is to celebrate, teach, help young people understand what their heritage is and to be proud of themselves.

What was the vision for the Artists Collective?

The founding of The Artists Collective was initiated by my husband, and his vision was to create a safe haven for at-risk youth to offer alternatives to the violence of the street, teen pregnancy, gangs, and drug abuse. I became the founding executive director, and it gave me the ability to coordinate all the pieces that went into it. But it was very difficult in the beginning. Once we began to get support from individuals who understood what we were talking about and the program that we thought we could develop, there was a great deal of support.

How did you and your husband respond to the initial resistance?

We had to step past it and ignore it. I was quite blown away with Hartford. In New York, if you go out anywhere, there are thousands of people. You don't see the same people. You also do not get to meet council people or the mayor of New York unless you are involved in politics. In Hartford, I found that I met the mayor and councilmen.

I can recall my husband coming home and saying, "You know, there's a young woman in Hartford and her name is Cheryl Smith. She teaches African dance to kids." Cheryl became a cofounder and the dance director. She never missed a meeting. She was there and always supportive. Cheryl borrowed space to teach dance. She was teaching at the library and anyplace she could find space. Ionis Martin, a visual artist, had a group that she had been working with. My husband had jazz musicians. Everybody was teaching out of borrowed spaces. I taught a few classes and had a few rehearsals happening out of Wadsworth Atheneum. We all came together and

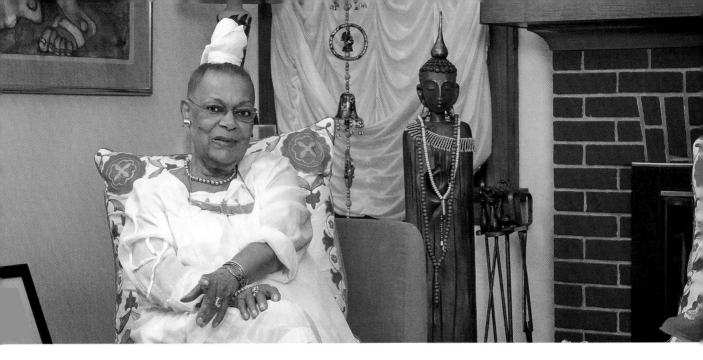

made plans. There was a lot of effort and a great deal of time that went into starting this. I think timing is of the essence for anything that a person wants to do. I think the time was right here in Hartford.

How did it feel when you got a building where all of your classes could be held?

There was a building on Windsor Street that was owned by two lawyers. The Hartford Jaycees helped us clean up the building and paint it. We had an open house on January 24, 1974. It was a Sunday afternoon, and the temperature was about 60 or 65 degrees. We had approximately 1,500 people come through. It was a magnificent day.

We stayed there for one year when I received a phone call telling me that the owners wanted to sell the building. After talking with some government officials, we were told there was an old school building on Clark Street. It was a beautiful building, but it was old. We got in there and rolled up our sleeves with any number of helpers. When we started the silk-screening department, we had posters made of Harriet Tubman, Nat Turner, Sojourner Truth, Frederick Douglass, Martin Luther King, and Paul Robeson. When doors opened, they would swing with our logo.

[Classes, activities, and events continued in the new building with the help of returning and new instructors, including Lee "Aca" Thompson, a former dance partner of McLean's at the Katherine Dunham Dance Studio in New York.]

Aca conceived the Rite of Passage Yabo Ceremony, which became one of the Collective's signature annual programs. Young people came in and they learned African dance, heritage, and culture. The ceremony would close with drumming, dancing, and a pledge which was a code of ethics that I developed, and the initiates had to say it as they stood up with their parents. If the initiate didn't have a parent, we would find someone from the community to be with them. I also developed "Skills for Living" under the Rite of Passage. It was really about all of the things we need to know in order to live.

The Clark Street building was wonderful, but it was tucked into a neighborhood. There was an open lot I would pass every day on Albany Avenue. I began looking at the possibility of that being our new

property. The transfer of the property, planning, and fundraising took 16 years, but I would not give up. The building is beautiful. It became a tribute and a testament to the culture of those people who gave their lives for our community.

Your many honors include being inducted into the Connecticut Women's Hall of Fame, and you hold honorary doctorate degrees from Trinity College and the University of Hartford. How does it feel to know that your program has touched people in the Hartford area and beyond?

You do what you do because you love it. It's wonderful to get awards, but I never think about that in those terms. They're all outstanding and well appreciated, but from time to time, I don't even think about them. The rewards are watching a little boy that comes in who can't read well and then he stands on the stage and he's magnificent, or a little girl learning her right and left. To me, those are the real awards, and I know that's what it meant to my husband as well. It's amazing what that does for a young person.

[One of the many recognitions the Collective has received was from Michelle Obama. She invited the Youth Jazz Orchestra to perform in Washington.]

There were 10 organizations that were selected as outstanding in the arts with youth, and we were the ones that were invited to perform. They requested the Youth Jazz Orchestra and a dancer. That was an exciting, wonderful time, to be invited to Washington by Michelle Obama. My son selected four major players—a saxophonist and a rhythm section (piano, bass and drums). We also invited a young man who had come to our dance department as a form of exercise after he had had polio.

We only hope that the Collective will be here for another 50 years. That it will be able to grow and change with the times and continue to do what it needs to do. I think what we did in the past and why the Collective was founded is needed even more today. From the very beginning it was my husband's intent to put saxophones, trumpets, and drums—not guns—in the hands of our youth. Everything that we did in the '70s is more relevant now. ■

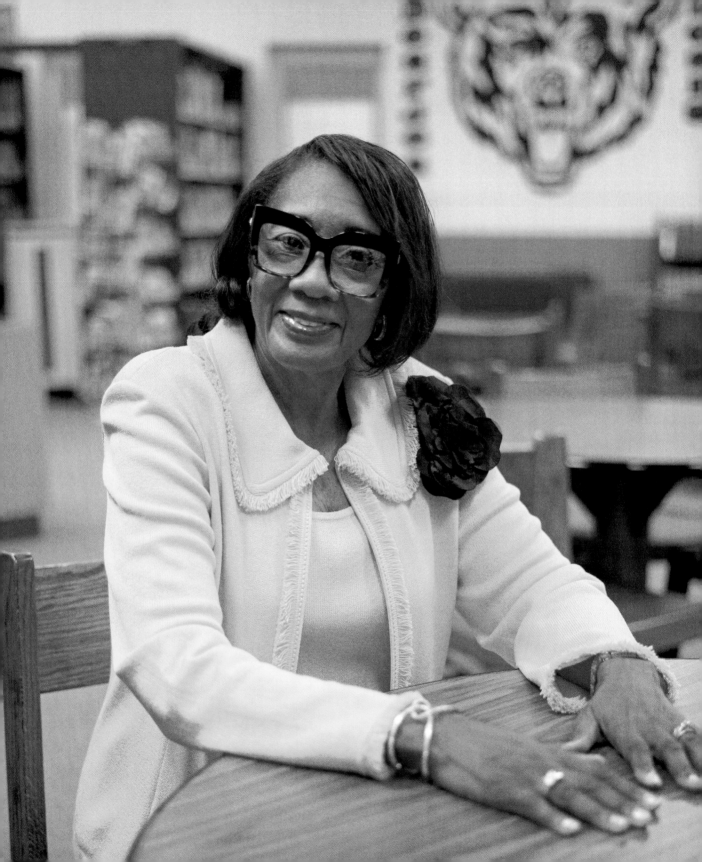

PEARLIE NEWTON

Guidance Counselor, 77, Bearden, Arkansas

Interview by Carly Olson
Portrait by Aaron R. Turner

Pearlie Newton is a retired English teacher and guidance counselor from Bearden, Arkansas. "Since my students were from a small town," she says, "I always wanted them to know that Bearden is your home, but that doesn't mean that you're always going to live here. There's a world outside of Bearden."

Carly Olson *Have you always lived in Arkansas?*

Pearlie Newton Always. All my years.

What makes it feel like home?

Arkansas is a great state, period. It has a lot of good scenic spots. But when my children were growing up, we did not confine ourselves to Arkansas. I wanted to do the same thing that my mom did for me—to expose them to other activities and areas that our town didn't have. We wanted to try and make sure that we let them know that even though you're from a small town, that does not define who you are, and once you know there's another world out there, you're just a microcosm of what is.

How did your mom impart that to you?

My mother was far ahead of her time. She was futuristic, I guess you could say. She knew what she wanted for her children. She wanted to give us the opportunities she didn't have, and she stressed education as a key. My mother wasn't a book-educated person, but she was well educated in the ways of life, the things that are most important. Knowing how to love, knowing how to give, knowing how to share, being determined, and not quitting.

I remember when we were children, just growing up—not necessarily children, but teenagers—she wanted us all to learn how to drive a car, and she would take us out, and she would teach us one at a time, depending on the age, and then she'd send us to the store, which was probably about a mile from where we lived. She always wanted us to travel, which was not very common during that time, because people did not have the finances and that kind of thing. She would always want to take us to a restaurant, and her idea of a restaurant at that time was just a burger place, but she wanted you to be able to order from the menu.

Now, this sounds just very ordinary, but it wasn't something that everybody would do at that time. Whatever she thought would expose us as we were growing up, she would do it.

You were an English teacher for many years. I always found my English classes to be impactful for exactly that reason. You can be exposed to other places in real life, but also through literature.

I tried to instill in my students a love for reading, but I always wanted them to know, just because you're from a small town, prepare yourself for a much larger world.

Newton at the podium during a 1990 meeting of the Arkansas Association For Counseling, Guidance and Development, where then-Governor Bill Clinton spoke.

You mentioned you went back to school for your master's degree after you already had kids. How did you do it?

Well, looking back, I'm not really sure. But at any rate, in order to be a counselor, I needed a master's, so I thought, "OK. I'll go back to school."

I didn't hire a babysitter. I just took the two kids with me during the summer, which is funny now. My youngest was probably 5, and I would just get them up in the morning, dress them, and we would drive to Arkadelphia, which is about a 55-minute drive. They had a nice student union, and my children were well-behaved, so they would sit in the student union while I went to class, and they would have puzzles, coloring books, and stuff like that.

After school, we still had family time, but usually I would study at night, in bed, and my husband would help me review and help me pass my tests. I would just give him the questions and say, "OK, ask me these and see if I know the answers." That was my way of learning and remembering while keeping him engaged, as well, so that he wouldn't feel he was just left out there by himself. Looking back, I can't even imagine how I did it, but I did.

It's inspiring that you just jumped into it and you just handled the challenges as they came up. Is that how you think about doing things?

Normally, I think about things for a long period of time, but with that, I guess I'd already worked it out in my mind. I knew I wanted a master's, and I knew I didn't want it in English, and I was just looking at my options, and I thought, "OK, we can do this."

How long have you and your husband been married, and how did you meet?

It's been 55 years. Our eyes met across a classroom. We were seventh graders, no doubt, but we just grew up together, probably six miles between where I lived and where he lived, but basically, we were in the same classroom and grade. You have no idea, but back in the day, you just kind of spotted somebody. You caught eyes. We didn't have the nerve to say anything to each other.

There's a difference between whispering "I like you" and being married for over 50 years! What advice do you have for maintaining a long-term relationship?

I think the best advice I could give any young couple is to be patient with each other, and be

"Young people need more patience, I truly feel, when it comes to marriage. Patience and commitment is the thing."

persistent in knowing you're going to make this work. You're not throwing in the towel when it gets difficult, but working through it. Just don't give up. If there's love, that's a good thing that will hold you.

My husband has been very supportive of whatever I thought I needed to do. He was always encouraging. One Christmas, and I do regret this to this day, he bought me a lambskin coat. It was gorgeous, but way out of our budget, and I said, there is no way I can keep this. But looking back, I think I should have just kept that coat and wore it. He wanted me to have it. It wasn't that I didn't appreciate it, I just thought, "We don't have that kind of money." He has always been a gift giver. When I finished my master's, he went and he bought me a nice diamond ring, and when I look back, he's always been there, and he's always been generous. It never mattered what it cost if he thought it would bring a smile or light my eyes, he would do it, and you know, I'm always the one watching the pennies and thinking, "Oh, we don't need to do that." So we balanced each other. He's just been there all my life.

Do you think opposites attract?

I think so. We are both tall and played basketball, but our personalities were different. He was a little more laid back and I was far more outgoing.

We're still, to this day, kind of opposite. The movies that he likes, westerns, I don't like those, but I watch them because I want to be in the room. Now we've got TVs in all the rooms, and I complain because he watches the westerns, yet I don't move to another room to watch.

He can walk in a room and I still know, "That's my man." I know when he walks in the room, even if I don't see him. It's like I can almost feel him. I don't know how, but I know. And he makes my heart skip a beat, even to this day.

What qualities does your generation have that you feel like some of the other younger generations might need more of?

Not throwing in the towel. Some stick-to-it-ness, if there's such a word. Just hanging in there and being determined, knowing that anything worth accomplishing isn't always easy. There will be some rough spots, but don't give up. I'm just not a quitter. I don't quit anything. If I begin it, I'm in it for the long haul. ∎

RUTH SIMMONS

President of Prairie View A&M University, 76, Prairie View, Texas

Interview by Treyvon Waddy

Ruth Simmons came out of retirement in 2017 to become president of Prairie View A&M University. She earned her bachelor's degree at Dillard University, her master's and doctoral degree in romance languages and literatures at Harvard. Before Prairie View, she served as president of both Smith College and Brown University in New England. She was named president of Brown in 2001 and became the first Black president of an Ivy League institution.

Treyvon Waddy *What has your experience at Prairie View been like so far?*

Ruth Simmons It's very interesting to be president of Prairie View. It's my first job ever in the state of Texas, being a native Texan. Second, being president of a state university is very different from my experience as president of private colleges and universities.

There's a lot of bureaucracy in state institutions, so finding a way to navigate that has been a major experience for me. It's wonderful to me because of the students, of course. I see them very much like I was at their age, striving, trying to get an education, and very hopeful about what they can do with their lives in the future. It is hard to explain how meaningful that actually is to me at my age, because I understand so much more now about the privilege I have to be able to do the work that I'm doing. So I'm immensely grateful.

Prairie View is of inestimable value to the state of Texas, and it's been around a long time. A lot of what you see in the state in terms of progress made by African Americans in this community is

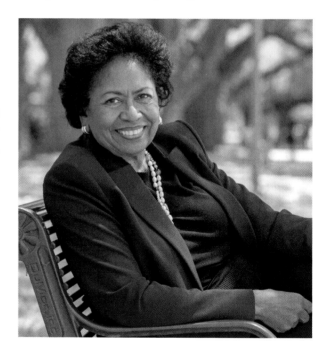

due to the existence of this university. And as a native Texan, to be a part of this legacy is especially meaningful because I understand what it would have meant if in 1876 the legislature had not created this institution.

What history does Prairie View have with Juneteenth?

When I think about meaningful dates in history across the country, I think about the fact that we of course celebrate the independence of the country. I don't know how many people understand how meaningful it was to African Americans to finally learn that slavery has ended and for African Americans to have been given their freedom. There is nothing that compares to that.

What do you do after you've enslaved an entire race for such a long period of time, giving them no rights to their bodies, no rights to their families, no rights to a future? What do you do when suddenly you declare that they are free? Well, there's a lot that you have to do. First of all, you have to make up for a lot of the things that they missed as human beings, and principal among those of course was the idea of education. The fact that Prairie View was created right at the end of Reconstruction in order to repair what had been done to African Americans makes our story intimately tied to Juneteenth.

There was a time when African Americans were embarrassed by Juneteenth, and so they did not speak of it in terms of our independence. I think it's nice that we're coming into an era where African Americans can declare openly and boldly what that history is and how they feel about it. That's a new kind of freedom for African Americans.

How do you personally celebrate Juneteenth?

In my family, and of course this goes back in Texas for generations, we tended to celebrate in the old-fashioned way. That is, we gathered in the country to have a common experience, and that usually meant food and barbecue, most likely. We started that when I was small and my family had been doing that, as I said, for generations, and we continue that today.

So we will have barbecue and we will have all of the "forbidden," "ethnic" things associated with us, because again, for a time, we were so embarrassed by the kind of tropes that were used against African Americans. Our love of watermelon, for example, and the other ways we celebrated were ridiculed, so the idea of Juneteenth is not only to acknowledge the history and sober nature of this holiday, and the sacrifices our forebears made, but also to say that we claim those tropes that were organized against us. We'll do those things and embrace our history with pride.

What advice to do you have for Black youth?

You will do as we did. And that is, you will learn and you will continue learning about the issue of race for the rest of your lives. You will learn that it is immensely complex, both the history and the current context.

What I learned over time is that each era has its own narrative for race, and we have to continue to be open to the fact that we are evolving as a society. With that evolution comes change about the nature of race. For example, we have many young people today who are of mixed race who have to find a way to organize their thinking around the fact that they are mixed race. When I was growing up, it was practically illegal for mixed-race couples to get married, if not outright dangerous. One has to think about the ways in which we can acknowledge and incorporate their reality into our history, while thinking also about the complicated ways in which African Americans in this country all have mixed blood.

There was a television profile on me once in which my family history was investigated. They identified a white relative of ours who lived in the same town. But that connection couldn't be acknowledged due to racism and discrimination.

So I say to young people: Be aware that you're part of a process of uncovering many, many stories that could not be told before. You are also in the process of uncovering untruths that have been promulgated since the 1600s. We are at the very beginning of this story that we have to uncover about race in this country, and so it is exciting to be a part of that process and understand you will be uncovering that history that has been missing.

I also say you must not be racist. Working actively as young people to deter racist thoughts, racist behavior, and race bias from yourself is the first work you have to do. If you see someone targeted because of their race, it's your duty to have the courage to intervene on their behalf. We have the obligation to show that we have learned from our own experience to be better around issues of race and class and sexism and homophobia, and all of the hatreds that arise when people are protecting their own identity at the expense of somebody else's.

Also, as I typically say in all of my commencement speeches: You're obligated to be engaged in the struggle. You cannot be passive. Finding ways that you can be involved and make a difference and change the future for those who come after you is an absolute necessity for young people.

What's the best way for Black Americans to get their voices heard?

Overturning the kinds of assumptions that we've lived with for such a long time. The most important thing during subjugation was for Africans and Blacks to be ignorant. Ignorant of the severity of the inhumanity they were experiencing. Ignorant of the ways in which they could combat their servitude. Ignorant of their ties to Africa. That was absolutely essential to impose that ignorance on African Americans. So the first thing is that we have to combat ignorance.

So the first obligation I see for African Americans is to love learning and to find ways to be informed. To think for oneself. To make judgments about what is good and what is bad, and not receive it from other people. To strive to be fair in all of our dealings, and so on. To combat ignorance is exceedingly important, so we must make sure that we are exposing people to the truth.

There are so many small ways to do that on a daily basis. Picking up a rare text and learning about something that nobody else knows about, or hearing about something falsely reported and calling it out for what it is. We love the phrase "speaking truth to power," but the truth really must be true. Speaking truth to power isn't just speaking out at what we don't like. It's speaking to what is real and authentic and humane and honorable.

I give my mother a lot of credit. Every day she spoke to us about being decent human beings, how to treat others, how to respond in a crisis, how to deal with oppression, all of those things. It's very important for us to do that with anybody that we encounter.

The African American community has a very long and rich history of helping others. Imagine being torn from your family during slavery. Imagine not having any security at all. African Americans learned to count on each other. They raised other people's children. They protected other people. That's been our tradition. If we can learn more about the history and values represented by our forebears, we'll be in pretty good shape.

What was your experience growing up in segregation?

When I was growing up, I had nothing to compare it to. Everyone I knew lived under the same burden. Everybody I knew was poor. Everybody I knew was exploited, so living within that context I did not feel on a daily basis overwhelmed by it because I simply didn't know.

"I say to young people: Be aware that you're part of a process of uncovering many, many stories that could not be told before."

I remember as a child going into town and experiencing the racism. We couldn't go into many places, and most notably we had to defer to whites. That meant if we were facing whites and they were meeting us on the street, we had to step aside to allow them to pass. We could never speak overtly or forcefully to a white person, and we could not look at them in certain ways.

It seems ridiculous now, but there was a code of behavior for Blacks in those days; almost anyone could severely punish you if you were out of line at all. Let's say I met someone on the sidewalk and I didn't step off and continued the way I was going. Somebody could discipline me right there. The power of so many different people to lynch and enact violence against Blacks was almost ubiquitous. Imagine living your life understanding that at any point in any encounter you could do anything you want to another group of people.

I always say the best thing my parents gave us was the ability to live to adulthood, which so many young people didn't get to do. The cost of that was suppressing who we were, suppressing what we thought, and suppressing our instinct to counter the bias that we faced. So it wasn't the kind of life one would ideally want to live, but here's the bonus aspect of it: We were in an environment with people who understood the massive show of inhumanity being perpetrated during those days, and as a community we organized to protect each other from the most vicious aspects of it.

When I went to school in Houston, the teachers were really something else. They made us see that it was possible that this structure would end at some point. They made us understand that we needed to be ready for a different reality. And the way to be ready for that reality was for us to become educated.

Was there a lesson you took away from that period that you apply today?

I guess what I took away from that time is the value of every human being. And one thing I never, ever want to do is think that someone is less than I am because of where they live, or because of the color of their skin, or where they come from, or because of how they worship. I think that frightens me more than anything else, that proclivity that human beings have to abase others based on their particular preferences and their particular ambitions.

In order for us to survive, we have to understand the fundamental humanity we all share. We ought to be able to see the fundamental humanity of human beings. I personally don't think that it's going to be possible for us to get out of this world alive if we don't learn that lesson. ∎

FLORA WHARTON

Horticulturist, 76, Cleveland Heights, Ohio

Interview by Sara Bey
Portrait by Cydni Elledge

In 1976, **Flora Wharton** opened her floral design business, Herb & Plants, in Shaker Heights, a predominantly white suburb of Cleveland. "Whether I was getting pushback from white people who were uncomfortable with me around, or even some Black people who said I was trying to be white having my shop in Shaker Heights, I didn't buy into it," Wharton says. "My passion for plants was my purpose. Nothing and no one was going to stop me."

Sara Bey *What first sparked your interest in plants and horticulture?*

Flora Wharton My mother named me after her aunt Flora Bell, who was the first Black head nurse at University Hospital. She always used to tell me "flora means plant life," so I was predestined to be a plant lover—it's who I am! But my father, Lewis Washington Wharton, truly inspired me. He was from Clemmons, North Carolina, and back in the day when he grew up, people grew their own food. So we had a garden in our backyard when I was a girl, and I always loved working in it. That was the way my father and I bonded. We grew tomatoes, cabbage, green beans—we would grow it all. My father was very popular in the Glenville area of Cleveland, and he would help other Black families by giving them fresh vegetables to eat right. He was the first entrepreneur I ever knew. Everyone else worked for GM or big companies, and my father had his own business as a builder. I was proud of that.

Tell me about your shop: Was it difficult as a Black woman to build a business in what was then a wealthy, predominantly white area of Cleveland?

A Black woman opening a plant shop in Shaker Heights was huge news. When I went to elementary school, it was Black and white kids together. When I went to junior high school, it all changed. All my white friends went to Cleveland Heights, and we went to Glenville. I lived through that racial divide of the city. I never let that hold me back. I believe people are people. My husband was an artist and had a studio in Shaker Square, and he told me that there were store spaces, so I decided to open Herbs & Plants. Every major newspaper and local magazine came out and took my picture. After the articles came out, an executive from Cleveland Hopkins Airport came to the store and offered me the contract to provide and take care of all of the plants at the airport. So from the beginning, I had great press, and that helped get the shop off the ground, and nothing was going to stop me. Looking back, it might have been more difficult than I allowed myself to realize, but I stayed focused on my goal.

"You have to have the courage and the entrepreneurial spirit to do this. Not all people can do this. They don't have the courage to do it, certainly in Black America, because we're still disenfranchised as a people in 2021."

Do you have any advice for young women who dream of opening their own business?

First, you have to have courage, because it is scary out here, especially for a Black American woman because we're still disenfranchised in 2021. And people will try to take your joy, which is scary. Get rid of all the joy robbers and keep looking up, even when you want to look down.

There's a movement among Black women today to "claim joy." Is there a time when you had to do that?

My husband used money to control me, and one day I had a serious a-ha moment—I realized I had my own money! I was so used to being controlled, it didn't occur to me that my business had become a success. I decided not to do what he told me, and it became scary. He came into the plant store one day and said, "Come on, it's time to go," in a very controlling way, and I knew I had to go on without him. As soon as I was able, I filed for divorce. I loved his talent, but I loved me more.

You were ahead of your time in your support for the LGBTQI+ community. Why was it important to you to be an advocate?

I'm the type of person who thinks whatever you are and whoever you are, that's wonderful. I don't believe in people judging people. When you're born, God makes you who he wants you to be. People will judge you for what you are, what you do, who you love—that is none of your business. You've got to live your own truth. I don't care what human beings think about me, because I know what God loves.

What's next for you?

I feel this opportunity to talk about my life has given me a new lease on life. I was starting to feel that when you get old, you become invisible. I didn't think anyone could see me anymore. This experience has made me think anything is possible. I'd love to help people find the joy that comes from having a beautiful garden. I always want to be surrounded by beautiful flowers and plants. ■

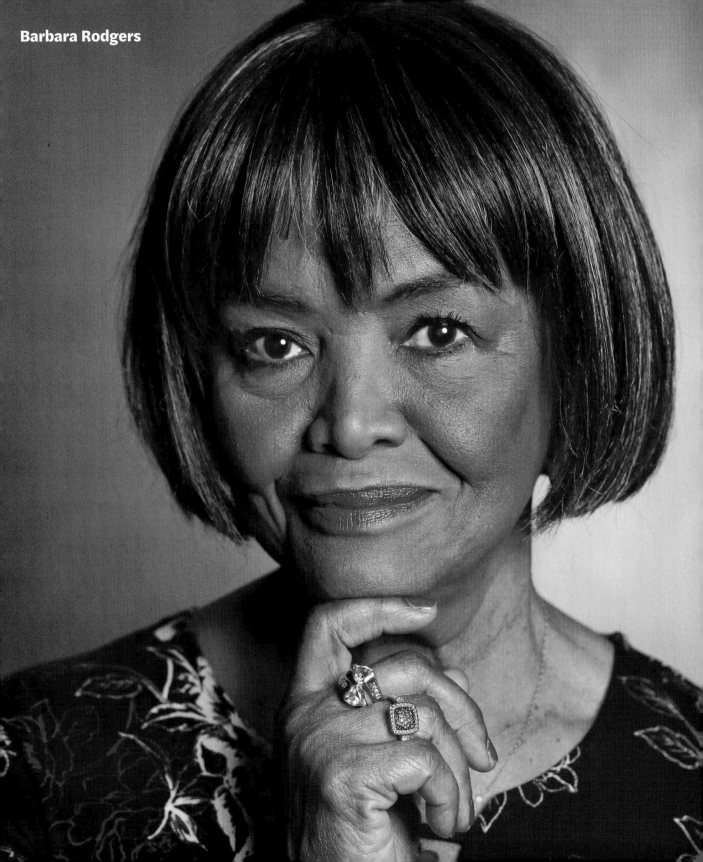

Barbara Rodgers

CHAPTER 6
Eloquence

ADRIANNE BAUGHNS-WALLACE

TV News Anchor, 77, Cornelius, North Carolina

Interview by Jamiah Bennett
Portrait by Paul Pettie

Adrianne Baughns-Wallace was the first African American news anchor in New England when she joined the WFSB team in 1974. Before becoming a broadcast journalist, she joined the Air Force and attended the State University of New York at Albany despite some doubts from teachers at her all-girls high school and a college professor of communications. When adversity followed her into her career as a journalist, she advocated for racial equity so that other Black people would not have to endure what she did.

Jamiah Bennett *There were times when you felt unsupported in your career. How did those experiences make you feel, and how did you respond?*

Adrianne Baughns-Wallace The first line of Black professionals coming into traditionally white organizations didn't know how to navigate, but we learned on the job, because we weren't going to be pigeonholed. When I got to WFSB, I decided that the most important thing for me was to influence how our community was being represented in the news. People assumed that it was all me, and it wasn't. We got together one night and started documenting what was happening to everybody and how we didn't feel comfortable going to HR at that time. We worked behind the scenes to support young people who were coming through and being made to feel as though they were totally incompetent. It wasn't that they were incompetent. They were not getting the same mentorship and support.

Can you describe the times when your group gathered together to share information?

Sometimes they were gatherings at people's houses. If there were events that we were invited to, we wanted to make sure there was a presence to try to raise the visibility. There were ways in which the community needed to learn how to advocate for itself. At that time, the producer would decide what was news, and the folks sitting around the table could advocate for things inside, but the best advocacy came from the pressure from outside. There was an education that we were all getting and needed to share within the community.

What was your group able to accomplish from sharing information about how Black employees were being treated?

We were able to persuade a WFSB producer. We talked about profiling the African American middle class, and it had never been done, as far as we knew, in television news at that time. That may not seem like a lot, but back then, that was an important

> **We need to look deeper. Who's running the organizations? Who decides what's news today? Who decides what the opinions are? Who decides the diversity of opinions? That's where the power is.**

series to put in. I think that began to help people open up their eyes to the reality of the perceptions of the African American community. That was also around the same time as *Black Enterprise*, so this was a great opportunity for us to highlight and profile not only the folks that got into *Black Enterprise* and *Ebony* magazines but everybody else in the middle, and the young people who were leaving universities and beginning to emerge in new sectors of the economy.

What was the response to the work that your group was doing?

I think the response was positive. My lens, for the most part, was how I chose to share with the general audience. I came in the old Walter Cronkite era. You just gave the news and you moved on. This is a whole new day.

How have you seen news change since you were a broadcast journalist, specifically with how Black Americans are portrayed?

When we look at the numbers of African Americans who show up on the screen, we're way ahead of where we ever were. We have a diversity of opinions. We can speak not only to issues that are germane to us directly as a culture and as a people, but we have a diversity of opinions in so many other areas—but we need to look deeper. Who's making the decisions? Who's running the organizations? Who decides what's news today? Who decides what the opinions are? Who decides the diversity of opinions? That's where the power is. That's not to demean the talented people who are in front and communicating and are delivering the truth and the information in journalism. I think that's going to be critical to our survival—not only as a people but as a country.

What would the news, or media in general, look like for you to think, "We've finally got it right?"

I think that our schools are going to be very important in that change, to some extent. Even the basic part of how we communicate and what our expectations are for our children. How do we teach folks—and not just by the textbook—about life? That would be an ideal world for me. The desire has to be nurtured in the earlier stages. You have to have a thirst for wanting to know more and be open to exploring other sides. I think that's part of education. It's part of a culture that our society would have to adapt. I'm hopeful that you, as young people, can see a future and that you have the energy, the will, and the desire to make it happen. We should be doing what we can to support you because the future is your vision now, not ours.

Is there anything else you want to say?

Someone asked me recently, "What would you tell your 30-year-old self today?" The word that came out was *bold*. I think that's somewhat connected to how I perceived myself as not having a level of self-confidence. I could do things behind the scenes more comfortably than I could up front. I look at these young activists today, and I'm just so proud of them. I just think they have such courage to confront systems. Unfortunately, I think that discrimination and oppression had such an effect on us. I'm glad to see that the succeeding generations are not feeling that level of pressure that we did at that point. So, I would say boldness. I think that's critically important.

In addition to being bold, what advice would you give to aspiring Black journalists?

To be bold, authentic, and get in good trouble just like John [Lewis] said, because whenever you confront any situation where people don't want to change, the truth has to be told. You've got to know what your point of integrity is. ■

MARIE BROWN

Literary Agent, 81, New York City

Interview by Sara Bey
Portrait by Flo Ngala

Marie Brown has spent her career in book publishing developing and promoting the work of Black authors and bringing attention to Black culture, first as an editor at Doubleday, where she rose to become the first Black woman senior editor in the company's history, and then, since 1984, as a literary agent at her own firm. She remains one of just a handful of Black literary agents in the country.

Sara Bey *Why don't we start by just talking a little about you: where you're from, where you went to school, things like that.*

Marie Brown Now, you know how old I am. This could go on for two hours. I was born in Philadelphia and left there at a very early age, as an infant, because of my father's work. He was teaching at Hampton, now Hampton University. It was Hampton Institute then, and he taught there for about eight or nine years and then accepted another teaching position and dean of the school of engineering at Tennessee State, in Nashville. So I spent probably the first 16 years of my life in the South in Hampton, Virginia, and then in Nashville, Tennessee. Subsequently, Daddy moved back to Philadelphia, which was his hometown as well as my mom's, and he accepted a job in Philly. So I transferred—in the middle of high school, which was traumatic—to go to school in Philadelphia, to finish high school in Philadelphia. What was interesting about that was that I had only attended segregated schools in the South, and when I went to register for high school in the second half of the 11th grade, it was the first time that I had attended an integrated school.

How did it feel to attend an integrated school?

I was sort of stunned at the difference. I could sense the difference in the classrooms because, at the time, Germantown was predominantly white, and there was one Black—African American, whatever we were then—teacher, Mrs. Wright. She taught math, and it was my understanding that she was the toughest math teacher, and I was blessed not to have her because that's my worst subject. So that was different, because I had some of the finest teachers that anyone could ever have, anywhere, at my high school in the South, and they were all Black. And they really tolerated nothing, no nonsense. It was like, "I know your mother and your father, and I know where you live," and that was it.

So here I was in this environment without friends, and I was the new girl in the middle of this student body who had grown up together. So that was challenging. The other thing that was challenging was that my English teacher and my French teacher really, really gave me a hard time, and my mother had to make several visits to the school, because the English teacher, first of all, accused me of cheating because it was just impossible that a Black girl from

Brown when she was an editor at Doubleday in the mid-1970s.

the South could even know these things. Mind you, my mother was an English teacher. The French teacher, she refused to believe that I could speak the language and translate the way that I did, but she had no idea how my French teacher in Nashville, Madame Williams, tolerated no English in her class, and we were expected to excel. So my new teacher would say things like, "Well, you must be Haitian, because you speak French."

You talking about your Southern teachers reminds me of how my grandma taught. No nonsense! Now, I realize we're taking a big leap forward, but how did you get into publishing?

I was mid-20s, working as a coordinator in the office of integration and intergroup education, responsible for programming in one of Philadelphia's eight school districts. That's when I met a woman,

Loretta Barrett, from Doubleday. She came to one of our in-service training sessions to talk about the new multicultural books that were being published, motivated by civil rights advocacy and Black history. As it turned out, she had taught with my mom in Philadelphia, and she discovered that I was Mrs. Dutton's daughter and invited me, whenever I was in New York, to have lunch. So that's what I did. My best friend and I went off to New York, and I called Loretta for lunch, and she said sure. It was a very publishing-type experience, very fancy, in a French restaurant, something I had never experienced in my life, ever.

She suggested that I speak to some people at Doubleday about what I was doing in the school system with multicultural books because she was editor of a new series of multicultural books, Zenith Books, and Zenith Books had been conceived and launched by a Black editor, possibly the first Black editor in trade book publishing, Charles Harris. I said, sure, I'll talk to the powers that be or anybody else interested in knowing what I'm doing in Philadelphia. They set up meetings so that I could discuss my job in Philadelphia and which books were the most popular in the curriculum, and so on. And as it turned out, it was a job interview. I don't even know if they knew it when I walked in the door, but given the fact that this was the era of affirmative action, and they were not finding too many Black folks hanging around and wanting to pursue careers in publishing, here I was, all the way live. And they said, "Oh, would you like to have a job?"

So I went back to Philly, and I thought about it, and I said to myself, Well, I can always return to the school system. I don't know when this opportunity will occur again, and I love books—and mind you, Sara, I knew nothing about the publishing industry, just like most people don't. Because we just don't have the exposure. I didn't know anybody except Loretta, who I just happened to meet by chance. So, anyway, I said OK.

What were some hurdles that you had to jump over when you began your publishing career?

Well, it was sort of challenging to be considered the authority on everything Black, and that's still the case. And I experienced blatant racism and as well as very subliminal racism, where, in professional spaces, the N-word was used, and it was like, Oh my God, this is something that you have to really figure out how you're going to manage these circumstances, and I did. I had to determine how I was going to continue working in that environment and not lose my soul.

That kind of leads into my next question. Was there anything you noticed when you first began working in publishing that you didn't like and really wanted to change? Maybe along the lines of how Black people were represented in books?

Well, the fact is that we weren't represented in books. There was a void. Otherwise, I would not have had that job. Representative Adam Clayton Powell was the one who really triggered the action by publishers to start looking for people like me to work in the industry. He had a hearing in the House of Representatives on diversifying book publishing, both in terms of career opportunities and the books themselves, publishing more books. You can't even imagine anything like that happening today, but he was the chairman of the House Education Committee, and so he commanded the publishers to come to Washington to testify, just as you see in any of these other hearings, about: What are you all doing? Oh, so you're not doing anything. But what now? What are you going to do about it?

And that's when everybody got on the bandwagon, in the 1960s up through the early '70s, and produced many, many books, many multicultural books. A lot of them were not good, but many of them were, and it also offered opportunities to writers who now hold an iconic place in American literature. So

when I showed up, I was able to pursue my interest in African American or Negro history and life and culture, or whatever it was that we were calling it, and Doubleday was really very good about allowing me to attend conferences and to cultivate various scholars to produce books and so on. So that was really a very satisfying period for me.

How did you become an agent?

I was a senior editor at Doubleday, and I left to become editor-in-chief of a startup Black women's magazine, *Elan*, which folded after three issues, and I didn't know what I was going to do then. I tried to find a job in book publishing again, and it was nearly impossible. A number of white editors with whom I had worked had been offered phenomenal jobs, and when I went on interviews, it was as if I couldn't read. I said, I don't know what you all thought I was doing for these past 10 years with these award-winning books and books that are still in print—and some of them are still in print today. I was beside myself. Eventually, I ended up working in a bookstore for two years. And I loved it, and I became assistant manager and assistant buyer at Endicott Booksellers, on New York's Upper West Side.

While I was there, people were calling me and saying, "You should be an agent," and I said, "I don't want to be an agent." Editorial was my beat, and I loved it, but I didn't want to be an agent. And they said, "Oh yeah, but now, publishers are requiring most authors who we're considering to come through agents because we're receiving too many submissions." So people were saying, "We'll send you authors, and you represent them, and then you'll get a contract, and you'll be able to work as an agent, and you'll see how you like it." It took me a long time to really adjust to being on the other side of the fence, so to speak, when before I was the one who was acquiring books as an editor. Now I was trying to sell them to the publisher.

"

If I went too deep into the culture, nothing I could say could convince people that there was an audience for that book. If 90 percent of the people you're working with don't know any Black people at all, it's really hard to convince them that we exist in great numbers.

How do you think your experience, as a Black woman specifically, has shaped your life journey?

That's a good question, Sara, because I think about it, but I don't express it often because nobody asks me. But the fact is that I had to make deliberate choices. Looking back, I don't consider myself an icon, or a survivor, or any of those other titles that have been given to me at this stage of my life, but I was someone who really understood what an opportunity was. And the opportunity was to work in a field that I loved and to stay focused, not to become caught up in being Marie Brown. Because otherwise I would not have been able to do the work, you know? I would just be someone going around and being a role model, at speaking engagements and all of that. So professionally, I think that I have learned how to be focused. And what I am doing socially is related to all of that; I have been introduced to the best of our cultural world through the work that I've done, all various forms of art, whether it's visual art or performing art, it's all been integral to my development. Because of publishing, I was able to experience these wonderful aspects of Black life.

And the key to that is Black life. I learned, sometimes the hard way, how to function in that world, that corporate world, that publishing world, but at the same time, I've never chosen that majority-world life over my community and my culture, because that has strengthened me. When you say, "Oh my God, how am I going to get up and do this another day? How am I going to go back into the battle?" But it's the beauty. It's the beauty of Black life. It's the challenges of Black life. It's being able to see what strengths you gain from all of what we have been through.

Harriet Tubman is one of my great, great heroines, and I keep telling people, "You can work hard. As a Black woman, look what Harriet did. You wouldn't even know how to get down your block without a flashlight in a blackout, let alone go through a forest in the woods with snakes and animals and everything and lead people to freedom. So don't tell me you can't. You can't do what? You can't get up and go to work every day? You can't stay the course?" Because I've seen so many people quit, just quit, I can't take it. I have been strengthened by this journey, and the deeper I get into the knowledge—because books bring knowledge, and what I understand is that they are documents that last for eternities, which is another reason why it's important for us to be in it, and it's another reason why I have learned to honor the fact that I've been given this responsibility, and I just have to stay the course. And the strength that comes from staying the course is amazing. You don't know it until you do it. ∎

DOROTHY BUTLER GILLIAM

Pioneering Reporter, 85, Washington, D.C.

Interview by Kenia Mazariegos
Portrait by Michael A. McCoy

When **Dorothy Butler Gilliam** arrived at the *Washington Post* in October 1961 to work on the city desk, she was the first Black woman ever to be hired as a reporter at the paper. She went on to become a legendary reporter, columnist, and editor, as well as an activist dedicated to public service. Gilliam served as president of the National Association of Black Journalists from 1993 to 1995. In 2010, the Washington Press Club honored her with its Lifetime Achievement Award. Her memoir, *Trailblazer: A Pioneering Journalist's Fight to Make the Media Look More Like America*, was published in 2019.

Kenia Mazariegos *An icebreaker: What is your biggest pet peeve?*

Dorothy Gilliam One pet peeve would be people who only talk about themselves. That's kind of a strange way to begin an interview, but it's important for me to respect the humanity of everyone, and somehow, when people talk about themselves it just feels . . . small.

I know what you mean—but this time around, you're going to have to talk about yourself! You were in your late 20s when Jim Crow ended, so you experienced it firsthand—the depression, the discrimination, the unfairness of treatment. What was it like growing up around that time?

Well, I am who I am because somebody loved me. People in my family, my church, my community. And even though Jim Crow had all hell breaking around us, because of our love and care for each other and the way we conducted our lives—which is very much in the Black tradition—we were able to live a life that gave us strength, that gave us meaning, that gave us a way to be helpful to others. A way to really know that we were not what white people in the Jim Crow South—I guess we'd have to say white-supremacist South, even then—we weren't who they said we were.

Was there a moment in time during your childhood when you realized that you needed to be tough, that this wasn't going to be easy for you or your family?

There were many moments. As young people, we would be walking to school and white kids would throw rocks at us. Our teachers and our families said, "Don't fight back, we will not be the kind of people they are." Not fighting back was tough. But in the end, it was the right way to go, because with all that happened, we still never became haters, even though we knew that our schools were getting the used books and the white kids were getting the new books, and there were just so many obvious discrepancies.

We had a sense of dignity and purpose. My father was a minister. He was a leader in our community. My mother had trained as a teacher, but when they moved from the country, where she could teach, to the city, she did not have the credentials that were required. So she worked as a domestic. And as much as I resented that she had to do that, and as much as I'm sure it was difficult for her to be trained as a teacher but to have the only job open to her be a domestic, she was a person who would never let anything destroy her dignity.

I recall when people would call her to come and work for them and they would say, "May I speak to Jesse?" And I would say, "Do you mean Mrs. Butler?" And my mother would say, "Give me the phone, Dorothy!" And then, "Hello, this is Jesse." That always hurt me, but her sense of self and her dignity was much more than what was required.

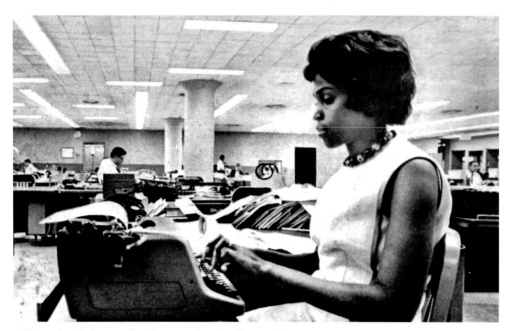
Gilliam at her desk soon after she started work at the *Washington Post* in 1961.

It must have been easy for some people, during that time, to give up—to not achieve. At what point did you know that you weren't going to stick to societal norms and that you would pursue journalism?

I was about 17. I was a freshman at Ursuline College, a Catholic women's college. I got a job at the Black newspaper in Louisville, the *Defender*, as a secretary. I had been learning to type, take shorthand, and all those things. And one day the editor came in and he said, "I'm going to send you out to cover a society story because the society editor is sick."

I was surprised. I had never been exposed to Louis-ville Black society, but when I began doing that, I was able to see that there were so many different worlds. This was a different world—the Black middle class, who had Waterford china, and beautiful dishes, and things my family didn't have. It was my ability to see that journalism could open and expose me to new and different worlds that really pushed me into the profession.

I decided I really wanted to train to be a journalist, and I was able, after the first two years, to go to Lincoln University in Jefferson City, Missouri—but at each step, the white supremacy was just always pushing hard against us. For example, the school I wanted to go to at first was the University of Missouri at Columbia, Missouri, and it turned out that every time a Black woman tried to get into that school, they would find a way to push and not let her enter. I ended up saying, I will go where I know I'm wanted! And that was Lincoln University.

I wanted to be able to write stories for the mainstream press that would really show the diver-sity among the Black community and show who we were. I mean, when I first arrived at the *Washington Post*, I overheard one of the old-time editors say, "We don't even cover Black deaths because they're just cheap deaths." To hear that kind of horrible statement coming from a newspaper editor is a good example of how deep this whole system was in American society.

What was happening at the moment you first stepped into the Washington Post *as the first Black reporter?*

I felt fear and apprehension. When I first walked in that newsroom, I recalled one of my professors at Columbia, where I had finished graduate school, saying, "You have a double whammy. You are going to have a tougher time both for your race and for your gender." So that's saying that my personhood—you know, separate from what I could do, just my very personhood—was going to be challenging in this industry. Yeah, emotions were—as I said in my book, *Trailblazer*, I felt like I was jumping into a rapidly moving ocean, and I had to jump in with a lot of white men who were seriously anxious to hold on to their power.

You covered the racial integration at the University of Mississippi, where James Meredith was denied admission for being Black. What was that like?

It was frightening. Mississippi's segregation was so deep. It was a lynching state. I mean, it was a state where Blacks were routinely strung up in trees, and wherein they'd have a lynching and people would come from all over to see it. They'd show the hanging Black body to children. Mississippi was very angry that James Meredith had the great will to integrate the University of Mississippi because it was a bastion of white supremacy.

I ended up sleeping in a funeral home because there were no hotels for Black people to sleep in. Sleeping with the dead was not an experience that I remember cheerfully, but I was glad to have a place to sleep—and, certainly, nobody bothered me.

The other thing I remember is just the bravery of the people, the courage of the people. I interviewed so many people in the community, and they were filled with fear, yes, but with hope. "My goodness," they said. "It actually happened! Somebody actually integrated that University of Mississippi." But then when I went to interview Medgar Evers, it was

just startling, his courage, because he said—despite all that was going on, when I left Oxford with the troops, with the Ku Klux Klan walking around with guns being displayed, with all these fanatics from all over the country who came to protest that, you know, the federals were taking over. It happened. Medgar Evers at that point was the NAACP field secretary, and when I interviewed him, he said, "Oh, we're not finished." He said, "This is just a first step. We're going to be integrating, you know, all the state colleges." Blacks were paying taxes that helped to support these institutions, they just were unable to enter them. So he said, "Our goal is to integrate all of these schools," and when I heard him say that I thought, What courage!

Seven or eight months after I interviewed Medgar Evers, he was assassinated outside of his house, and what they would say is that this is the price our people had to pay for freedom. And part of it comes from, in the case of Medgar Evers, his love for Black people, his knowledge that things had to change, and his willingness to do what had to be done. He was not naïve thinking that perhaps nothing might happen to him. He knew that, you know, he was being constantly hunted down.

Did his death contribute to your work in activism?

I don't think it directly did, but I do know that part of my deep desire was to try to make journalism a profession—and I'm talking about daily newspapers then, of course; you know, things have changed tremendously now—but to try to make journalism a place where we could talk about the reality of America. Where there'd be enough people of color to share honestly and to write the stories that displayed the reality of what was going on. One of the things that kept me at the *Post* for so long was that I was able to begin writing a column in which I could really share my opinion of what was going on, and then I worked as an editor, where I could hire reporters who could come in and could write articles about what was happening in the communities from a deep and informed perspective.

"

For me, journalism was a way to begin to push against the norms and try to have a way to let whites—those whites who would be open—to begin to know much more about the Black community.

Are you happy with what's going on in the newsroom now, that there's more diversity, that Black women are able to wear their natural hair on camera?

Yes, even the changes that have happened in 2020, especially after the death of George Floyd and the pandemic, Black Lives Matter—those changes have been very positive. I want to acknowledge the changes that have been made. I'm happy, for example, that the *Washington Post* has hired an African American woman as the managing editor for diversity. But I still feel there's so much work to be done.

What would you tell a new journalist who's trying to break into the field, someone who just graduated from school?

Well, I do still mentor people, and there's a young man I mentor who is not just breaking in, he's been in a while, but it's still important to bring all of the necessary skills, and it's important to bring a level of courage, in terms of writing about subjects that may not feel so comfortable in the newsroom. You've got to really understand how to do your work, to do it well, to do it quickly, but you also have to be willing to take some chances and push to do some articles that may not be popular.

I remember when I was writing columns, it got very uncomfortable because I was saying things that they didn't want to hear, or they didn't want to print, but they did print them. As a matter of fact, I'm compiling a book of columns that I wrote in the '80s and '90s, and part of my wish is to show their relevance to today.

One of the things I did when I was president of the National Association of Black Journalists, I interviewed a lot of the journalists to see how they were feeling, and they said that the white editors were very resistant to a lot of their story ideas. I've seen the same thing on college campuses. When I was working at George Washington University—I started a program for young people called Prime Movers Media—the GW students would come to me and say, "I don't want to work on the college newspaper because these white editors continue to say 'That's not a good story, nobody cares about that.'" So it's really important for editors to have a more open mind, and to understand the importance of diversity, and to write stories about what's really happening.

I think the media failed terribly during the Trump era when they gave so much attention to Trump when there were so many other stories that needed to be written, and I hope that there will continue to be a more open-minded attitude on the part of media. People are going to have to change their way of thinking. ∎

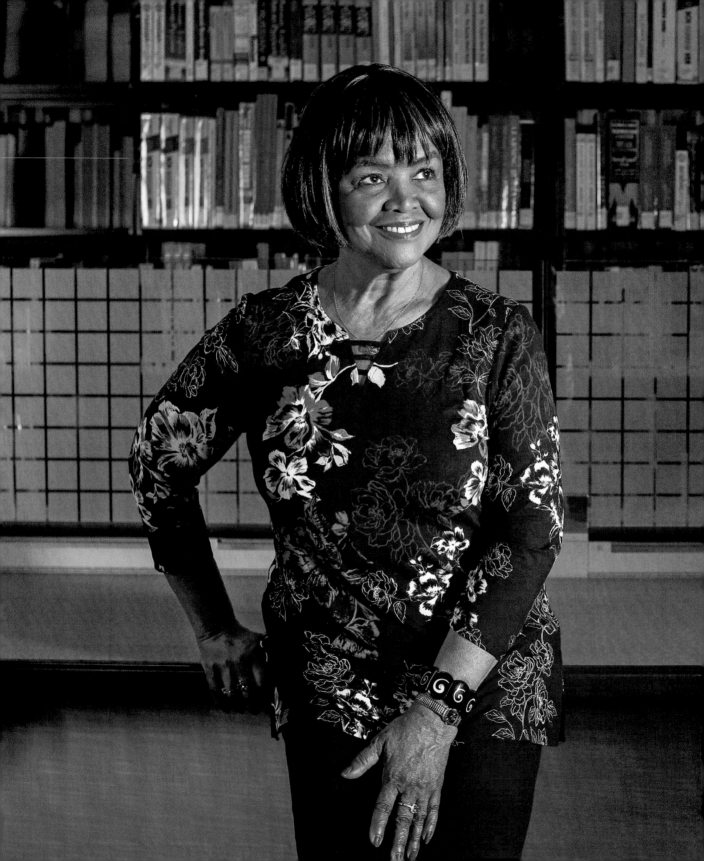

BARBARA RODGERS

Broadcast Journalist, 75, San Francisco

Interview by Mya Vinnett
Portrait by Yalonda M. James

Barbara Rodgers made a career out of listening. When others downplayed or dismissed voices at the margins, she paid attention. A Bay Area broadcast icon, Rodgers arrived in San Francisco in 1979 to work at KPIX *Eyewitness News*, where she was the third Black female reporter in the station's history. Shortly after that, in 1982, she cofounded the Bay Area chapter of the National Association of Black Journalists. Across three decades, Rodgers took on many roles at KPIX, including anchor, reporter, and show host, winning eight Emmy Awards in the process. After leaving the station in 2008, Rodgers went on to cocreate and cohost *The Bronze Report*, a news program focused on in-depth coverage of the stories impacting the Black community in the Bay Area.

Mya Vinnett *You were born in Knoxville, Tennessee. Can you explain what kind of opportunities were available for people of color and women when you were growing up?*

Barbara Rodgers None. Well, I shouldn't say none. None that related to anything that I wound up doing. When I was a kid, people always used to ask us, "What do you want to be when you grow up?" Growing up in the South during Jim Crow when everything was segregated, your options were quite limited. I used to always say I wanted to be either a ballerina or a police detective.

I had not set my sights on being a journalist. In fact, I had not thought at all about being a journalist, because I knew no one—no females, no Black people, no people of color—who were journalists. But I liked watching the news. With my father, we watched Huntley-Brinkley every night, and that was the main TV news anchor team back in the '50s. It was

fascinating, but I never thought of myself as being the person who would sit behind the anchor desk.

You started your career as a computer programmer for Kodak. What did that job teach you?

I think one of the things I've learned about me over the years is I'm willing to take risks. That was a big risk—going to a city where I knew absolutely nobody, going to work for a Fortune 500 company. Here's this little girl who didn't even know she was going to get to go to college, who took her babysitting money and paid for the SAT, gets a scholarship, goes to college, comes in out of the rain, gets offered a job with a Fortune 500 company, and moves into a whole new world that opened up. So, I became a computer programmer and absolutely hated it.

They found me a job in the public affairs department. My first assignment was to determine why they were not getting very many Black applicants for their

Rodgers in 1972 on set with her co-anchor, Al White, at WOKR in Rochester, New York.

clerical jobs. I spent three months interviewing all kinds of people around the community, and talking to people who had applied for jobs and had not gotten them. And the bottom line on the report was that Kodak didn't get the applications because they don't offer Black people any jobs. Word gets around. That was not the answer they wanted. So that did not go over well. Ultimately, they sent me to work on another project on housing for minorities, and I was working under the human relations commission. What I found out later is they loaned me out with the idea that I would get nothing done, because they weren't quite ready for me to tell them the truth.

You started on TV in Rochester, New York, with some occasional appearances. Can you pinpoint what led you down the path of journalism?

There was a group called Action for a Better Community that had been pushing for jobs in all kinds of areas, and one of the areas that they were pushing forward in was television, because there were no Black people on TV.

The guy who had been on audio the first time I had been on, he had an idea for a program, and they kept turning him down. Now the pickets were out every day. The station wanted to get rid of these people, so they went to him and said, "What was it, that show you wanted to do?" It was a show aimed at the Black community, and they were like, "Well, what do you need to do it? Do you have anybody in mind?" "Yeah, that girl who was on the show."

What they had really done was committed to 13 weeks of doing this public affairs show, which was unsponsored, so they said, "We can't pay you." I kept my day job. But what a surprise when you have not programmed for a group of people forever and then suddenly you give them something. At the end of the 13 weeks, the show was very popular. They renewed for another 13 weeks, and that show stayed on. I think it was still on when I left, probably stayed for 15 years.

You were the first woman and first Black person hired in the news department in Rochester. When you moved to KPIX 5 in San Francisco, what was diversity in the newsroom like there?

Oh, very different. San Francisco is very diverse. Still, I was only the third Black female reporter they had hired. Even today, there are Black women on a lot of the other stations, but my former CBS station in San Francisco still does not have a Black female reporter or anchor.

"Journalism was the job I was supposed to have. I just didn't know it. It had to find me. I didn't find it."

There are still many areas in entertainment, journalism, and life in general where there are a lot of firsts to come. As someone who has been a first many times in your life and your career, what advice would you give to all of the firsts who are yet to come?

I think the main thing that you have to remember is, whether you're the first or the 15th, that you have to be true to who you are. You also have to have your own standard of what I consider a standard of excellence. I worked hard, no matter what I was doing. That's why I was successful, because I worked hard.

What would you say has been the biggest obstacle you've had to overcome?

Probably the biggest one was trying to convince them to pay the kind of money that they should have been paying me based on my value, based on the work I'd done, the numbers of awards I'd won. You know, all those things that normally you would look at and say, "This person deserves this level." It was—it still is—hard for them to see a Black female as being the equivalent of a white male.

It was a great job in so many ways that, the parts of it that didn't work, I chose not to focus on those.

You have eight Emmy Awards, you've interviewed stars, you've been viewed by millions of people throughout your career. What do you think your greatest contribution to the world has been?

Listening and hearing what people have been saying for a long time, and nobody was listening. That's the main thing: listening. Paying attention to what you hear and not going to a story thinking you already know the story, because sometimes you miss what really is the story if you go in with your mind made up. Some of the stories that I got awards for or got nominated for awards were stories that had been done as throwaway stories by other people, and I saw something different in them. ∎

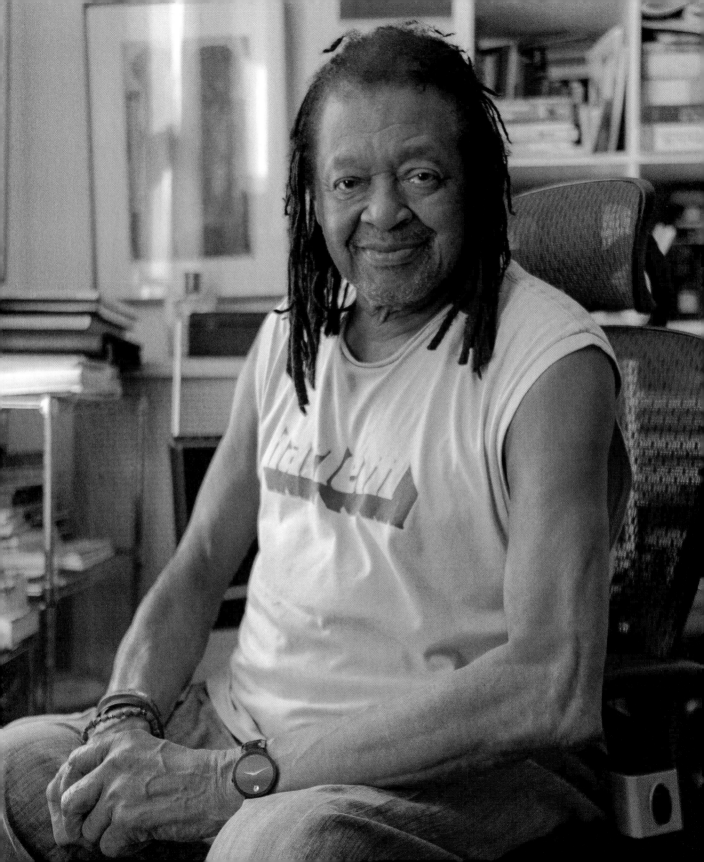

QUINCY TROUPE

Writer, 81, New York City

Interview by Sara Bey
Portrait by Stephanie Mei-Ling

Quincy Troupe is a poet, journalist, and biographer. An interview he conducted with jazz trumpeter Miles Davis, published in 1985 by *Spin* magazine, led to his collaborating with Davis on *Miles: The Autobiography*, which won an American Book Award in 1990. He has published an additional 19 books, including *The Pursuit of Happyness*, which was the basis of the 2006 movie starring Will Smith.

My father was 6′3″. He was a legend in St. Louis, as a baseball player and basketball player. My mother . . . I had a great mother. She was a little woman, 5′2″, and beautiful physically and inside—but she didn't take no stuff. He was a ladies' man, and my mother didn't like that. She threw him out because she caught him doing all kinds of stuff, which was a shattering thing for my brother and me.

My father always expressed regret for doing what he did with my mother, which humanized him in my vision. But she still wouldn't take him back.

We had a comfortable life, in a way, because my mother worked and my dad always sent money. We lived in a house at first, but then when he moved—I don't want to say that he stopped sending money, but we had to leave that two-story house that we lived in, and we moved downtown. It was about a six-room flat, but it was not the same kind of place as where I was born and raised. That house had a backyard and it had a front porch—and we moved to the second floor over Joe's Supermarket.

My brother, Timothy, was always interested in playing drums, and I was always interested in sports.

I became a very good basketball player and baseball player. I went to George Washington Carver Elementary School, which was a two-block walk over to Bell Avenue. So we had to go past the tavern and go across Franklin, which was a terrible street at that time. We had to leave our neighborhood, and there were gangs in every one of those little neighborhoods. I remember people dying up under the window, right at our front doors. My whole life changed at that point. At first, I was this happy-go-lucky guy, having a great life and being a little kid, and then, all of a sudden, you know—because there were a lot of cutthroat guys in the neighborhood.

But I was a really, really good student. And because my mother had books around the house, I loved books. At an early age, I read all kinds of books—I just loved the books. Every time I would go out, I'd have a book in my back pocket.

After my father and mother divorced, she met another man who was a musician. China Brown. He had his own band. He was a bass player, and he had a band that was at the Riviera, which was the big music club in St. Louis, where everybody came—Billy Eckstine, Nat King Cole, all the great Black

singers. He was in the house band, so he made some money. So the next thing I knew, my mother told us we were going to move to the North Side.

By this time, I had entered Vashon High School—which was another problem, because to get there you had to go through other gangs, you know. But my cousins, all the boys and the girls, were really tight-knit, so we all hung together and nobody bothered us.

We were the second Black family on our block, and we moved over there into a very nice house, a very nice house. The white people never spoke to us. This white woman who lived next door to me and her family—the girl was about the same age I was—went to Beaumont High School. I transferred to Beaumont, but she never would speak to me. It was seven of us Black people that went to this school, Beaumont. Seven. We stuck together, because the white kids wouldn't say nothing.

I was always still reading books and all that, and I had all these scholarships to go to these white colleges. But by that time, I was tired of these white people. I was tired of dealing with them, you know. So, my father said, "They want you to come to Grambling College in Louisiana, and Tennessee State." I said, "Those are Black schools." He said, "I know the coach down at Grambling real well, and the president of the school." By that time, my father was a big-time scout, so he knew all the people. So I said, "I'll go to Grambling." I didn't know anything about Grambling.

I went into the Army and went to France and was on an all-Army basketball team when I started writing. I joined the Watts Writers' Workshop, with Budd Schulberg. [Schulberg, an Oscar-winning screenwriter, started the workshop as a creative outlet for young writers in 1965 after the Watts Riots in Los Angeles.] I met all these writers. Johnie Scott, who went to Stanford. And Ojenke—a.k.a. Alvin Saxon—who had gone to UCLA. He was a

"I had this odd combination of reading books, the athlete, and the thug, because I grew up having to protect myself."

physicist and had majored in physics and chemistry and all that. We are still best friends to this day. Another poet out there, who I'm friends with, K. Curtis Lyle. We started to talk about all these great poets and these great writers like Richard Wright and James Baldwin.

I met James Baldwin and I'm like, This is what I want to do.

I had gotten the idea to do an anthology, and somebody said, "Well, you ought to go talk to Toni Morrison. She's at Random House." I hadn't read any of her books at the time, but I went to Random House and met Toni Morrison. I came in with the idea of doing an anthology of writers from all over: Latin America, Africa, Black America, Chinese. By this time, I was reading everybody.

She took it, and I published this book called *Giant Talk*, and it became the forerunner to a lot of books. She was my editor. We got to be so close. By this time I was really up into it, and I published my first book of poems, *Embryo*.

And that's the way it started.

I don't have a favorite of my books. The one that's gotten me the most notoriety, that's been translated into 35 or 36 languages all over the world, is *Miles: The Autobiography*. *Miles and Me*, my memoir, has been translated into 20-some languages.

I knew him really well—we got to be really good friends. I idolized Miles when I first heard his music. I was first attracted to Miles by his music. I loved his music. And then I loved his attitude. If he didn't like you, he didn't speak to you. He didn't waste time talking to you. That was the way it was.

Another one was *The Pursuit of Happyness*. Chris Gardner [who went from homelessness to being a successful stockbroker, wrote a memoir, and was eventually played by Will Smith] came and found me. There was a knock on the door. I go to the door, it's Chris Gardner. I looked at him and I said, "Yeah, who are you?" He said, "I'm Chris Gardner." I said, "What do you want?" He said, "I want you to write my story." I wrote the book, and it became a number one New York Times best seller. I didn't know it was going to be like that.

To young people, I say, "Read books. Read masters, great writers first. Get grounded in great writers." My favorite novelist is Gabriel Garcia Marquez. One of the highest points in my life was when I met Pablo Neruda, who is my idol as a poet, and Gabriel Garcia Marquez, who I got to meet—who had read my Miles book and loved my Miles Davis book.

Have confidence in yourself and in your ability— there's nothing wrong with that. But listen. Young people have to listen, because they don't know every- thing. I thought I knew everything, too, because I could shoot a 25-foot jump shot. But I didn't. ■

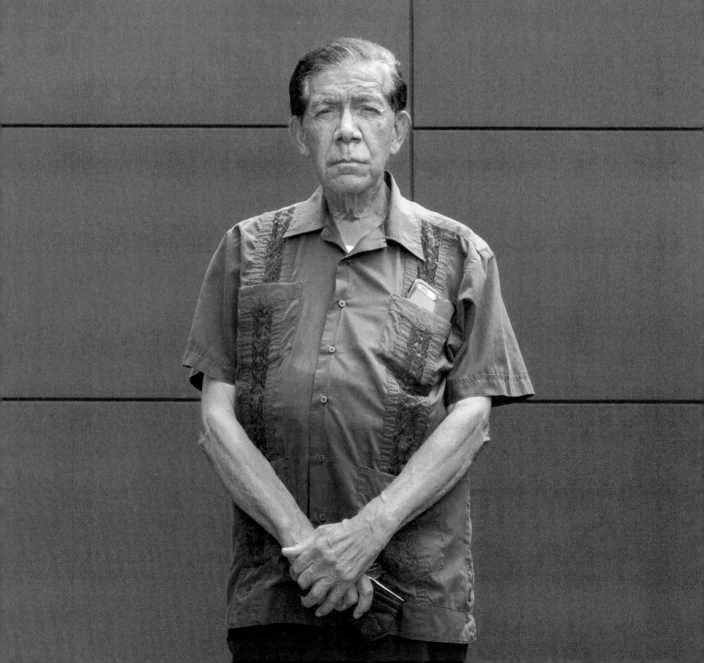

CECIL WILLIAMS

Civil Rights Photographer, 84, Orangeburg, South Carolina

Interview by Dejane Lawrence
Portrait by Nora Williams

Cecil J. Williams is a publisher, an author, and a well-known civil rights photographer. He has worked as a photographer for publications such as *Jet* magazine, the newspaper the *Afro-American*, and the *Pittsburgh Courier*. He was also a stringer for the Associated Press. He is the author of several books, among them *Unforgettable, Orangeburg 1968*, and *Freedom & Justice*. His work can be found in more than 130 publications, 17 newspapers, 11 television documentaries, and in several museums and galleries across the country. He operates the Cecil Williams Civil Rights Museum in Orangeburg.

Dejane Lawrence *What is your earliest memory?*

Cecil Williams My earliest memory would be at my house on Quick Street here in Orangeburg. When I was growing up and playing out in the backyard of my home, there was a sugarcane growth. I remember going back there and playing Tarzan.

How would you describe your childhood?

I had a happy childhood. But of course, segregation prevailed in all aspects of my life. The library was segregated, the schools were segregated, the playground facilities were segregated. Growing up in that kind of atmosphere made me very aware that I was living in a part of the United States that was different from what I would expect, being a citizen of the United States.

What invention from your lifetime are you most amazed by?

I am amazed by a very recent invention, the cell phone. I appreciate the ingenuity behind Steve Jobs and the development of, first of all, the Macintosh computer, and then the smartphone, because instead of a computer at your desk you really have a computer in your pocket.

If you could go back to any age, what would it be and why?

I would go back to age 21. Because if I could go back to 21 and know everything that I know now, there would be investments I would make! I believe that I was born at the most ideal time to witness mankind achieving a certain degree of triumph over racism. I came of age in this time in the United States when we did make a marginal impact.

A self-portrait (made by using a time exposure and a camera on a tripod) at Wilkinson High School, 1954.

"None of us are perfect. We make mistakes every day. But surely, you shouldn't have to get life in prison for making a small mistake."

Not only did you live it, but you recorded it through your photography. What events led to you becoming a photographer?

I started in photography at 9 years old. My brother, who usually used the camera, passed it on to me. I grew more than just an ordinary attachment to that device. I was obsessed by the capacity of that little camera to capture something and freeze that moment in time. It also enabled me, at that early age, to be able to go to Edisto Gardens and take pictures of people who would pay me $1–$1 then is probably $5 now. That was a sizable amount for a 9- or 10-year-old person. So that's when I first became attached to the use of the camera.

Was there a person or event that changed or impacted the course of your life?

Each person who came into my life in some kind of way, they were very important, and they had a great impact, starting with my teachers and the influence they had. My parents had a great influence on my values. They were supportive in seeing that I had the best kind of education, that I had sufficient food to sustain me from one day to the next, clothing, paying for things, helping me to buy a car or riding in the car that they had. We all stand on the shoulders of so many others.

Have you ever met any prominent people?

Oh, I'm not trying to brag when I say this, but I have probably photographed anyone that you could name, whether they are in sports, entertainment, motion pictures, actors, actresses—such as Muhammad Ali, even Joe Louis, Sugar Ray Robinson. In baseball, Jackie Robinson. In tennis, Arthur Ashe. In motion pictures, Cicely Tyson, Lena Horne. If you could name any president of the United States, I have photographed them, except Trump, and I really don't care to photograph him at all anyway.

What was your inspiration in creating the Cecil Williams Civil Rights Museum?

The creation of my museum was not an overnight obsession. It is an obsession, though, to create this, because I believe that if you want to know where you're going, you also have to know where you've come from. My entire museum is full of thousands of artifacts, documents, manuscripts, and memorabilia from the era of the civil rights movement. Our history, and all the freedom, the justice, the humanity, and all the good things that we can enjoy today were because people engaged in the civil rights movement, where we, as people of color, gained freedoms that impact us today. So much emphasis and credit must be given to the people that helped to carve that path.

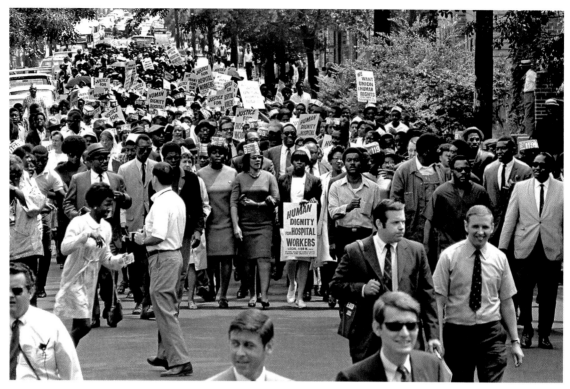

Coretta Scott King marches with hundreds of others in the 1969
Charleston Hospital Workers Strike in Charleston, South Carolina.

Protests against segregation on the
streets of downtown Orangeburg,
South Carolina in 1962.

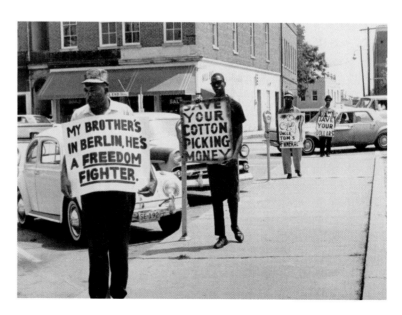

What are your thoughts about the Black Lives Matter movement, and police brutality among the African American community?

Let me say that we cannot do without the great courage and the heroism on the part of our police and law enforcement systems of the United States. We would not want to live in an area or community or in a state or county or city or in this United States without law enforcement. But there have been cases of police brutality on the part of some untrained or ill-trained officers. In the case of George Floyd, they suspected that a counterfeit bill was passed; the crime committed was not worth the punishment. So that police officer was the jury and judge and committed him to death for such a small infraction.

Though times have changed from when you were younger, do you still see slivers of the world you knew growing up?

There was similarity to the marches and demonstrations, the protests all over this world, that people in spite of the Covid restrictions came out in the street to address those concerns of police brutality. However, I want to place some of the blame on our political people—people who have high positions, in the federal, state, county, and city governments of America. I have yet to hear any of them, in all the conversations on television, reading the newspaper, address the high rate of incarceration we have, especially among African Americans. There's a whole institution of prisons that's been created to put people of color in prison for minor infractions of the law. The system needs drastic corrections so we can go forward treating every person with respect.

In all your years of living, what is the most important thing you have learned about yourself?

One of the lessons that I've learned in life is the power of our maker in our lives, and that we should be God-fearing. And of course, give more credit to God and religion in our everyday lives, so that we can take on the challenges we face today. And then the family unit, the lessons you learn in the family and the power of the family. And then the teachers, when it comes down to education, they were so very important. My education at Claflin, in fact, is without parallel. I don't believe that I could have gone any place in the entire world and gotten a better education than the education I received at Claflin University.

Looking back, are you happy with the life you've lived? Any regrets? Anything you would change?

I am very fortunate to have lived the life that I have lived. I believe that I could not ask for very much more. To have been in a position of being brought up in an environment where there were so many challenges, but we were able to overcome those challenges—I feel very blessed and fortunate to have lived the life that I have lived. And my contribution is to provide a museum like the one I have created, so that we might be able to still look at the images of yesterday, so that we can carve out a better present and a better future. ∎

Contributors

INTERVIEWERS

De'Aundre Barnes is a native of Greensboro, North Carolina, and a 2021 graduate of North Carolina Central University with a major in mass communication and a concentration in broadcast media.

Jamiah Bennett is a 2020 graduate of the University of Connecticut with degrees in journalism and sociology.

Sara Bey is a freelance writer from the Chicago area. A senior at Ohio's Miami University, she has published work in the *Miami Student* newspaper as well as *Men's Health* magazine. She is studying psychology and family science with a minor in art therapy.

Brittany Bracy is a journalism student at Las Positas College in Livermore, California, with an emphasis in broadcasting and a passion for writing.

Ashlea Brown is a reporter interested in narrative and audio stories. She graduated from UC Berkeley's Graduate School of Journalism in May 2021.

Danae Bucci has been a reporter at WJCL in Savannah, Georgia, since May 2020. Prior to that, she worked at WHDH in Boston, NBC's *Meet the Press*, the *Colorado Springs Gazette*, and several local newspapers. Bucci graduated from Northeastern University in the spring of 2020 with a bachelor's in journalism.

Hali Cameron is a graduate of Alabama State University, where she received a bachelor's in journalism.

Mariah Campbell is a freelance journalist from Longview, Texas. She is currently a senior journalism major at Texas Southern University.

Destiny Chance is morning anchor for WYFF *News 4 Today* in Greenville, South Carolina. Greenville is Chance's hometown, where she graduated from J.L. Mann High School. She also graduated from the University of South Carolina.

Melanie Curry is a recent journalism graduate of Emerson College and is an editorial assistant at Hearst Magazines. A part-time freelancer for more than three years, she has contributed to *Men's Health, Byrdie, HelloGiggles,* and more.

Quinton Hamilton is a freelance writer who received a master's degree in 2021 from Quinnipiac University.

Danielle Harling is an Atlanta-based journalist with a passion for sharing stories that are often overlooked. Her work has been published in *House Beautiful* and *Fodor's The Carolinas & Georgia* travel guide.

Allana Haynes is a community news reporter for Baltimore Sun Media. She previously worked as an editorial assistant there, where she managed the weekly events calendars and contributed stories to various sections of the paper. In 2017, she graduated with a master's degree from Columbia University's Graduate School of Journalism.

Jada Jackson is a Chicago-based journalist writing about social justice, culture, fashion, and sustainability, and where those topics intersect. She is a 2019 graduate of Columbia College Chicago.

Kayla James joined KCCI News in Des Moines, Iowa, in January 2020 as a general assignment reporter. She previously spent two years in Cedar Rapids covering several Eastern Iowa cities and communities. Before that, she called Florida her home for 20 years. She graduated from the University of Florida with a degree in broadcast journalism and another in political science.

 Jerusha Kamoji is a San Francisco State graduate with a bachelor's in international relations and a minor in journalism. She is interning as a staff writer at Clearlink and works at New Degree Press as a freelance associate editor.

 Ashley Kirklen is a reporter and anchor at WLWT in Cincinnati. She previously worked at stations in Macon, Georgia, and Marquette, Michigan. She was born in Gary, Indiana, and is a graduate of Indiana University, where she earned a bachelor's degree in communications. She is a member of National Association of Black Journalists.

 Jackson Kurtz has been a reporter at KMBC in Kansas City, Missouri, since January 2021, after previously working at WJCL in Savannah, Georgia. Kurtz grew up in Overland Park, Missouri, and studied broadcast journalism at the University of Kansas, where he spearheaded news programs at the student-run TV station, KUJH.

 Dejane Lawrence is an honors student at Claflin University in New Jersey, majoring in mass communications with a minor in marketing and a concentration in public relations. She expects to graduate in May 2023.

 Chris Lovingood has been a reporter and anchor at WRAL in Raleigh, North Carolina, since August 2021, after stints at stations in Pittsburgh, and Fort Myers, Florida. Lovingood is originally from Peoria, Illinois.

 Kenia Mazariegos is an on- and off-camera reporter covering beauty, lifestyle, and women's issues. She is a graduate student in the strategic communications program at Columbia University's School of Professional Studies, and earned a bachelor's in digital media from the University of the District of Columbia.

 Stewart Moore is an anchor at WESH in Orlando, Florida, where he has worked since August 2011. He is originally from Rock Hill, South Carolina. Before joining WESH, Moore worked as the morning anchor for WIS in Columbia, South Carolina, and WTXL in Tallahassee, Florida. He graduated from Florida State University with a major in creative writing and a minor in communications.

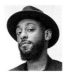 **Jamel Mosely** is an entrepreneur, DJ, brand specialist, and award-winning visual story-teller. He is a founder and vice president of marketing and sales of Collectiveffort, a creative agency and coworking space for creatives in Troy, New York, a founder of Root3d, a BIPOC-centered wellness and healing center in Albany, New York, and the owner of Mel eMedia, a full-service multimedia outfit. He is dedicated to building creative ecosystems that will create jobs and provide equity to underserved and marginalized communities.

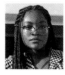 **Elizabeth Okosun** is a freelance writer who covers pop culture and lifestyle journalism. Her work has been featured in *Men's Health, Oprah Daily,* and *Runner's World.*

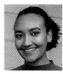 **Carly Olson** is a journalist and editor based in Northern California, where she was born and raised. She is a contributing editor at *House Beautiful,* and was previously an editor at *Architectural Digest.* Olson is a 2017 graduate of Tufts University, and is currently working toward her master's in journalism at UC Berkeley.

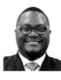 **DiVonta Palmer** is a 2021 graduate of Alabama State University, where he majored in communications with a concentration in radio and TV. He is a veteran of the United States Army.

 Jonathan Piper II is an advocate and public speaker from Oakland who attends Chabot College in Hayward, California. He interned with KDOL *Youth Beat,* a multimedia program.

Kristian Rhim is a recent graduate of Spring-field College and a features reporter with the Atlanta Falcons. He interned at *USA Today* and is an alum of the New York Times Student Journalism Institute. He was a fellow at *Philadelphia* magazine, and his reporting has also appeared in ESPN's *The Undefeated* and *Men's Health* magazine. He is a member of the National Association of Black Journalists.

Rhondella Richardson is coanchor of weekend morning newscasts at WCVB in Boston, where she has worked since arriving in 1996 as a general assignment reporter. Prior to WCVB, she worked at KING in Seattle; WJAR in Providence, Rhode Island; and WMUR in Manchester, New Hampshire. Richardson graduated Magna Cum Laude from Northwestern University's Medill School of Journalism in 1990.

Jaliah Robinson is a mass communications major at Claflin University.

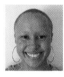

Ryce Stoughtenborough is a freelance journalist with a knack for visual storytelling. She graduated from San Francisco State University in 2020 with a bachelor's in journalism.

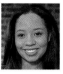

Mya Vinnett, Stanford University '22, is a communication major and aspiring broadcast journalist who interviews emerging talent on her YouTube show, *Some Real Talk*.

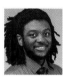

Treyvon Waddy, a senior at Texas Southern University, was a summer 2021 intern at the *Houston Chronicle*.

Christina Watkins is an anchor at WDSU in New Orleans. She previously spent three years in Charlotte, North Carolina, at Spectrum News, the state's only 24-hour station, where she anchored the weekend morning newscast. Originally from Oviedo, Florida, a small town outside of Orlando, Watkins graduated from Florida International University in 2012.

Rachel Williams is a 2021 graduate of Alabama State University with a major in political science and minor in communica-tions. She is the chapter founder of a women's empowerment organization titled the Curve ASU and currently serves as the College Democrats of America Black Caucus national council chair.

PHOTOGRAPHERS

 Kwaku Alston has photographed some of the most famous faces of our time for a diverse list of clients including the *New York Times Magazine, Time,* ESPN, *Essence,* Coca-Cola, Disney, Netflix, and Apple. He has also partnered with a variety of charities and nonprofits, including the DesignACure Breast Cancer Awareness Campaign, the Black AIDS Institute, and the Smiley Faces Foundation.

 Vonecia Carswell is a New York City-based portrait and editorial photographer. Her affiliations include the National Association of Black Journalists, Diversify Photo, and Black Women Photographers.

 Erik Carter is originally from Texas, began his career in New York City, and now lives in Los Angeles. He strives to highlight the stories surrounding Black and LGBTQIA+ communities, championing and celebrating the nuances of their many voices.

 Tiffany L. Clark is a New York City-based freelance photographer and producer who specializes in documentary, lifestyle, and portraiture. Her work has appeared in the *Washington Post, New York Times T* magazine, *Chicago Tribune, Palm Springs Life* magazine, and others. Originally from St. Paul, Minnesota, Clark has a passion for the arts, fitness, traveling, and the outdoors.

 Sahar Coston-Hardy is a fine-art and landscape-architecture photographer focused on the social structure of race and cultural identity. She is a 2020 Women Photograph + Nikon Grant recipient. A graduate of the Tyler School of Art and Architecture at Temple University, she has lectured widely on urban design photography and visual storytelling. She is a contributing editor to *Landscape Architecture* magazine, and her work has been featured in *Architect* and *LEVEL*. In 2020, Coston-Hardy was named one of 10 Emerging Architectural Photographers to follow by ArchDaily.

 Erin Douglas is an experienced travel, lifestyle, and documentary/reportage photographer with a mission to tell authentic stories that inspire people and move them to action. Her work has been featured in *Essence,* the *Baltimore Sun, Baltimore* magazine, *Travel Noire, Condé Nast Traveler*, and the book *Shut Up and Run.*

 Cydni Elledge is a photographer from Detroit, whose love for art transformed a hobby into a profession. Her work has been published widely, including in the *New York Times,* NPR, *Vanity Fair, ProPublica, Vogue Arabia, Man Repeller,* and *MFON Women of the African Diaspora*. Elledge is a 2016 Documenting Detroit Fellow. She holds a bachelor of fine arts in photography from the College for Creative Studies.

 Amber N. Ford is a photographer/artist based in Cleveland. She received her B.F.A. in photography from the Cleveland Institute of Art in 2016. Ford is best known for her portraiture. Her work has been shown in galleries such as Kent State University, Transformer Station, SPACES Gallery, the Morgan Conservatory, the Cleveland Print Room, Zygote Press, and Waterloo Arts in Cleveland.

 Yalonda "Yoshi" M. James is an award-winning staff photojournalist and video producer at the *San Francisco Chronicle*. Her passion is documenting stories focusing on social justice issues. James is formerly a staff photojournalist and video producer for the *Commercial Appeal* in Memphis, Tennessee.

 Octavio Jones, who is based in the Tampa Bay, Florida, area, has a passion for telling the stories of marginalized communities through his photographs. He has more than 10 years of experience as a documentary photographer, most recently as a staff photojournalist/editor at the *Tampa Bay Times*.

 Jai Lennard grew up in the San Francisco Bay area in California. He studied at Morehouse College in Atlanta, took his first photo course in London, and completed his B.F.A. in photography at the School of Visual Arts in New York City. His clients include the *Hollywood Reporter, Billboard,* the *New York Times*, Warby Parker, Club Monaco, and more. Lennard founded Color Positive, a nonprofit that aims to network Black photographers, stylists, and directors in the editorial and commercial world.

 Da'Shaunae Marisa is a freelance documentary, editorial, and commercial photographer originally from the Midwest and currently based in Los Angeles.

 Joe Martinez is a portrait photographer in St. Louis. He is passionate about creating images and telling stories of under-represented people who push boundaries and take up space in places they are traditionally not seen.

 Cheriss May is a lauded portrait photographer and adjunct professor at Howard University, her alma mater. She is a frequent contributor to the *New York Times*, and has been published in *O, the Oprah Magazine*, the White House website, ABC News, the *Today* show, and *People*, among others.

 Michael A. McCoy, a Baltimore, native and disabled veteran who served two tours in Iraq, has found in photography a critical therapeutic outlet. His work has been featured in the *New York Times, Washington Post,* Associated Press, Reuters, Getty Images, the *Washington Post Magazine, Time, AARP,* and others.

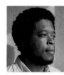 **Gavin McIntyre** was born and raised in California and currently works as a staff photographer for the *Post and Courier* in Charleston, South Carolina. He graduated from San Francisco State University in 2015 with a bachelor's in journalism with a concentration in photojournalism. He has worked for Al Jazeera America's *Fault Lines* program, the *Bay City Times*, the *Sacramento Bee*, and *The State*.

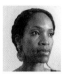 **Stephanie Mei-Ling** is a Black American/ Taiwanese documentary photographer who splits her time between Brooklyn and Los Angeles.

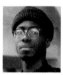 **Zerb Mellish** is a first-generation Liberian American photographer and photojournalist living and working in the Dallas-Fort Worth, Texas, area. Inspired by the topic of identity, his work and practice mainly focuses on and celebrates Black experience through the visual narrative.

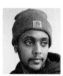 **Meron Menghistab** is an Eritrean American photographer working primarily in portraiture and narrative-based work.

 Nancy Musinguzi is a visual artist, freelance photographer, and visual anthropologist working and living in Minneapolis. They have self-published eight photography books, most recently *The Letter Formally Known as Q*, a multimedia oral history and archival project documenting the intergenerational narratives of queer/ trans American immigrants of color and their personal experiences of migrating.

 Flo Ngala is a New York-based photographer with a passion for authentic image-making and photojournalism. She has worked for publications and commercial clients across documentary, music, portraiture, and fashion, including Atlantic Records, *Billboard,* Facebook, *GQ,* Netflix, Nike, Reebok, *Rolling Stone,* the *Guardian,* the *New York Times,* and Universal Records.

 Greg Noire is a Houston-based live-music and portrait photographer with more than a decade of experience. He has worked with artists such as Childish Gambino, Demi Lovato, Drake, Teyana Taylor, Travis Scott, and many more. Noire has also served as a staff photographer for music festivals including Lollapalooza, Austin City Limits, Coachella, Astroworld Festival, Governors Ball, and the iHeart Music Festival.

 Nate Palmer is a documentary portrait photographer living and working in his hometown, Washington, D.C. He received a B.F.A. in photography and imaging from NYU Tisch and is a regular contributor to the *New York Times, National Geographic, Rolling Stone,* and others.

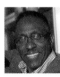 **Paul Pettie** is a freelance photographer based in Cornelius, North Carolina, whose photography is influenced by his training in art and architecture.

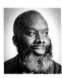 **Andi Rice** has always had a camera in his hand. His mother introduced him to photography to fight childhood boredom. "My mother taught me the basics on an old Canon film camera," he says. "I was hooked."

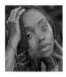 **Makeda Sandford** is a 26-year-old photographer based in Brooklyn by way of North Carolina. She specializes in narrative portraiture, primarily of young members of the Black diaspora.

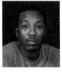 **Michael Starghill** is a commercial and editorial photographer specializing in portraiture, sports, and documentary photography. He was born and raised in Houston before leaving to attend American University in Washington, D.C.

 Whitney Thomas is an African American photographer from Philadelphia. For more than 20 years, Thomas's focus has been primarily in beauty, fashion, and music photography. His images have appeared in magazines including *Ebony, Essence, Vibe, People, O at Home, Slam, The Source, Sister to Sister,* and *Uptown,* as well as book and CD covers for numerous nationally known celebrities and artists.

 Aaron Turner is a photographer and educator based in Arkansas. He received his M.A. from Ohio University and an M.F.A. from Mason Gross School of the Arts at Rutgers University. He was a 2018 Light Work Artist-in-Residence at Syracuse University, a 2019 EnFoco Photography Fellow, a 2020 Visual Studies Workshop Project Space A-I-R, and a 2020 Artist 360 Mid-American Arts Alliance Grant Recipient.

 Valaurian Waller is a native Detroiter and self-taught documentary photographer whose current work largely explores religion and social issues. Her photos have been published in the *New York Times, Detroit Free Press, Detroit News, Metro Times, Model D,* and *Bridge Detroit.*

 Lynsey Weatherspoon is a portrait and editorial photographer based in Atlanta, and Birmingham, Alabama. Her work has appeared in the *New York Times, USA Today,* NPR, the *Wall Street Journal, Washington Post, Time,* ESPN, and *The Undefeated.* Her work has been exhibited at the African American Museum in Philadelphia and Photoville NYC. She is a 2018 awardee of the Lit List. Her affiliations include Diversify Photo, Authority Collective, and Women Photograph.

 Nora Williams is a South Carolina native. She shoots documentary, lifestyle, and editorial photography. Her work is characterized by her use of vibrant pops of colors.

 Shaleah Williams, a New Haven, Connecticut, native, has been taking pictures since she was gifted a Polaroid camera as a child. She provides photography for all occasions and especially enjoys capturing lifestyle portraits, weddings, and events.

DESIGN

Mike Nicholls is an Oakland, CA-based award-winning creative director, book designer, brand strategist, publisher, visual artist and community builder. He translates ideas into visionary creative solutions utilizing over 20 years of design experience and natural talent. Mike is also the founder of Umber, a platform highlighting creative perspectives that matter. His work has been recognized by such places as *Blavity's* Afro Tech, *Print Magazine*, Muse by Clio, and *Communication Arts*. Mike's design of *Lift Every Voice* was inspired by his time spent growing up seeing stained glass windows in the Baptist church of his hometown in Charlotte North Carolina. More of his work can be found at www.thisismikenicholls.com.

PHOTOGRAPHY CREDITS

ABC Photo Archives / Getty Images: 92 (top)

Afro Newspaper / Gado / Getty Images: 2 (middle left), 82

Kwaku Alston / Getty Images: 61 (top left), 94

Courtesy of Joseph Anderson: 2 (top middle), 142

AP Photo: 35

AP Photo / Jack Thornell: 36

Courtesy of Anna Bailey: 64, 66

Courtesy of The Beach Company: 187

David M. Benett / Getty Images: 72 (bottom)

Bettmann / Getty Images: 27, 31, 90, 189

ullstein bild / Getty Images: 4 (middle left), 61 (bottom middle), 74

Courtesy of Bon Secours: 173 (bottom left), 186

Courtesy of Alvin Brooks: 176

Courtesy of Marie Brown: 214

Vonecia Carswell: 139 (top middle), 150, 152

Erik Carter: 106, 130, 132

CBS Photo Archive / Getty Images: 4 (top right), 92 (bottom), 97

Veronica Chapman: 162

Cheryl Chenet / Getty Images: 75

Tiffany L. Clark: 139 (bottom left), 168, back cover (middle right)

Courtesy of Claudette Colvin: 23

Sahar Coston-Hardy: 4 (bottom middle), 138, 164, 166

Eddie Davis / Gainesville Sun: 52

Margo Davis: 21

Jim Dennis: 226

Erin Douglas: 2 (bottom right), 118

Cydni Elledge: 173 (middle right), 202, 204

James Estrin / The New York Times / Redux: 8

Courtesy of Clarice Freeman: 173 (top left), 183

Courtesy of Dr. Melissa Freeman: 151

Amber N. Ford: 139 (bottom middle), 146

Ron Galella / Getty Images: 72 (top)

Courtesy of Lillian Greene-Chamberlain: 107 (top middle), 120, 121

Brownie Harris / Getty Images: 2 (bottom middle), 70

Hearst Archive: 57

Rob Howard / Harpo, Inc.: 7

Kevin N. Hume / San Francisco Examiner, a unit of Clint Reilly Communications: 17

Yalonda M. James / The San Francisco Chronicle: front cover (bottom right), 2 (top right), 12, 13 (top left), 13 (middle left), 13 (top right), 14, 18, 28, 33, 46, 206, 224, back cover (middle left), back cover (top right)

Octavio Jones: 2 (top left), 61 (top middle), 98

Courtesy of Opal Lee: 4 (top middle), 44 (top)

INDEX

ACKNOWLEDGMENTS

Special thanks to:

Steven R. Swartz, without whose enthusiasm for this project from its inception this book would never have been possible.

Oprah Winfrey, for always valuing the stories of those who paved the way and for embracing Lift Every Voice and giving it a home at Oprah Daily.

Ryan D'Agostino, for conceiving and shepherding "Project Tell Me: Lift Every Voice," and Tiffany Blackstone and Mark Jannot, for their collaboration and editorial wisdom.

Alix Campbell, Lynzee Marmor, Roni Martin, Christina Weber, and the Hearst Magazines Visual Group, for bringing the new generation of talented Black photographers to the project and to Hearst.

The dedicated team at Hearst magazines who brought the initial project to life, including:

Julia Berick, Bianca Betta, Carrie Carlson, Kim Cheney, Shelby Copeland, Laurie Feigenbaum, John Gara, Cybele Grandjean, Abigail Greene, Allison Keane Katelyn Lunders, Lauren Puckett-Pope, Cassie Skoras, and Joseph Zambrano.

Tim O'Rourke, Maria Reeve, and the photographers and journalists who reported and published *Lift Every Voice* features across Hearst newspapers.

Ebonee Athanaze, Barbara Maushard, Travis Sherwin, and all the Hearst television journalists who conducted and broadcast interviews with Black elders in their communities.

Kristine Brabson, Alexandra Carlin, Adam Glassman, Leigh Haber, Lucy Kaylin, Gayle King, Kate Lewis, Alison Overholt, and Zuri Rice for their support and guidance.

Jacqueline Deval, Nicole Fisher, Zach Mattheus, and Nicole Plonksi for transforming the "Lift Every Voice" project into the *Lift Every Voice* book, along with Ray Chokov, Kevin Jones, Jay Kreider, Bill Rose, Tracy Spangler, and Ruth Vazquez on the Hearst Books team.

Brian Madden and the consumer revenue team who helped the book reach its audience.

HEARST
HOME

Cover and book design by Mike Nicholls

The text of this book was composed using three typefaces.

Halyard and Dapifer by Darden Studio, a firm that pursues typography that is the result of earnest inquiry, suited to contemporary technical and design expectations, and rooted in the values and practices of five centuries of typefounding.

Bayard by Vocal Type Co., a diversity-driven font foundry started by Tré Seals in 2016. Each font reimagines a piece of history from a different underrepresented culture—from the Civil Rights Movement in America, to the Women's Suffrage Movement in Argentina, and beyond.

Library of Congress Cataloging-in-Publication Data Available on request

10 9 8 7 6 5 4 3 2 1

Published by Hearst Home, an imprint of Hearst Books/Hearst Communications, Inc.

Hearst Communications, Inc.
300 W 57th Street
New York, NY 10019

Hearst Home, the Hearst Home logo, and Hearst Books are registered trademarks of Hearst Communications, Inc.

For information about custom editions, special sales, premium and corporate purchases:
hearst.com/magazines/hearst-books

Printed in The United States of America

ISBN 978-1-950785-81-0